The Prints of Benton Murdoch Spruance

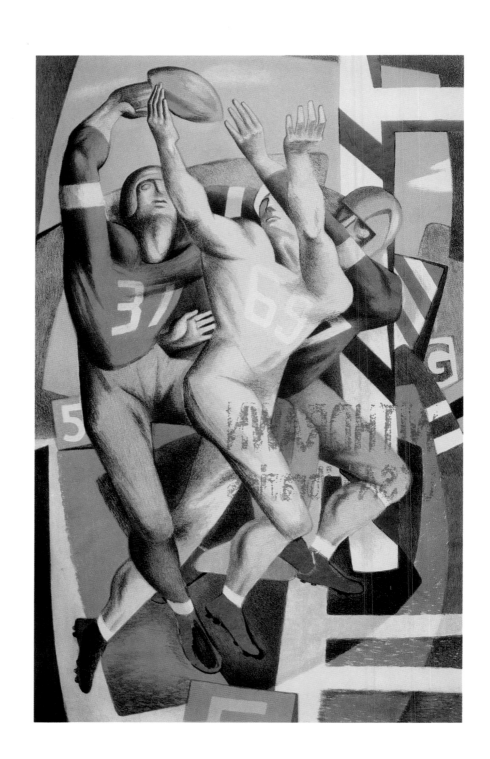

The Prints of Benton Murdoch Spruance

A Catalogue Raisonné

Introduction by Ruth E. Fine

Foreword by Robert F. Looney

Catalogue by Ruth E. Fine and Robert F. Looney

Published in cooperation with
The Free Library of Philadelphia by

upp University of Pennsylvania Press
1986

Library of Congress Cataloging-in-Publication Data

Fine, Ruth E., 1941–
 The prints of Benton Murdoch Spruance.

 Bibliography: p.
 Includes index.
 1. Spruance, Benton, 1904–1967—Catalogues
raisonnés. I. Looney, Robert F. II. Spruance, Benton,
1904–1967. III. Free Library of Philadelphia.
IV. Title.
NE539.S67A4 1986 769.92′4 85-26465
ISBN 0-8122-8004-0 (alk. paper)

Printed in the United States of America

Frontispiece: *Forward Pass*, 1944, cat. no. 231

Contents

Foreword

Benton Murdoch Spruance was much more than a distinguished artist of national renown. His career focused in large part upon service to the art community, not only in Philadelphia but throughout the nation as well, and much of his importance lies in all that he was able to accomplish for his fellow artists.

He had a keen sense of the place of the artist in the life of the community, and as a founder of the Philadelphia chapter of Artists Equity, he helped to give to the individual artist a strong voice in community affairs. The city of Philadelphia is indebted to Spruance for much of its "public" art— the sculptures in open spaces and works in public buildings—for after his appointment to the Philadelphia Art Commission in 1953 he was instrumental in securing the approval by the city council of an ordinance requiring 1 percent of the cost of public buildings to be allocated for works of art.

Spruance's natural gifts as a teacher and administrator were signaled by awards, several honorary degrees, and appointments to administrative positions at various institutions of learning in the Philadelphia area. Teaching, quite apart from its practical aspects, was to him an important function of the artist, and he brought to this profession a keen understanding of the learning process and a will to share his knowledge in as creative a manner as possible.

Along with his colleagues Jerome Kaplan and Samuel Maitin, he helped establish Prints in Progress, a program designed to bring printmaking directly to the young people of Philadelphia's public schools through demonstrations in which they could participate. Conceived by Walter L. Wolf, the program was then under the auspices of the Philadelphia Print Club.

Although Spruance was well known as a painter, his greatest successes were achieved in graphic art, specifically in lithography. The art of lithography was advanced through Spruance's early experiments in color printing.

The memorial collection of his work now in the Free Library of Philadelphia was established in 1968 by Emerson Greenaway, then director of the Free Library and a close friend of Benton Spruance. It is composed of more than 450 of his prints, studies for paintings and prints, color separations, photographs, and memorabilia. Appropriately these materials now are a matchless resource in an educational institution to which the general public has ready access.

The closely formed body of Spruance's art reflects the life of the man himself. His prints, taken in chronological sequence, constitute a unique record of his times, his world, and his experience. But above all he emerges clearly as a warm, compassionate human being.

Spruance was born in Philadelphia in 1904 and was educated in local schools. He studied architecture at the University of Pennsylvania, painting at the Pennsylvania Academy of Fine Arts and the Graphic Sketch Club.

In both his junior and his senior year at the Academy, he won the William Emlen Cresson Travelling Scholarship, which enabled him to go to France. In Paris he tried his hand at lithography for the first time at the studio of Jacques and Edmond Desjobert. This was in 1928, the beginning of his career as an artist. Also in 1928 he married Winifred Glover, a source of strength and inspiration throughout his life.

In the 1920s and 1930s, when Spruance was on the threshold of his career in art,

the preferred medium in printmaking was etching. Very small gemlike prints in very large cream-colored mats were the fashion, and they appeared frequently on the walls of collectors. Lithography and other print media were not dead, however. Indeed, the printmaking world was very much alive in all its variations, and experiments in new methods were frequent, especially after 1933, during the period of the WPA (Works Progress Administration) art projects.

Benton Spruance, however, continued to make lithographs and to concentrate on experiments in methods and techniques. In this sense he was something of a pioneer, especially in his experiments in the use of color.

His gifts as an artist were soon recognized. His paintings were exhibited widely, and his prints, also shown in New York and other cities, won prizes in open competitions sponsored by the Philadelphia Print Club. From this time on, his reputation as a major artist grew and spread. He received commissions to paint murals and to illustrate books as well.

Throughout his career he received many honors for his achievements, among them the Philadelphia Art Alliance Medal of Achievement and election to membership in the National Academy of Design and in the American Institute of Architects.

He began work in 1965 on a set of prints that are generally regarded as his most masterful works. These are the twenty-six lithographs based on his reading of *Moby Dick*, themes from which recur often in the prints made during the last two decades of his life. The prints were exhibited for the first time in 1968.

Spruance died in December 1967.

Robert F. Looney
General Editor

The Prints of Benton Murdoch Spruance

Introduction

RUTH E. FINE

The mythic vision of Benton Murdoch Spruance stemmed from two sources: auto-biographical experience and literature. Remarkably well read and keenly intelligent, he accepted no less a theme than the human condition for his artistic expression. The delights of nature; the evils of excessive temporal pleasure; the effects (both positive and negative) of mechanization on twentieth-century sensibilities; the horrors of war and civil disruption; love of friends and family; and awareness of the existential void—all seen within the framework of deep religious concern—formed the content of his work. Spruance fully believed that a work of art functioned as a moral, intellectual, and spiritual force, and the mood of his work was generally serious, reflecting his awareness of the tragic in life but also manifesting his belief that the good prevails. Spruance produced hundreds of paintings and drawings and completed several architectural commissions; but his desire for direct communication through his work made the print, historically a successful means for reaching a broad public, the most natural vehicle for his ideas. Lithography was his principal graphic medium, accounting for 536 of his 555 known prints. The remaining few include etchings, drypoints, aquatints, woodcuts, and monoprints. The catalogue raisonné which follows forms a record of this graphic oeuvre.

Spruance's earliest important source of artistic inspiration was George Bellows, who died just about the time Spruance began to make prints.[1] Bellows's use of caricature and his interest in athletic subjects, especially, influenced the younger artist's work through the 1920s and early 1930s.

Bellows was only the first of many influences, however, for Spruance was passionately involved with the history of art, and he prized the work of the past as a spiritual source for the present.

Dürer, Rembrandt, Poussin, Blake, and Goya were among his principal idols.[2] As many artists do, he no doubt worried over how his work fitted into the ever-changing structure of art history; his desire to establish connections with the past is probably one reason why he ultimately became committed to heroic themes of a sort rarely adopted in so overt a form by artists in the twentieth century. Spruance was also attracted by modernism, although he never fully accepted abstraction. Picasso was his primary influence among his contemporaries, but Rouault, Max Beckmann, the Mexican muralists Orozco, Siquieros, and Rivera, and the American precisionist Charles Sheeler were of obvious interest to him as well.

Spruance explained his efforts at balancing traditional themes and modernist form in this way: "Two elements are always present in my way of working. One is the attempt to use space in an organized way; the other is the use of the look of the world itself *as I see it*. The first becomes the abstract form which, nondecorative in its depth, is the prime conception of we Western people; the second becomes the theme expressed in that form—which gives meaning and humanity to the picture."[3] The artist was "looking for something behind the physical fact, attempting to express an elusive emotion or intuition by means of recognizable forms in significant and provocative relationship."[4] During the 1930s, when Spruance came of age as an artist, prints were applauded as an art of the people, and interest in lithogra-

phy was particularly high. For example, in the Fifteenth Annual Exhibition of American Prints, held at the Philadelphia Art Alliance in 1937, 88 of 118 objects exhibited were lithographs.[5] The prevalence of lithographs reveals an important change in the attitudes of artists interested in printmaking. Etching had been a more popular medium during previous decades; Americans had been strongly influenced by the work of Whistler and other artists who led the etching revival in England and France at the end of the nineteenth century. By the mid-1930s, though, the emphasis had shifted, and etchings were relegated to the domain of the connoisseur. The lithography process, unlike etching, can yield an almost unlimited number of good impressions and was embraced as the appropriate technique to express a new vision.[6] American lithographers were compared with the great nineteenth-century French lithographer Honoré Daumier in the sharing of a political and social vision. Spruance himself wrote that the tradition of the print "commands all creative men to work, integrated into the civilization in which they live, to use as their symbols the broadly understood symbols of the people, and to use them in such a way that their aesthetic value is communicable to all. . . . this is the very essence of what historians call American."[7]

Spruance's large body of printed works, produced over more than four decades, embodies a vast range of themes, styles, and processes. His etchings, drypoints, aquatints, woodcuts, and monotypes are of negligible importance. The etchings and drypoints (cat. nos. 537–45) were student exercises. The three aquatints (cat. nos. 546–48) came at mid-career, in 1953, apparently at the encouragement of the

French printer, Roger Lacourière, while Spruance was on a trip to Europe.[8] Only one (cat. no. 548), so far as we know, was an edition. The woodcuts, too, date from the early 1950s, and the process may have been undertaken with the encouragement of Morris Blackburn.[9] They were done about the time that Spruance began to print his own lithographs, and it is possible that his friend "Blackie" was trying to persuade him to shift to making woodcuts, which are far less laborious to print. Spruance did not, however, pursue this undertaking very far. Only four woodcut images are known (cat. nos. 549–52). The monoprints (cat. nos. 553–55), made late in the artist's career, in 1965, stemmed from outside encouragement, too, this time that of the renowned print collector Lessing J. Rosenwald, who was a close friend of the artist's.[10]

The lithographs, and particularly the experiments in color lithography, represent Spruance's major achievement and form the main body of this catalogue. The artist's development was a fluid one, and changes in theme, style, and process evolved simultaneously. These three aspects of his work, however, will be discussed separately in the following sections of this introduction, each of them within a chronological framework.

THEMES
Spruance's themes were many: landscape; cityscape; still life; genre scenes; imaginative symbolic pieces; and, at the end of his life, subjects from literature. Portraits, too, were an important involvement, and unlike his other subjects, which occupied his attention for fairly defined periods of time, Spruance made portraits throughout most of his career.

Football highlights Spruance's early period, and prints depicting the game brought him his first acclaim. In them, he captured the speed and drama of the game through his simplification of form and his construction of dynamic compositions. The first, *Football* (cat. no. 4), of 1928, is among the artist's earliest lithographs; but the game continued to intrigue him as a subject in his art for well over a decade, and, in fact, the last football essay was also one of Spruance's first complex color compositions, *Forward Pass* (cat. no. 231, frontispiece), of 1944.

During the early 1930s Spruance produced a number of other particularly successful lithographs in which he similarly dramatically simplified form while retaining the strength and totality of his subjects. Among them are *Approach to the Station, Bulldog Edition,* and *Late Departure* (cat. nos. 70, 76, 89)—all early train and subway images; *Schuylkill Bridges* (cat. no. 100), one of the artist's many depictions of Philadelphia, especially the Germantown section where he lived; and the portrait *Sophie* (cat. no. 83).[11] For the most part, however, apart from the football prints, rather conventional landscapes, portraits, and genre scenes dominate Spruance's very early work. Many of them are of interest mainly because they foretell subjects and formal investigations that became increasingly important in later, more successful, pieces. For example, *Homing Instinct* and *Out of the City* (cat. nos. 8 and 33) initiate Spruance's continuing fascination with transportation and the speed of American life. The former also is the first of the complex figure compositions that reach a peak with *The People Work* series (cat. nos. 141–44). Note, too, *The Stool Pigeon* (cat. no. 11), one of Spruance's

few images of actual violence, but the first of many that focus on death, more broadly conceived as man's awareness of his aloneness and his own mortality. An actual image of death first appears in 1934, in *Conversation with Death* (cat. no. 103). The artist's earliest directly religious piece, *Annunciation* (cat. no. 97), dates from that same year. Both signal interests that dominate Spruance's later work. Particularly interesting for its evocation of mood is *Church at Night* (cat. no. 59), of 1932, which also shows a drastic modification of form in rather naturalistic terms; *Shells for the Living* (cat. no. 80), of a year later, by contrast, demonstrates another kind of effort at simplification and abstraction— this time by sharply flattening and layering the forms, in sympathy with the precisionist work of Charles Sheeler, or, perhaps, the work of Stuart Davis.

During the 1930s when, as indicated earlier, prints were considered an art of the people, the depression forced upon many artists a preoccupation with America's internal conditions. Henri Marceau, then curator at the Pennsylvania Museum of Art (now the Philadelphia Museum of Art), aptly stated in 1937 in his foreword to Spruance's *The People Work* series: "The measure of an artist's success is largely to be found in his ability to live within his own times and to find in his daily surroundings the pictorial material through which he will speak to his audience." This was generally interpreted to mean that humanistic issues were best expressed through the depiction of human form. Spruance's work throughout his career demonstrates his general acceptance of this notion of humanism. His most overtly social-conscious work, in keeping with the times, was produced from 1935 through

the 1940s, after which religious and mythological themes took precedence.

The diverse fabric of American life was Spruance's focus during the late 1930s: highway subjects like *Highway Holiday*, *Road from the Shore*, and *Traffic Control* (cat. nos. 107, 108, 130, 132); the effects of the depression, as seen in *Vagrant* (cat. no. 158); and relations between men and women, as in *Introduction to Love* and *Caustic Comment* (cat. nos. 110 and 126). Most important during this period, perhaps, are the four prints issued in portfolio with Marceau's foreword quoted above: *The People Work*. This is the first of several complex narrative series that Spruance produced, the format being one he obviously found sympathetic to his thought processes. In these four images, *The People Work—Morning*; *—Noon*; *—Evening*; *—Night*, the viewer is invited to make many more diverse contrasts and comparisons, both formal and thematic, than would be possible in a single motif.

Symbolism was an aspect of Spruance's pictorial vocabulary from almost the beginning of his career (e.g., *Garden of Eden*, cat. no. 64). Examples from the late 1930s include *Symbols of Grace* (cat. no. 139), an image of church and home in which the title tells much (titles are always important to Spruance's meaning), and *Macbeth—Act V* (cat. no. 148), in which Spruance aims to transform the commonplace—the funeral of a "poor old guy" —into the heroic tragedy of one of Shakespeare's greatest efforts.[12] Also of note in the symbolic mode is a series less well known than *The People Work: The Thirties—Graduation; The Thirties—Windshield*; and *The Thirties— Requiem* (cat. nos. 175–77).[13] The *Windshield* piece presents a forceful contrast of the idyllic with the tragic—a summary

of the American experience as Spruance understood it at that time. Indeed, it was at this time that he wrote of his "search for a personal expression of an American art form."[14]

The forties was a period of extraordinary transition in Spruance's work. The war and its aftermath, as well as Spruance's growing maturity as an artist, were among the reasons for the substantial changes that occurred. As far as his themes are concerned, myth and religion took over the artist's attention by the end of the decade. En route, a number of singular images were produced. Several of them are outside of Spruance's mainstream. *American Pattern—Barn* (cat. no. 184) is one, and it is his most successful statement in the precisionist mode. *The Adirondacks—The Sentinels* and *Adirondacks Garden* (cat. nos. 212 and 213) are two others. They remind one of Spruance's Pyrenees landscapes of the late 1920s (cat. nos. 38 and 39), but in the later pieces we see the landscape in the hands of an artist far more in control of his work, despite the fact that he had made no lithographs of landscapes for more than a decade. And not until 1960, with the three Gettysburg sites (cat. nos. 424–26), does pure landscape (although certainly with spiritual and political overtones) appear again. *Ridge Valley Churches* (which really is a landscape, albeit, again, with strong narrative overtones) and the two versions of *The Women in Front of Their Houses* (cat. nos. 234, 255, and 256) show most clearly Spruance's admiration for Rouault, undoubtedly based in part on the French artist's commitment to religious subjects, an unusual one in the twentieth century.[15]

More in the mainstream of Spruance's lithographs of the early 1940s than the pre-

ceding examples are the war pieces and those based on religious or biblical themes. Often both interests are combined, as in the three versions of *The Conversion of Paul* and *Deliverance* (cat. nos. 194–96 and 224). During the later years of the decade, Spruance issued many religious pieces, among them the tortured *Saint Anthony* (cat. no. 282). This postwar period appears to have been a time of focus on experiments: with drawing techniques on the stone, with form, and with color. In these respects, *Somnambulist* of 1948 (cat. no. 271, color plate no. 1*) is of particular significance. The subject is a woman in an interior, a theme that was to become popular with the artist in his later lithographs; but apart from the subject, the lithograph is of prime importance to Spruance's formal development and to his use of color.

As noted, Spruance began to print for himself about 1950. Despite the enormous demands printing would have made on both his time and his physical energy in addition to those already tapping his creative energy, he apparently needed the independence he gained to pursue his developing goals. Beginning about 1950, Spruance's prints were larger, more complex in both composition and number of colors, and apart from the portraits (discussed at the end of this section), essentially embraced literature as theme. Spruance's desires to be his own printer and to connect his images to the written word might both have stemmed from his great admiration for William Blake. That master from the late eighteenth and early nineteenth centuries also printed for himself, and his two late series, *Illustrations of the Book of Job* and *Illustrations of Dante*, would have served Spruance well as

models for his own late work.[16] Religious themes (*Jacob and the Angel*, *Tobias and the Angel*, *The Lamentation*, the saints, the Crucifixion, Job) and myth (*Penelope*, Ariadne, centaurs, minotaurs, and unicorns) preoccupied much of his time from 1950 until his death.

But Spruance also admired modern literature. Two of the late series celebrate the poetry of Saint-Jean Perse: *Anabasis* (cat. nos. 381–90 and also 391, see color plate no. 2), *Seamarks* (cat. nos. 414–18), and the major efforts of the last three years of the artist's life were inspired by Herman Melville's *Moby Dick*. After much exploratory work, Spruance's *Moby Dick* eventually consisted of twenty-six prints and a title page illustration. Hand printed in a small number of proof impressions only, the series was issued (posthumously, but as planned by Spruance) in an offset edition with a text by Lawrance Thompson (see note preceding cat. no. 492). In his text, Thompson introduced *Moby Dick* as follows: "In a closely related sense, Benton Spruance makes no attempt, here, to 'illustrate' Melville's famous epic. Instead, he chooses to 'interpret' a selected sequence of images and actions which, as it happens, are of central importance in Melville's narrative." Thompson went on to describe Spruance's five-part structure: the first part introduces certain of Melville's major themes; the second "deal[s] with images, characters, and events" of Ahab's quest for the White Whale; the third concentrates on images "endow[ed] with metaphysically symbolic overtones of meaning"; the fourth, with Ahab's "compelling emotion, suffering, and agony"; and the last, with important images from the latter portion of Melville's narrative.[17]

As mentioned earlier, throughout his ca-

*Color plates appear on pp. 318–330.

reer Spruance made portraits, and they account for about fifty of the lithographs. The earliest, such as *Girl's Head*, done in 1928 (cat. no. 5), for the most part are portrait studies of considerable specificity. The later pieces, on the other hand, like *Boy in Space*, a 1958 portrait of Rudd Canaday (cat. no. 401), and *Figure in a White Studio; White Portrait* from 1959 (cat. no. 398) tend to be more abstract figure compositions. Spruance's models were usually family and friends, and in his portraits and figure compositions one most clearly discerns Spruance's gentleness and warmth. These pieces are a direct expression of his love for humanity which, for him, was the true raison d'être of his work. The technical and stylistic development of the portraits as a group essentially follows the evolution of his other work as discussed below. Interestingly, even in so particularizing a genre as portraiture, Spruance tended to generalize and idealize form. In the 1960s, however, as his work became increasingly abstract and more fully symbolic, he produced no portraits at all, and the figure compositions were pointedly narrative.

STYLE
Spruance's early lithographs—landscapes, genre scenes, and portraits—show his immediate ease with the medium. Drawn on the stone with a sense of spontaneity and directness, they are composed of short crayon marks, swiftly placed, and they maintain the character of the dry, linear means with which they were produced. Tones are generally established by layering these same sorts of strokes one on top of another. Essentially the prints were naturalistic in intent, although his figure compositions (e.g., *Amusement Park—Vienna*,

cat. no. 2) clearly show a penchant for caricature that developed from his admiration for George Bellows. As the artist moved through the 1930s and into the 1940s, various additional modes of expression influenced him. Among them were synthetic cubism as understood by American precisionists (e.g., *Design for America, No. 1*, cat. no. 115); the work of regionalists like Thomas Hart Benton, one aspect of which is an expressionist proclivity to exaggerate gesture in all manner of things (e.g., *Plans for the Future*, cat. no. 162); and the bulbous forms of the Mexican muralists (e.g., *Repose in Egypt*, cat. no. 178). At times, the artist's concern with caricature became almost vicious (e.g., *Siren Song*, cat. no. 124). In the same period, however, he also produced so straightforward and gentle an image as *Portrait of a Sullen Girl* (cat. no. 137). Whether dealing with exaggerated or naturalistic form, observed or imagined subjects, the subtlety and drama of Spruance's images depended upon his skillful use of the lithograph crayon in achieving nuance or starkness given the necessities of a particular idea. Basically, he was involved with the simplification of form and the layering of shapes on the picture plane, generally within a highly organized format. Strong tonal contrasts dominated the images as Spruance became increasingly adept at modeling volumetric form. Often he leaned upon his ability to evoke mood (usually somber) to help carry the meaning of an image, which he had done so successfully as early as 1932 in *Church at Night* (cat. no. 59). A splendid example in a naturalistic vein is *Figure with Still Life* (cat. no. 164), from the late 1930s; as an example of an imaginative piece, one might point to *Riders of the Apocalypse* (cat. no. 222), done a few years

later. In general, the characteristics outlined above prevailed in Spruance's work through the early 1940s.

One does sense Spruance's restlessness as early as 1943, however, in *From the Sea* (cat. no. 218), the artist's earliest attempt at a new kind of spatial fluidity. And in his work from 1945 to 1950, he struggled to evolve in a suitably recognizable form a language that paid respectful attention to the activation of the picture plane and acknowledged both his debt to the past and his awareness of contemporary abstraction. In 1945, in *Kim and Art* and both versions of *A Wind Is Rising and the Rivers Flow* (cat. nos. 238, 241, and 242), Spruance divided the surface of the pictures into discrete areas by means of a dark line; at the same time, he retained idealized, naturalistic imagery that functioned as volumes in space. A similar effect is seen the following year in the *Ecclesiastes* prints (e.g., cat. no. 244). The efforts at abstraction in these particular instances seem rather forced, and not until 1948 did he make a successful breakthrough, in *The Somnambulist*, mentioned previously. In this lithograph the divisions of the surface are planar, and they relate rather directly to the simplification of the form throughout. In addition, *The Somnambulist* is one of the earliest examples of Spruance's use of the subtle, chalky colors that soon became a hallmark of his color prints.

Through the early 1950s, Spruance quite frequently used the strategy hit upon in *The Somnambulist*: the division of the surface into discrete areas that contained the objects (figures, tables, plants, etc.) of the composition. Often the surface divisions establish areas that appear as if veils were placed over certain parts of the image (e.g., *Subway Playground*, cat. nos. 294 and 295). In other prints, a rhythmic line slices through the image/ground and activates and unifies the surface (e.g., *"Hast Thou Observed My Servant Job?"* cat. no. 300). Actually, the artist first used this strategy, although less successfully, in 1945 in *Kim and Art*. Many prints of the late 1940s and early 1950s, however, show none of this investigation into spatial abstraction; instead, they depict a rather straightforward narrative, stylized or idealized or both to varying degrees (e.g., the three *Saint Francis* prints, cat. nos. 325–27, color plate no. 3).

In the prints of the late 1950s, one finds greater coherence between the compositional divisions and the objects depicted. Form is flattened and exaggerated to emphasize mood, ranging from serene to tortured. The drawing style is often highly gestural (e.g., in the serene mood, *The Window—Day* and *—Night*, cat. nos. 378 and 379). The prints of this period show most clearly the influence of Picasso's style. For example, the sense of anguish that permeates such works as *Guernica* infused energy into many of Spruance's images (e.g., in the tortured mood, *Black Friday*, cat. nos. 393 and 394).

By the end of the 1950s and into the next decade, this simplification of form, gestural use of line, and clear divisions of format had become essential to Spruance's style. So, too, had his distinctive palette, which consisted of colors so extremely personal that one never quite arrives at appropriate names for them. Browns, blues, and greens predominate usually, often slightly chalky in effect, with touches of reds, golds, oranges, and purples, set off by rich, warm blacks. Richness of color balanced simplification of form, and areas of color

shifting in pictorial space replaced linear compositional divisions. These changes took place on an increasingly large format. Indeed, when Spruance began printing his own work, just as he became more involved with experimental methods of working on the stone and with printing in color, so, too, the scale of his work became much larger.

During the early 1960s, Spruance further refined the pictorial scheme suggested above, concentrating, from 1965 until his death in late 1967, on the *Moby Dick* project, which had become his major preoccupation—his personal "Passion." The series was Spruance's soulful summary of man's fate: his metaphors were the agony of life and death by water. The series is also an encyclopedia of the artist's formal and technical investigations. It is, as he had intended, his magnum opus.

PROCESS—PART 1
Briefly, lithography is a process that depends upon the antipathy of grease and water. To make a lithograph, an image is drawn onto the surface of a flat, specially prepared slab of limestone or prepared metal plate (Spruance printed exclusively from stone). The drawing is made with a greasy substance, either in a solid, crayon form, or in a liquid form, similar to India ink. The stone is then chemically treated to fix the image (this process of chemically treating the stone is called etching, but it is unrelated to the very different, intaglio graphic process also known as etching). After the stone is treated, or etched, printing takes place. First, the stone is dampened with water, which is repelled by the drawn areas that contain grease; ink is then rolled across the stone, adhering to the

grease areas but being repelled by the open areas that previously had accepted the water. The dampening with water and rolling with ink is repeated several times for each impression (maintenance of the proper balance of water and ink is crucial). When the stone is fully inked, a sheet of paper is placed upon it, and together the stone and paper are fed through a flatbed press with a pressure scraper bar; the image is thus transferred from stone to paper.[18]

Lithography was not taught at the Pennsylvania Academy of Fine Arts in the late 1920s when Spruance studied there. His introduction to the medium took place in 1928 at the shop of Edmond and Jacques Desjobert, when Spruance was in Paris on the first of his two Cresson grants for study in Europe. Returning to Philadelphia determined to continue working on stone, the young artist located Theodore Cuno, an old German lithographer who worked for the Ketterlinus Lithographic Manufacturing Company in Philadelphia, where he had printed for Joseph Pennell.[19] At night, Cuno printed privately for artists in his small basement workshop.[20] Interrupted only by a second Cresson grant that enabled him to work again with the Desjoberts, Spruance's close professional association with Cuno lasted into the early 1950s. After that, the two men remained on friendly terms, but for the most part, the artist printed his stones himself, gaining greater freedom to pursue his visual experiments.

Spruance used the *chine collé* method for the printing of his earliest Paris lithographs (printing on a thin, usually cream-colored, Oriental paper held directly to a heavier, usually whiter, sheet by means of the papers' gluelike sizing; the difference

Fig. 1. Study for *Arrangement for Drums*, cat. no. 191
Black crayon on tracing paper. 12 × 19 (30.4 × 48.2)

Fig. 2. Study for *Arrangement for Drums*, cat. no. 191
Lithography crayon on tracing paper. 12 × 19 (30.4 × 48.2)

in the paper colors often makes it appear that a print was printed in two colors—a ground color and an image color). The artist apparently liked the effect of this method because a few of the early editions printed by Cuno were printed in two colors, yellow and black, possibly in an effort to imitate the way the *chine collé* impressions looked (e.g., *Portrait—Mrs. G.*, cat. no. 9). Apart from these, a few later pieces similarly executed (e.g. *Repose in Egypt*), and an occasional experiment with color (the earliest in 1930, *House at Eaux Bonnes* [cat. no. 41]), Spruance's lithographs were printed in black ink alone until 1943. His work of that and the following years shows his increasing interest in color, and beginning in 1950, color printing was his chief concern. He did, however, until almost the end of his life, continue to produce images printed in black ink alone (or a single other dark color), often versions of his color compositions.

Despite the spontaneous appearance of much of Spruance's work, from the very start of his career he very carefully worked out the compositions for his lithographs before approaching the stone. For his black-and-white prints he made drawings, often quite a number of them (see studies for *Arrangement for Drums*, cat. no. 191, figs. 1–8). Sometimes he made highly finished gouache or oil paintings related to the prints (compare fig. 9 with *Tulpehocken Road*, cat. no. 235), especially for his late, complex color litho-

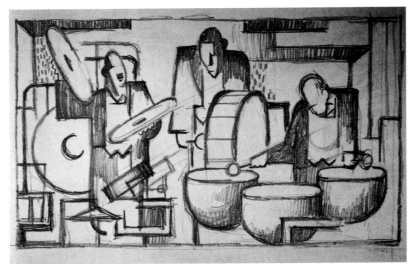

Fig. 3. Study for *Arrangement for Drums*, cat. no. 191
Lithography crayon on tracing paper. 12 × 19 (30.4 × 48.2)

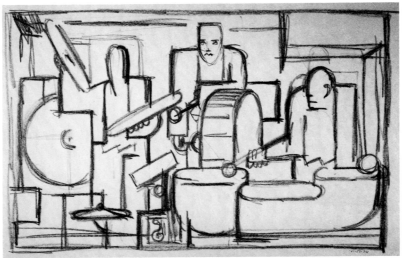

Fig. 4. Study for *Arrangement for Drums*, cat. no. 191
Lithography crayon on tracing paper. 12 × 19 (30.4 × 48.2)

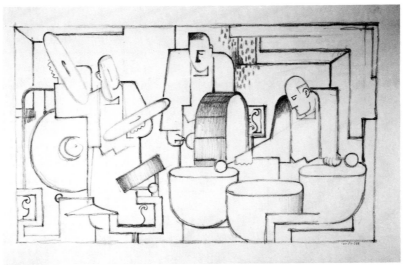

Fig. 5. Study for *Arrangement for Drums*, cat. no. 191
Lithography crayon on tracing paper. 12 × 18⅛ (30.4 × 46.2)

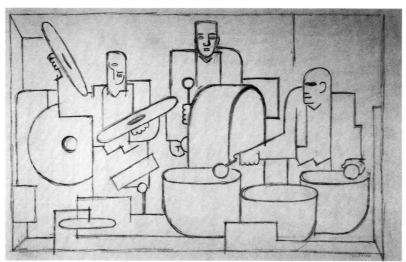

Fig. 6. Study for *Arrangement for Drums*, cat. no. 191
Pencil on tracing paper. 12 × 19 (30.4 × 48.2)

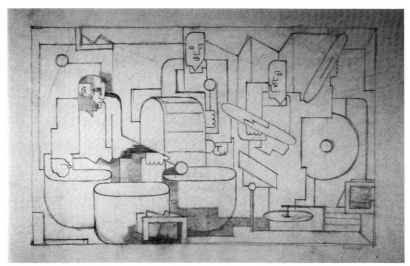

Fig. 7. Study for *Arrangement for Drums*, cat. no. 191
Pencil on tracing paper. 12 × 19 (30.4 × 48.2)

Fig. 8. Study for *Arrangement for Drums*, cat. no. 191
Red conté crayon on tracing paper. 12 × 18½ (30.4 × 46.7)

Fig. 9. *Tulpehocken Road,* 1944?
Oil on canvas. Size unknown

Fig. 10. Study for *Tobias and the Angel,*
cat. no. 535.
Watercolor with india ink and opaque white.
30 × 22 (76.2 × 55.7)

graphs like *Tobias and the Angel,* (cat. no. 535), (see fig. 10). Spruance worked in a variety of media: brush or pen and ink, chalk, pencil, sanguine, and combinations of these. For example, several studies for *Broken Carousel* (cat. nos. 284, 285) have survived. One, in black chalk (fig. 11),

shows how the artist worked out the distribution of forms in the composition; another, in gray wash (fig. 12), shows how he evolved areas of tonality. At times, Spruance's prints were based rather loosely on prior images. For example, the central figures in his 1939 mural, *The Strength of Democracy Abides with the Family* (fig. 13), were the source for the 1940 lithograph *Repose in Egypt.* In other instances, the drawings or paintings or both are very close to the lithographs: studies for *Closed Road* and *Vagrant* (cat. nos. 72, 158, figs. 14, 15), for example. On occasion, he used drawings to transfer images directly to stone (see study for *Master of the Pequod,* cat. no. 527, fig. 16). Furthermore, when printing in color, along with making studies, Spruance also made numerous variant color proofs, and he often elaborately hand-colored impressions of the principal stone (e.g., *Salome—and John,* cat. no. 292, see color plate no. 4).

It was not unusual for Spruance to make several interpretations of a theme, often a number of years apart and consequently with substantial changes evident from one to another (e.g., *The Lamentation,* cat. nos. 197 and 286). Specifically during the 1930s and 1940s, however, a different kind of variation is found: a number of examples show that Spruance drew an image onto the stone, apparently had very few impressions printed, then removed the image

Fig. 11. Study for *Broken Carousel*,
cat. nos. 284 and 285.
Black chalk. 20½ × 18¾ (52 × 47.5)

Fig. 12. Study for *Broken Carousel*,
cat. nos. 284 and 285.
Ink wash. 24 × 18¾ (60.5 × 47.9)

from the stone (possibly leaving a ghost image as a guide), and immediately closely reinterpreted the subject with a second (and sometimes third) effort (e.g., *Short Gain*, cat. nos. 127–29).[21] Thus, it is clear that Spruance did not necessarily consider a printed image to be any more precious than a study drawing and that, at times, his printed images were used in the same manner as study drawings. The closeness of these variant versions can be quite startling, and one must look carefully to discern the differences, especially because their initial effect on the viewer may be identical. Despite all of this extensive preparatory planning, and the reworking of ideas on the stone, Spruance's images generally retain an aspect of spontaneity. Indeed, this quality of vigorous directness was one the artist probably prized as his career progressed through the 1950s and early 1960s, when abstract expressionism was understood to be the major force in contemporary American art.

PROCESS—PART 2
Among Spruance's early portraits are a few transfer lithographs (in this method the image is drawn onto a specially prepared paper from which it is transferred to the stone). The process was used extensively by Pennell and was probably introduced to Spruance by Cuno. The artist did not use it after 1930, presumably because its lack of directness was not to his liking. Apart from these few early transfer examples (e.g., *Blond Model*, cat. no. 31), from the start of his career Spruance worked directly and vigorously on the stone, using grease crayons of varying softnesses and hardnesses, alone, to build tones. Occasionally, using a razor blade or other sharp tool, he scratched back into the drawn areas to model form more particularly, ac-

tivate surfaces, and so on. He used this method of working until 1948. That year, in developing *World of One's Own* (cat. no. 266), he first used a greasy liquid called tusche in combination with the crayons. Tusche drawings are more difficult to etch and to print consistently than

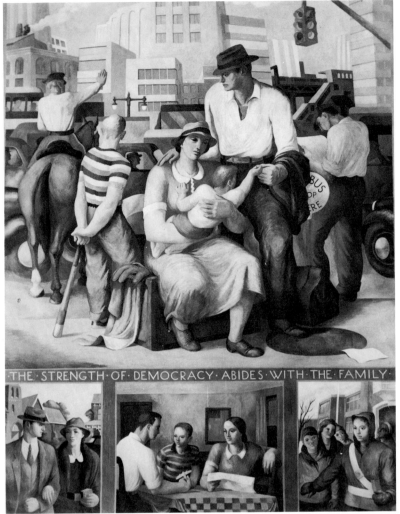

THE·STRENGTH·OF·DEMOCRACY·ABIDES·WITH·THE·FAMILY·

Fig. 13. *The Strength of Democracy Abides with the Family*, 1939
Oil on canvas. Size unknown

Fig. 14. Study for *The Closed Road*, cat. no. 72
Pencil and lithography. 14¼ × 16½

crayon drawings, and one suspects that Spruance's desire to break new ground with additional and more complicated techniques was the start of his break with Cuno, who apparently was quite traditional and conservative.[22]

In any event, from 1948 on, Spruance was increasingly experimental in the techniques he used for drawing on stone: combining washes of tusche, diluted with either oil or water (and sometimes using both kinds for working one image), with crayon drawing of varying greasiness; working with lighter fluid to make a variety of rich visual textures; impressing actual textured materials of various sorts (net, paper towels, etc.) into wet tusche; using various weights and kinds of drawing implements, and so on. His challenge was to extend and exploit the potential of the stone's surface and thereby further animate his images. The year of *World of One's Own*, 1948, was also the year in which *The Somnambulist* was issued, marking the beginning of Spruance's serious color experimentation as well. Two years later, in 1950, he used his first Guggenheim Foundation Fellowship specifically to improve his printing skills. He must have been pleased with the results of his efforts, because between 1950 and 1953, he worked less and less with Cuno: it would appear that the kinds of experimentation with lithography that the artist was undertaking could be comfortably continued only if he had total control of the process. From this point on, Spruance functioned as both artist and printer, with a few exceptions, among them very large editions and the brief periods (1953, 1962–63, 1966) when he worked at some of the great ateliers abroad (UM Grafik, see color plate no. 5; Desjobert; and Curwen Press), probably in order to learn more about their sophisticated

methods. He was unusual in this regard. Artists tend to shy away from meeting the demands of lithography printing; and the demands of such complex color images as Spruance's are especially rigorous and stringent. For that reason, for the most part, artists interested in this medium worked (and still work) with professional printers, concentrating their own energies specifically on making the images.[23]

Spruance, however, free from the limitations he found in his collaboration with Cuno, not only worked on the stone in a more adventurous manner but also evolved a way of color printing that employed a rather personal subtractive method. After drawing his complete key, or main, image onto the stone and printing an edition of it in a first color, Spruance would remove areas of the image by strongly etching away certain areas of the drawing from the stone (the equivalent of erasing areas, a very strong etch acting as the eraser). A second color then would be printed, covering the first except in those areas that had been removed with the etch. Any number of areas could be removed—subtracted—by this process, and the process could be repeated any number of times, allowing for the successive overprinting of the desired number of colors. Repeatedly and precisely positioning a sheet of paper on the stone to allow for several colors to be printed in their proper places on the image—registration—is extremely critical with this method of working. The slightest shift in position will produce an off-register color and, thus, a fuzzy image. In fact a slight fuzziness is evident in some of the images of the 1950s as a result of Spruance's use of this subtractive process.

Spruance eventually found the subtractive method somewhat limited, and he later came to make color prints in the more

Fig. 15. Study for *Young Lincoln*, cat. no. 183
Pencil. 21⅝ × 15⅞ (55.5 × 40.5)

Fig. 16. Study for *Master of the Pequod*, cat. no. 527
Pencil on tracing paper, with tracing in brown conté crayon on verso. 20½ × 18 (52 × 45.7)

traditional fashion, placing parts of the image on a stone, printing it, grinding down the stone to remove the image, making a second drawing, printing it, grinding, and potentially adding a third, fourth, fifth,

Fig. 17. Color separation proof for gray-rose stone of Vanity of the Mind: *Judith*, cat. no. 288

Fig. 19. Color separation proof for brown-red stone of Vanity of the Mind: *Judith*, cat. no. 288

Fig. 18. Color separation proof for green stone of Vanity of the Mind: *Judith*, cat. no. 288

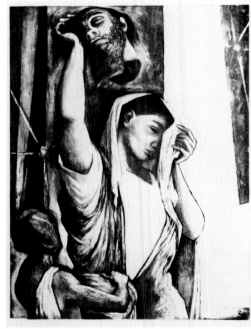

Fig. 20. Color separation proof for black stone of Vanity of the Mind: *Judith*, cat. no. 288

drawing on stone and printing each of them so that all parts of the image, in the end, together formed the whole (see color separation images, figs. 17–20). On the large Moby Dick prints (see color plate no. 6) it was not unusual for two colors to be printed at one time, provided they were drawn on widely separated areas of the stone. And for some of the most complex images, all of the printing strategies mentioned above were probably combined.

Most of Spruance's important color prints are quite involved, consisting of as many as ten colors. The artist approached the stone in the same way he approached a painting. He was interested in subtle color nuance rather than a powerful, graphic image. And he was interested in the density of color

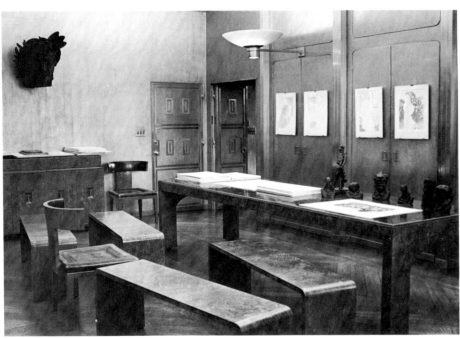

Fig. 21. The study room at Alverthorpe Gallery as Spruance left it on December 5, 1967, after preparing for his class about Daumier to be held the next day. His death intervened, and the class was never held. Upon hearing of his friend's death, Lessing J. Rosenwald had the photograph taken.

that evolved as the ink was layered onto the paper. Such complex printing became further nurtured by artists of the 1960s and 1970s, working in collaboration with professional printers.[24] But Spruance was working independently as both artist and printer, making his achievements in color lithography all the more distinctive and unusual. Insofar as the art of lithography in the United States is concerned, Spruance was, indeed, a twentieth-century pioneer in the use of color. His late color prints, particularly the Moby Dick series, which brought him much acclaim, are an apt finale to the career that was heralded by the early football subjects: in both instances the artist has given us powerful encoun-

ters, with heroic, mythic overtones. In their reflection of reality, Benton Spruance's prints exemplify early notions of American modernism.

NOTES
1. Carl Zigrosser, "Benton Spruance," in *The Artist in America* (New York, 1942), 3; and Carl Zigrosser, *Benton Spruance* (exh. cat.; Philadelphia [Philadelphia College of Art], 1967), n.p. In the autumn of 1925, the year of Bellows's death, a large memorial exhibition of his paintings, drawings, and lithographs was held at the Metropolitan Museum of Art, New York. It is certainly possible that Spruance, then in his first year as an art student, saw the exhibition, but no proof of this has been found.

2. The art history lectures Spruance presented to students as an adjunct to studio work were highly prized. For many years he discussed prints at Lessing J. Rosenwald's Alverthorpe Gallery (closed 1979). The present writer, a guest at lectures delivered a year before the artist's death, noted that he pointed to particular ideas in the work of Dürer, Rembrandt, and others that he felt would be especially relevant to specific students.

3. Quoted in Henry C. Pitz, "Benton Spruance, an Interview," *American Artist*, 14, no. 9 (November 1950): 35.

4. Ibid.

5. Dorothy Grafly, "The Print—America's Folk Art," *Magazine of Art*, 31, no. 1 (January 1938): 33. Eighty-two of the lithographs were in black and white, and only six were in color.

6. The graphic workshops of the Works Progress Administration, the first of which opened in New York in 1936, were important to the development of the art of lithography in the United States. There is no evidence, however, that Spruance worked in any of the shops, although one was established in Philadelphia in 1936.

7. Benton Spruance, "The Place of the Print-Maker," *Magazine of Art*, 30, no. 10 (October 1937): 615.

8. Jerome Kaplan provided this information.

9. Ibid.

10. Letter from Spruance to Rosenwald, October 2, 1965.

11. Many artists have lived in Germantown and depicted their picturesque surroundings. See, for example, "Artistic Germantown," *Philadelphia Inquirer Magazine*, May 4, 1958: 8–10, which shows Spruance and others at work; Spruance and other Philadelphians depicting a particularly colorful local event may be seen in "Mummers as Philadelphia Artists Have Painted Them," *Sunday Bulletin Magazine*, December 31, 1961: 8–11.

12. Quotation in Zigrosser, *Artist in America*, 86.

13. According to Zigrosser, ibid., 86–87, these three lithographs were originally conceived as part of a more extensive series—a critique of the 1930s.

14. Application letter for a John Simon Guggenheim Memorial Foundation fellowship, 1939.

15. *Portrait of the Artist as Model* (cat. no. 204) depicts a volume bearing the French artist's name (misspelled) on its cover.

16. See cat. no. 498 for Spruance's version of one of Blake's Job series.

17. Lawrance Thompson, *Moby Dick; The Passion of Ahab* (Barre, Mass., 1968), n.p.

18. For further technical reading, see Garo Antreasian and Clinton Adams, *The Tamarind Book of Lithography: Art and Techniques* (New York, 1971) and its useful bibliography.

19. According to Mary Jane Affleck, "Famed Artist Backs Lithos as Medium of Democracy," *Germantown Courier*, March 5, 1953, Spruance was directed to Cuno by Herbert Pullinger, another artist living in Germantown.

20. In regard to Theodore Cuno, Clinton Adams generously shared his manuscript for *American Lithographers, 1900–1960: The Artists and Their Printers* (University of New Mexico Press, 1983).

21. According to Jerome Kaplan, in regard to color printing, Spruance did not completely grind the image from the stone but would leave a ghost image of grease (the grease in the partially ground stone appeared a lighter value than the parts of the stone that had not been drawn upon). This ghost acted as a guide for the subsequent color.

22. Jerome Kaplan provided this information.

23. In 1960, June Wayne established the Tamarind Lithography Workshop in Los Angeles with funding from the Ford Foundation. Its purpose was to train lithography printers in order to save what was then considered by many to be a dying art form in this country. Since 1970, Tamarind Institute, at the University of New Mexico, has continued this work, and many Tamarind graduates have set up their own lithography workshops.

24. In 1957, three years before Tamarind was established, Tatyana Grosman started Universal Limited Art Editions, the first of the important print publishers that have dominated public activity in the print world during the last three decades.

Benton Spruance: A Memoir

JEROME KAPLAN

Benton Spruance believed in the master-apprentice approach to teaching art. My twenty-year collaboration with him in the print workshop at the Philadelphia College of Art, beginning in 1946, when I returned from World War II to finish art school, gave me a solid grounding in aesthetics and technique, and I continue to teach from this early artistic training.

Battalions of ex-GI's went to art school after World War II. It was fortunate for this future "apprentice" that I graduated in 1946, earlier than most, and had been awarded the lithography prize at PCA by Ben. At this time Ben moved the print-making classes to the Philadelphia Museum of Art, where the quarters were much more spacious than at Broad and Pine Streets. He called me to come to his class in the fall of 1947 to discuss a proposition. He wanted to know if I would be interested in assisting him with his teaching. I readily agreed. He then gave me one bit of advice: "Don't date the students." It was good advice.

Ben's demonstrations for the class were hypnotic experiences. He was a master showman, using his speech and hands effectively to impart information. I found that looking over his shoulder during his wall reviews and individual critiques was a positive way to learn the teaching profession.

Ben leaned toward socialism, and I suspect that my ethnic background added some weight to my being hired by him. An interesting incident occurred in 1946 during my senior year that showed Ben's political persuasion. For some reason the class had produced an enormous number of stones to be printed. Ben hired Raymond Steth, a black artist/lithographer to

help with the printing, because he was the best person for the job. The higher echelon at PCA was slightly shaken by this occurrence, but Ben's stature in the art community precluded any repercussions. Still, when Ben was appointed to the Art Commission, he regretfully changed his voter registration from Socialist to Democrat.

Holding the lithography class at the museum in the Education Department provided many interesting experiences. The students had access to the Print Department, then under the curatorship of Carl Zigrosser. Carl was very gracious about allowing the students to use his department, and they eagerly took advantage of this valuable resource. The lunches in the cafeteria with the museum staff and other artists were exciting and stimulating. Many visiting artists would come through the lithography class. Willem de Kooning visited one day and complained about his first encounter with lithography. He disliked the hard litho pencil that he was given to use. He felt it was very unsympathetic. Ben demonstrated tusche for him, and he said he wished he had known about that material. Years later in New York someone else showed him tusche, and the results were displayed at the Museum of Modern Art. At another time, Harold Paris demonstrated to the class the use of a "hot" etch for working a lithograph from black to white.

I actually began my apprenticeship to the master by dampening the stone with a wet sponge while he handled the more critical task of inking. Many years later when I moved out of the apprentice category, I asked him if I should acquire a degree (I had graduated from PCA with a diploma), and he modestly replied that my experience with him was more beneficial.

Ray Ballinger, the director of the Advertising Design Department at PCA, hired me in 1948 to teach one of his courses after my first year with Ben. Ben then gave me a lithography class of my own. He always stressed the importance of professionalism and creative work, exhibiting, keeping records of prints made. With this encouragement I gave up the thought of trying to be a free-lance illustrator and attempted to follow in Ben's direction. (If the phrase "role-model" had been in vogue then, I would have used it.)

When I moved to Germantown in the early fifties I lived a half dozen blocks from Ben. He would pick me up in his car every morning, and off we'd go to the museum. During the summer no classes were held, so we would work on our own stones and print on the two presses. We would trade prints with each other and share our color experiments. It was at this time that he developed his subtractive method of color lithography. Ben would discuss his various explorations of the technique and ask for my reactions. Ben had tried many printers over the years, and none of them satisfied him, especially for his color lithographs. So Ben became a superb lithograph printer, which is especially apparent in his *Passion of Ahab* suite.

Ben's enthusiasm for lithography infected Morris Blackburn, Franklin Watkins ("Watty"), and Alex Abels during those days at the museum, and they took up that medium, working with us in the museum lithography shop. When Watty's wife was seriously ill and needed transfusions, several people (including Ben) donated blood. Watty, under Ben's guidance, did a multi-color lithograph as a "thank you" for the donors.

The room at the museum which housed the presses was next door to the room used to store the wet paintings of the museum's education classes. Over each section was the name of the instructor for that class. Clayton Whitehill's name was over the door to the men's room. Watty would say that he had to go to the "Whitehill." Some weeks later I put Watty's name on top of Clayton's and we all waited until Watty had to use the facilities. He really let out a squawk when he saw his name in "lights." The atmosphere was productive, but it had its lighter moments.

One of the high points of my association with Ben was sitting in on his History of Prints course, held at the Alverthorpe Gallery. His lecture on Goya was an inspired session in which he compared the different suites (Caprichos, Disparates, etc.) to the movements of a Beethoven symphony. Lessing Rosenwald would sometimes come into the class and add some pertinent anecdotes. It is sad that taping devices were not then available.

When Ben retired from PCA in 1967, he asked me if I would take over the History of Prints course. I wasn't able to make a snap decision as I had when he offered me the opportunity to teach with him years before. A week went by and I consulted my wife. His was going to be a tough act to follow. But I finally consented. He took me out to lunch at the Art Alliance and went over his syllabus. Ben knew I had to flesh out and organize the course to my studio-oriented mind. After teaching the course at Alverthorpe for a number of years, I can see why Ben enjoyed it so. It was an enriching experience to be able to use the prints, drawings, and books from the Rosenwald Collection. The cooperative staff there also added to the pleasure.

Ben had the medium totally under control in his last years. At his studio on Germantown Avenue in Mount Airy, there was

a huge stone on the press practically all the time. Ben would resurface the stone, draw on it, and process it all on the press, since the stone was too heavy to be moved around by one person.

While I was preparing for one of my first teaching sessions at Alverthorpe, Ben stopped by. Enthusiastic and in good spirits, he showed me one of the Daumier bronze busts that Lessing allowed him to borrow for one of his lectures at Beaver College. This was an unusual thing for Lessing to do, and Ben was possibly the only person who would have been allowed to remove a piece from the premises.

The next day Ben was dead.

Win Spruance gave me Ben's green Harris tweed jacket. I like to wear it. It reminds me of all that Ben did for prints, especially lithography, and of how much I owe to him. In our twenty-year partnership I never ceased to be awed by his energy and creativity as artist, teacher, political activist. He was a true renaissance man.

Benton Spruance: Artist, Citizen, Teacher

SAMUEL MAITIN

A friend, engrossed in good conversation one evening, drew us into a philosophical mood. In offering an insight to explain social, cultural, and political phenomena of the 1980s, he hypothesized that great period-identifying attitudes in society oscillate. If rendered graphically, the variations resemble continuing sine curves, requiring about twenty years to move from high (creative, humanistic times) to low and then back up to high achievement and compassion again.

My friend's observation about this possibility and many other matters is to be respected. He is intelligent, fiercely honest, and he is a Nobel laureate. I have a special affection for such heroic types. And it was an evocative idea—it immediately brought crisp memories of Benton Spruance, whose principles, now dimly seen, became explainable in relation to today's different views.

Spruance, artist, lived and worked for at least a very productive part of his career at a zenith of the curve, but now, these years since his death, we are experiencing an inevitable low. Thinking about and remembering Benton, if my Nobel friend is correct, I believe we may positively expect better times soon.

Spruance is known to have associated himself with attitudes in an unequivocal way that many young artists and art-peripheral folks find embarrassing today: humanism; hope; unreserved compassion for others; efforts to create beauty. He believed high moral standards were worthy and attainable; that individual decency, participation, and idealism do matter in living; that these qualities can improve the world even if just a little; and that the presence of such qualities and the improvement of the world are highly desir-able. There is not much left of his ideals in current practice today. The words are still here, but depression, distrust, helplessness, narcissism, dishonesty, conservatism, isolation, and loathing for others and self are common now. A poison infects people and culture.

Happy, childlike excitement, romantic wishing (wishes then just might become realities), personal strength to participate for "progress and betterment" of people and their art were characteristics of the age when Ben Spruance thrived. He proselytized such values. Indeed, he was identified by both his art and his life as a symbol of honor. No one thought ill of him, and he shared his information with other artists. He worked for them and he was protective. Ben's considerable influence in the community seems, now, almost to have been cultivated so that he could elevate other people and help persuade powerful persons in politics and institutions to realize their own cultural responsibilities.

Spruance was instrumental, both nationally and locally, in the creation of Artists Equity, a self-help organization to protect professional artists. He persuaded curators, collectors, and galleries to consider printmaking a serious art. He advanced eloquently, privately and publicly, the exciting political ideals of the Clark-Dilworth urban philosophy, which set in motion a continuing cultural, physical, and political renaissance in Philadelphia. He became an important figure in Philadelphia's life during the city's golden age in which government acted for the good of its citizens and produced more astonishing accomplishments than ever before. Spruance was one of the most luminous persons of the time (the only major artist), and he helped to turn the moribund Philadelphia around. He aided in creating a compassionate, healthy city. Benton Spruance was

the most perfect example of the responsible citizen-artist I have ever known. There is no one like him in the art world at this time.

But if he was the generous public-spirited artist, he was even more the creative artist and teacher. The condition of today's art world might shock him. Paralysis of spirit was unthinkable to Spruance. Picture making to him was a noble pursuit never separated from the condition of the world around him. Artists were helpful friends to one another then; they were concerned with much more than their individual selves. It would have been unusual for painters, sculptors, and printmakers to isolate their interests from the problems of others. Then, artists zestfully participated in all manner of actions, movements, and causes, civil as well as aesthetic, and Spruance was recognized as a fair-minded leader among them. Those were days of affectionate camaraderie. As the time cycle continues and moves upward, we may expect some kind of new expression of humane concerns. At the zenith, Benton Spruance will be adulated, in danger of becoming mythicized. He would have hated that. Besides, his example will be reduced to idealization and made unempathetic for us when we need his spirit still.

His prints and paintings, already valued at many times their original prices, will command even higher ones. How fortunate for the collectors who will have guarded his works. Probably no one more than Spruance would be more amazed at new art finance—he believed so much in the democratization of his art.

Paradoxically, Spruance was a gifted teacher, a fact that always surprised me because so few great artists are great teachers as well. I became, ultimately, a teaching colleague and eventually a close friend of

Spruance, and of his wonderfully supportive wife, Winifred, and his two sons, Peter and Stephen. Earlier, however, I was a young student in his art classes; his lectures at the Philadelphia Museum School of Art were greatly superior to the art history courses at the University of Pennsylvania. I attended both institutions and I never revealed my unavoidable comparisons to Ben, but the differences were disquieting to a youth. Spruance's teaching was devoid of arrogance. Information was similarly comprehensive in both lecture series, but Benton made us aware of the people who created the images we studied; we could empathize with the artists. He related art works to their own places in time and made us aware of the conditions of life then, and he made us feel the joy and gravity of art and civilization. Thereby, we grew to respect our own efforts in the scheme of things. Not so at University of Pennsylvania. History was presented in a lifeless, rather depressing manner that defined "pedantic" to me. It seemed that examination of the exoskeleton of creative production never allowed understanding of the wonder of art itself. Spruance, of course, had a marvelous advantage: he had the unusual tangential talent of being a magnificent speaker—the best I have ever heard.

In the printmaking workshops where he was department head, he moved about ceaselessly, athletically, from nascent lithograph to lithograph. He explained, urged, tended each young artist's art into satisfying birth. With his shirt sleeves pushed up, revealing unexpectedly powerful forearms and wrists, wearing an inky apron, he rolled up lithostones, demonstrating the difficult printing task. When a new print was slowly pulled from stone, Ben glowed with delight. He was surprisingly childlike at these times. His response

to the first peek at a new work was ingenuous. Although he had attended such births thousands of times he was always freshly awed. And then he murmured encouragements; he discovered good qualities. He loved prints and the people who made them. He had difficulty being negative. Suggestions for improvement, criticisms, came along eventually, but the student was never diminished. When time had permitted reflection, Ben identified possibilities for progress of each work, but he was very protective of every individual artist's own nature. He criticized, but he also nurtured.

As students, we knew Ben had contributed vastly to art, that he was one of the world's best lithographers, but the work that poured from his classes never looked like his own. Such was not true in others' classes. The phenomenon of never allowing disciples was not the case in other cities. It seems that the greatest teachers in Philadelphia's history were alike in this regard. They urged younger artists to be themselves, to identify their own feelings. Benton Spruance, Thomas Eakins, Arthur Carles, Paul Froelich, Daniel Garber, Ezio Martinelli, and many other teachers might have profited by permitting youngsters to adore them by imitation, but they did not succumb to the temptation. Not only would their egos have been enlarged, but in a very practical way, each master would have been recognized as the source of an important "school" and would have gained wider public reverence. Museum curators are especially vulnerable to such schools, having trouble in dealing with individuals.

The best Philadelphians never sanctioned artistic slavery of the young. Natural adolescent rebelliousness was wisely directed into highly personal channels; competition with the master became the very force that promoted an amazing di-

versity of imagery in Spruance's classes. To this day, I don't know of a single artist trained by him who is a little Benton Spruance.

Spruance, despite his social and political concerns, knew very well that no works of art themselves can effect dramatic change for world betterment. They can never change the human condition no matter how much the artist wants to. And so Ben allied himself, his corpus, and his reputation with numerous community causes. He used his celebrity and eloquence for public benevolences, although he understood that he could never recover the time lost from his own art. He served on boards, juries, and committees that were tedious, even painful for him, but he felt that he had dues to pay. He was called upon constantly to defend the defenseless. Ben was a very strong and effective figure; he never questioned the significance of people and culture. Although his production of pictures was prodigious, he could have created more if he had not responded to so many problems that were not his own. Even so, it is not possible to consider the art of the 1930s, 1940s, and 1950s without identifying him as one of the major talents of those decades. He earned his place in the art history of America, and he raised lithography and printmaking to the first-class positions they have today.

As time and modes oscillate, as we climb back from nadir to visit again levels of decency and excellence, Benton Spruance will seem more gigantic than when he lived. Study of him and his art will help us to remember a great past and to look forward with confidence to the best of times yet to arrive.

How good to have known him, to have been his friend.

Chronology

1904 Born, 25 June, Philadelphia, Pa., on North Thirteenth Street, home of maternal grandmother, Ella V. Dick; elder of two children of Benton Murdoch and Edith Dick Spruance.

1906 Father died shortly after the birth of younger sister, Eleanor.

1913 Mother married Jacob Potter, a widower with six children, and moved with Benton and Eleanor to Potter home in Wyncote, Pa.[1]

1918 Mother died in influenza epidemic; stepfather remarried two years later.

1921 Graduated from suburban Cheltenham High School.

1922–24 Attended the University of Pennsylvania School of Fine Arts with intentions of studying architecture and took courses at Graphic Sketch Club. Worked as a draftsman for architectural firm of Heacock and Hokanson.

1924–25 Worked for several months in a lumber camp in West Virginia with friend Edmund Watkins.

1925–29 Attended Pennsylvania Academy of the Fine Arts: made a few etchings.

1926 Began part-time teaching at Beaver College, Glenside, Pa.

1928 Married Winifred Glover; spent honeymoon in Europe having received William Emlen Cresson Travelling Scholarship in the category of illustrator; in Paris, executed first lithographs at shop of Edmond and Jacques Desjobert. Began working as a designer at furniture and interior design firm O. E. Mertz and Co.; continued there until 1935.

1929 First son, Peter Benton, born. Received second Cresson Travelling Scholrship, not used until 1930. Participated in two-person show at Philadelphia Print Club: etchings by Jessie Walmsley White and lithographs by Benton Spruance. First two lithographs, *Old Wall of Flor-

ence* and *Amusement Park—Vienna* (cat. nos. 1 and 2) included in "First All-American Exhibition of Lithography" at Philadelphia Print Club.[2] Won Jacqueline Harrison Smith (first) Prize for *Portrait of Betty Schnabel* in the Philadelphia Printmakers Annual exhibition, also at the Print Club.[3] Began making lithographs with printer Theodore Cuno.

1930 First one-man exhibition, at Edward Side Gallery, Philadelphia. Became artist member of Philadelphia Print Club. Traveled in Europe on Cresson Scholarship with artist Robert Gwathmey, again making lithographs at Paris workshop of the Desjoberts; also studied painting with Andre L'hote.

1931 Second son, Stephen Glover, born.

1932 One-man exhibition, at Philadelphia Print Club.

1933 First one-man exhibition in New York, at Weyhe Gallery, where Carl Zigrosser (later curator of Prints and Drawings at Philadelphia Museum of Art) championed contemporary printmakers. Invited to show in "First Biennial Exhibition of Contemporary American Sculpture, Watercolors, and Prints," Whitney Museum of American Art, New York. Joined full-time faculty at Beaver College as chairman of Department of Fine Arts, a position he held until his death. Served as chairman of the Print Committee at Philadelphia Art Alliance until the 1950s, after which he remained a member of the committee into the mid-1960s.

1934 Invited to show in "Second Regional Exhibition: Paintings and Prints by Philadelphia Artists," Whitney Museum of American Art, New York. Joined faculty of the Philadelphia Museum School of Industrial Art (later, the Philadelphia

College of Art), teaching interior decoration and lithography among other subjects; was director of the college's first Division of Graphic Arts (later called Printmaking) from 1951 until retirement in 1964.

1935 One-man exhibitions at Philadelphia Print Club and Gimbel Gallery of Contemporary Art. Awarded honorary Master of Fine Arts degree by Beaver College.

1936 *Short Gain* (cat. no. 129) published by American Artists Group, Inc.

1937 Spruance's "The Place of the Print-Maker" published in October issue of *Magazine of Art. Fencers* (cat. no. 145) published by American Artists Group, Inc.

1938 One-man exhibitions at Philadelphia Print Club and Carlen Galleries, Philadelphia. About this time, lithography workshop set up at School of Industrial Art.[4]

1939 Mural commission *The Strength of Democracy Abides with the Family* (related to cat. no. 178) executed for the Juvenile and Domestic Relations Branch of the Municipal Court Building, Philadelphia. Illustrated Hubert Skidmore's *River Rising*, published by Doubleday, Doran and Company, New York.

1940 One-man exhibition at Weyhe Gallery. Illustrated Hubert Skidmore's *Hill Doctor*, published by Doubleday, Doran and Company, New York.

1941 One-man exhibition at Seattle Art Museum. Rejected from military service for health reasons; engaged during war years in labor relations work for the government. Carl Zigrosser became curator of Prints and Drawings at the Philadelphia Museum of Art; the two men remained close friends until Spruance's death;[5] during the 1940s and into the

1950s, Spruance, Zigrosser, and a group of others, among them the Philadelphia Museum's Henri Marceau and artists Robert Riggs, Franklin Watkins, and Alexander Abels, met regularly in an informal group they called "The Brain Trust."

1942 One-man exhibition at Philadelphia Print Club. Included in "Between Two Wars: Prints by American Artists 1914–1941," Whitney Museum of American Art, New York.

1944 One-man exhibitions at the Philadelphia Print Club and the Philadelphia Art Alliance. Taught summer school for Pennsylvania Academy of Fine Arts at the Chester Springs campus. Elected to Board of Directors, Philadelphia Print Club, the same year Berthe von Moschzisker became the club's director; von Moschzisker and Spruance, who was active throughout his life in club activities, remained close friends until the artist's death.

1946 One-man exhibition in Pennsylvania Academy of the Fine Arts, Philadelphia Artists Gallery. Taught summer school at the academy's Chester Springs campus. Acted as monitor of newly formed artists' workshop at Philadelphia Print Club: Stanley William Hayter frequently came as visiting critic from his Atelier 17, then in New York, and Spruance's printer, Cuno, conducted several lithography sessions.[6]

1947 One-man exhibition at United States National Museum, Division of Graphic Arts (now Smithsonian Institution Museum of American History), Washington, D.C. Began teaching art appreciation classes part-time at Germantown Friends School and continued to do so until 1957.

1948 Elected Associate of the National Academy of Design. Lithograph com-

missioned by *The New Colophon* in celebration of 150th anniversary of invention of lithography (cat. no. 272). Held School of Industrial Art lithography classes in Education Department of the Philadelphia Museum of Art until about 1952.

1949 One-man exhibitions at Munson-Williams-Proctor Institute, Carnegie Institute, and the Frank Rehn Gallery, New York. Founding member of Philadelphia chapter of Artists Equity Association, Inc. About this time, produced mural paintings *The Owl* and *The Falcon* for Missouri-Pacific Railroad observation car designed by Harbeson Hough Livingston and Larson.[7] Delivered the key address at the William Emlen Cresson awards ceremony at the Pennsylvania Academy of the Fine Arts. Chairman of Germantown Community Council's Committee on Human Relations.

1950 A John Simon Guggenheim Memorial Foundation Fellowship (the first of two) allowed time to improve abilities as master lithography printer. Began to print on his own as well as in collaboration with Cuno.

1951 One-man exhibitions at Philadelphia Art Alliance (with checklist), Moore Institute of Art, Science, and Industry (now Moore College of Art), Philadelphia, and Mount Holyoke College, South Hadley, Mass.[8] Included in exhibition "Les peintres-graveurs actuels aux Etats-Unis," Paris. Began using his subtractive lithographic process (e.g., the *Job* prints, cat. nos. 298–301).

1953 Traveled in France (working with the Desjoberts and etching printer Roger Lacourière), Italy, and Austria. Purchased lithograph press (installed at Beaver College, Glenside, Pa. until

1964); did most of own printing from this point on. Appointed member of Philadelphia Art Commission, retaining position until his death. Fourth president of Philadelphia chapter of Artists Equity Association.

1954 *Fortune Teller* (cat. no. 331) published by International Graphic Arts Society; one-man exhibitions at George Washington University, Washington, D.C. (with checklist), and Woodmere Art Gallery, Chestnut Hill, Pa. (with checklist). Began several years of service on board of Samuel S. Fleischer Art Memorial.

1955 One-man exhibitions at Pennsylvania Academy of Fine Arts, Frank Rehn Gallery, Penn State University, and Oklahoma Art Center. Appointed member of Library of Congress Pennell Fund Purchase Committee; served until 1962. Elected to Board of Trustees of Beaver College, retaining the post until 1961.

1956 One-man exhibition at Louisiana State University. *Penelope* (cat. no. 362) published by International Graphic Arts Society. Work included in exhibition "Dessins américains contemporains," Strasbourg.

1959 One-man exhibition at Utah State University. *Black Friday* (cat. no. 394) published by International Graphic Arts Society. Elected Academician, National Academy of Design. Received Society of American Graphic Arts John Taylor Arms Memorial Prize for creative excellence over a period of years and Philadelphia Museum School of Art (Philadelphia College of Art) Alumni Association Medal of Merit. With Spruance's strong support, the Philadelphia City Council approved the ordinance that 1 percent of cost of public buildings be allocated for the fine arts.

1960 One-man exhibitions in Boston Public Library, Philadelphia Print Club, Texas Western College, El Paso, and University of Redlands, Redlands, Calif. One of original members of Board of Directors of Tamarind Lithography Workshop, Inc., Los Angeles, as well as member of Tamarind Panel of Selection for artist-fellows: continued in both capacities until his death. Spruance, Jerome Kaplan, and Samuel Maitin formed first artist's committee for Philadelphia Print Club's Prints in Progress program.[9]

1961 Traveled to West Coast, visiting San Francisco and Los Angeles, where he produced *The Sea—Galilee* (cat. no. 435) at Tamarind. Awarded Christian R. and Mary F. Lindback Foundation Award for Distinguished Teaching by Beaver College. Chaired College Art Association panel "Is There a Print Making Revival?" (Panel members were Jules Heller, Reginald Neal, Malcolm Myers, Clinton Adams, and Gordon Gilkey.)

1962 One-man exhibition at Associated American Artists, New York (with checklist). Awarded second John Simon Guggenheim Memorial Foundation Fellowship (for work with master printers) and honorary doctor of fine arts degree from Philadelphia College of Art. Mural commissioned for nondenominational chapel in Philadelphia House of Detention, Holmesburg; installed 1963. Served on artists' advisory committee for Print Council of America's "American Prints Today?" exhibition.

1963 One-man exhibition at George Washington University Library (with checklist). House of Detention mural commission exhibited at Pennsylvania Academy of the Fine Arts before its installation at Holmesburg. Guggenheim funds enabled him to work abroad with the Desjoberts, Paris; at Curwen Press, London; and at UM Grafik, Copenhagen (see cat. nos. 454–63).

1964 One-man exhibitions at Beaver College, Mansfield State College, Mansfield, Pa. (with checklist), and Philadelphia Print Club (part of the club's fiftieth anniversary celebration). *City Church* (cat. no. 472) published by Philadelphia Print Club. Moved lithograph press from Beaver College to Germantown Avenue studio: until this time, except when working on large-scale commissions, Spruance maintained painting and drawing studio at his home and printed at the college.

1965 One-man exhibition at Philadelphia Sketch Club. Awarded Philadelphia Art Alliance Medal of Achievement and the first annual Philadelphia Sketch Club Award for Distinguished Service to the Arts. Presented radio broadcast (WIV, Philadelphia) "Notes on American Lithography."

1966 One-man exhibitions at Jane Haslem Gallery, Madison, Wisconsin, and Sessler Gallery, Philadelphia. Exhibition at University of Wisconsin, Wisconsin Union Gallery: "Four Printmakers: Altman, Peterdi, Spruance, and Pozzatti."

1967 One-man exhibitions at Philadelphia College of Art (with catalogue) and the Wayne Elementary School. *Tobias and the Angel* (cat. no. 532) published by the Philadelphia Print Club. Introduced the Moby Dick series to a meeting of the Philobiblon Club at the Franklin Inn Club, Philadelphia, of which he was a member. Traveled to Paris and then to London where he worked at Curwen Press (see cat. nos. 533 and 534). Elec-

ted honorary member of American Institute of Architects. Died suddenly, at home, 6 December.

1968 The Moby Dick series exhibited posthumously at Philadelphia Museum of Art. Memorial exhibition at Pennsylvania Academy of the Fine Arts (with catalogue).

1969 Exhibition at Free Library of Philadelphia to celebrate formation of the Memorial Collection of Spruance's lithographs. Dedication of Benton Murdoch Spruance Art Center at Beaver College. A selection of prints by members of Society of American Graphic Arts donated by the artists to the Philadelphia Museum of Art as a Benton Spruance memorial.

1970 One-man exhibition at Franklin and Marshall College, Lancaster, Pa.

1971 One-man exhibition of prints, proofs, and working drawings at the Philadelphia Print Club.

1973 One-man exhibition at Sacred Heart University, Bridgeport, Conn. (with catalogue).

1976 One-man exhibition at the Hahn Gallery, Philadelphia.

1977 One-man exhibition at Lehigh University, Bethlehem, Pa., and circulating to Reading Public Museum and Art Gallery, Reading, Pa. (with catalogue).

1978 Circulating exhibition of 1977 seen at Wilkes College, Wilkes-Barre, Pa., and the Hahn Gallery.

1981 One-man exhibition at the Hahn Gallery.

1984 One-man exhibition at Associated American Artists Gallery, Philadelphia.

NOTES

1. Information regarding Spruance's family life for the most part is based on conversations with the artist's sons, Peter Benton and Stephen Glover, which took place sporadically from 1980 to 1982 but mainly in December 1982. In addition, Professor Lloyd M. Abernethy, Department of History, Beaver College, who has written a biography of Spruance, very generously shared his findings.

2. These early exhibitions indicate interest in Spruance's work from the very start of his career. They are the first of dozens of two- and three-person exhibitions and group shows in which Spruance participated throughout his career; for the most part, however, this chronology notes one-man exhibitions only.

3. This is the first of many awards Spruance received in local and national juried print exhibitions; for the most part, this chronology mentions major fellowships and awards only, rather than awards for specific prints in juried exhibitions.

4. For information about the Philadelphia College of Art graphic workshop, we thank Charlotte Daley Giordano, who did research in the archives at the college, and Professor Jerome Kaplan of PCA's Printmaking Department and a colleague of Spruance's for two decades.

5. Zigrosser's personal collection, now at the Philadelphia Museum of Art, contains many exceedingly rare, if not unique, impressions of prints from early editions that Spruance may have destroyed.

6. We thank Berthe von Moschzisker for the information about Cuno's participation.

7. Unmarked, undated clippings on file with Spruance material at the Free Library of Philadelphia.

8. Winifred Spruance was a 1925 graduate of Mount Holyoke.

9. Under the auspices of the Print Club, Prints in Progress, conceived by Walter L. Wolf, sponsored printmaking demonstrations in public and private schools and other institutions.

A Note to the Reader

This catalogue has evolved from a checklist prepared by William Dolan Fletcher on file in the Print and Picture Department at the Free Library of Philadelphia. When his information was neither confirmed nor denied by our own findings, we have noted it in the appropriate catalogue entries with a reference to Fletcher.

Catalogue entries are organized by technique—lithographs, etchings, woodcuts, and monotypes—and, within techniques, essentially chronologically. As indicated in the Introduction, throughout most of his career, Spruance was his own printer-publisher. As with many artists of his generation, neither edition consistency nor documentation regarding production matters appears to have been of great concern to him. If he did maintain any ongoing written accounts relating to his work, we have been unable to locate them. It is clear, however, that Spruance printed several images at more than one stage of their development. In discussing them, these stages, when mentioned, are referred to as "states" throughout the catalogue. Spruance often made variant impressions of his color prints, changing colors, leaving out one or another color, or interchanging the stones to be printed in particular colors. These variant impressions were not considered proofs but an integral part of his editions, and they were numbered as such. For example, in a letter of 19 March 1963 to Sylvan Cole, Jr., Spruance wrote the following regarding the printing of *Mother and Child* (cat. no. 453): "of the total edition of twenty five, *ten* are in the dark grey and *fifteen* in the blue. (I got a little bored with the blue and decided to shift gears—and just so the entire edition is recognized as being twenty five—quel difference!)." (We might note that the only impression of this print we have seen is numbered by Spruance as part of an edition of thirty.) In any case, in all entries for color prints we have noted the colors we believe were used for the basic edition, but one should expect to see color impressions that differ considerably from these catalogue descriptions.

Papers for the early Desjobert prints are described below. The majority of the other lithographs are printed on Rives BFK or Rives Heavyweight. Van Gelder Zonen is also seen frequently. During the 1930s, Spruance used various oriental papers; during the 1940s, he used Strathmore Bristol on occasion; and in the 1960s, Crisbrook waterleaf entered Spruance's paper repertoire. Many other papers were also used, but each edition was not necessarily printed in its entirety on a single type of paper, so we have omitted paper descriptions within the individual catalogue entries.

Most of the lithographs were printed at the Desjobert workshop in Paris, by Theodore Cuno in Philadelphia, and by Spruance himself. Few of the prints are so marked. In general, prints from the Desjobert workshop by artists known to have worked there during the late 1920s and 1930s are characterized in part by the papers used: a thin cream sheet applied *chine collé* onto a white, medium-weight, wove sheet. On this basis we have ascribed certain prints of 1928 and 1930 (the years in which Spruance worked in Paris on his Cresson Fellowships) to Desjobert. Three additional prints (cat. nos. 37–39) are tentatively ascribed to Desjobert on the basis of paper quality or size (larger than that associated with Cuno). A few impressions bear Cuno's blindstamp, "Cuno. Phila., Pa. Impression" (but not necessarily consistently throughout an edition), and a few others have been annotated by Spruance,

Fig. 22. Impression from Benton Spruance estate stamp, enlarged several times.

"Imp. Theo Cuno." Apart from these, the prints that have been firmly ascribed to Cuno are those ascribed to him in the catalogue for the exhibition of Spruance's lithographs held in 1967 at the Philadelphia College of Art (see Selected Bibliography), which was prepared with Spruance's assistance. Otherwise, editions believed to be printed by Cuno are ascribed to him but with a question mark. Until the 1960s, Spruance did not consistently annotate prints that he printed himself with "imp." Apart from impressions so annotated and impressions ascribed to him in the Philadelphia College of Art catalogue, editions believed to be printed by Spruance but not confirmed as having been are also followed with a question mark. In the 1950s and 1960s, Spruance worked briefly with several professional printers in Europe, but, again, most of the resulting prints are unmarked. If we have not been able to confirm the workshop, we have followed the shop's name with a question mark.

We have found no information regarding the printers for Spruance's early etchings and his woodcuts of the 1950s. We assume (with a question mark) that they were printed by the artist.

Spruance often stored his prints unsigned, untitled, unnumbered, and undated until they were sold. Over the years, his memory of this information varied. Thus, different impressions of a single image are differently annotated. It is not unusual to find as many as three titles, dates, and edition sizes for an image, and we have, when known, provided this alternate information in the entries. Descriptive titles, assigned by the authors when none were assigned by Spruance, are in parentheses. Titles followed by a question mark were listed in the Fletcher checklist and may refer to the print described. In the cases of variant dates, we have placed the prints in the year we believe to be accurate

and listed this date first, followed by others we have seen on impressions of that image. After Spruance's death, his widow, Winifred Glover Spruance, signed, dated, titled, and annotated with edition size the work remaining in his studio. Since her death, impressions have been signed by Spruance's two sons, Peter and Stephen. Impressions signed by them are marked with their own initials and/or with the estate stamp. (See figure 22.) Signatures, generally initials, and inscriptions given in catalogue entries are those within the printed image.

Measurements are given in centimeters with inches in parentheses; height precedes width. Measurements for lithographs and monoprints refer to the outermost points of the image; for etchings, drypoints, aquatints, and woodcuts, they refer to the platemark or edge of the woodblock.

In the entries for the Moby Dick series (cat. no. 492 and following), AP stands for Artist's Proof.

The collections of the Free Library of Philadelphia (FLP), Philadelphia Museum of Art (PMA), National Gallery of Art, Washington, Rosenwald Collection (NGA), Library of Congress (LC), Boston Public Library (BPL), and the Spruance estate were the key sources for the information in this catalogue. When possible, impressions signed by Spruance during his lifetime were used.

Catalogue Raisonné

1

2

1. *Old Wall of Florence*, 1928
Edition 22
29.8 × 23.5
(11¾ × 9¼)
Black ink on cream chine collé
Stone unsigned
Printed by Desjobert
FLP; PMA

2. *Amusement Park—Vienna*, 1928
Edition 22
24.7 × 24.2
(9¾ × 9½)
Black ink on cream chine collé
B.M.S. lower left
Printed by Desjobert
FLP; PMA

3

4

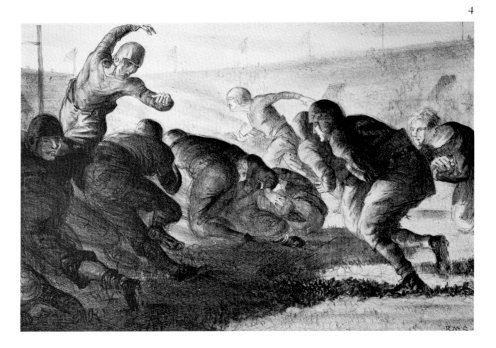

3. *The Prater Vienna*, 1928
Edition 12
29.3 × 23.5
(11½ × 9¼)
Black ink on cream chine collé
B.S. lower right
Printed by Desjobert
PMA

4. *Football; Backfield*, 1928
Edition 12
23.9 × 34.7
(9⅜ × 13⅝)
Black ink on cream chine collé
B.M.S. lower right
Printed by Desjobert
PMA

Catalogue Raisonné
41

5

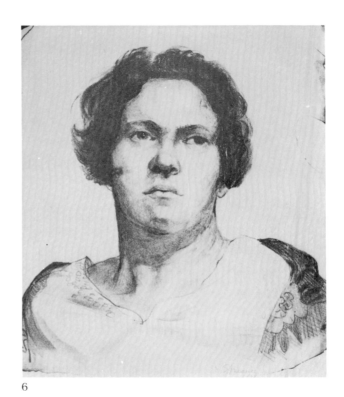

6

5. *Girl's Head*, 1928
Edition 12
30.5 × 24.3
(12⅝ × 10⅛)
Black ink on cream chine collé
B.M.S. lower right
Printed by Desjobert
FLP; PMA

6. (Head of a woman gazing right), 1928
Edition unknown
32.4 × 29.2
(12¾ × 11½)
Black ink
Stone unsigned
Printed by Cuno?
FLP

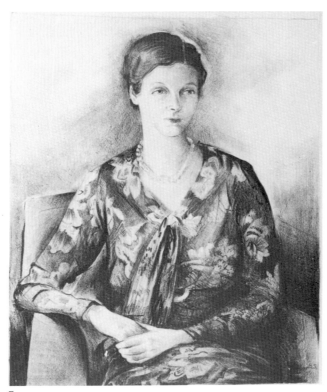

7

8

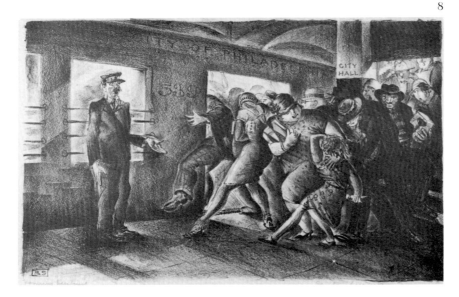

7. *Portrait—W.G.S.*, 1928; 1929
Edition 35
31.2 × 24.4
(12 ¼ × 9 ⅝)
Black ink
B.S. lower right
Printed by Cuno?

FLP

Note: W.G.S. is the artist's wife, Winifred Glover
 Spruance.

8. *Homing Instinct*, 1929
Edition unknown
22 × 35
(8¾ × 13¾)
Black ink
BS in box, lower left
Printed by Cuno?

FLP; PMA

Note: Fletcher cites Breuker and Kessler as the
 printers; we have located no reference to the firm
 elsewhere.

Catalogue Raisonné
43

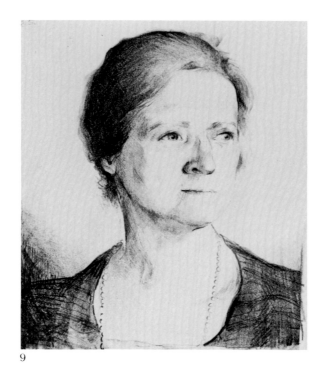

9

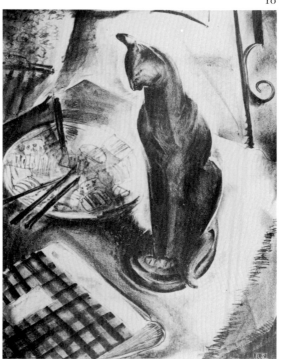

9. *Portrait—Mrs. G.*, 1929
Edition 14
26.6 × 21.5
(10½ × 8½)
Two colors (yellow, simulating chine collé, and
 black)
B.S. in box, upper left
Printed by Cuno?
FLP; PMA
Note: Mrs. G. is the artist's mother-in-law, Florida
 Rumble Glover; Fletcher cites Breuker and Kessler
 as the printers (see note to cat. no. 8).

10. *The Statuette*, 1929
Edition 25
31 × 22
(12¼ × 8⅝)
Black ink
B.S. in box, lower right
Printed by Cuno?
FLP

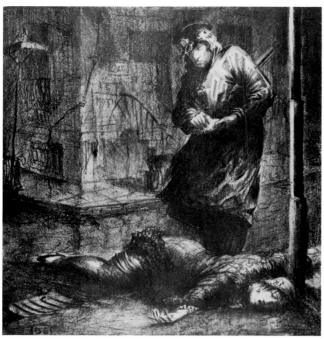

11

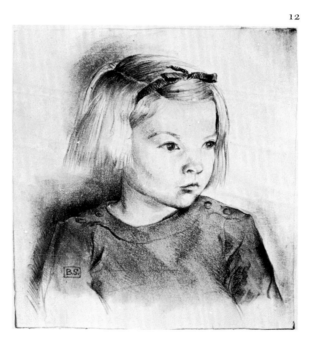

12

11. *The Stool Pigeon*, 1929
Edition unknown
25.6 × 23.5
(10⅛ × 9¼)
Black ink
BS in box, lower left
Printed by Cuno?
FLP; PMA
Note: Fletcher cites Breuker and Kessler as the
 printers (see note to cat. no. 8).

12. *Portrait of Betty Schnabel*, 1929
Edition unknown
23.4 × 20.5
(9⅛ × 8⅛)
Black ink (some impressions are on chine collé,
 using papers of weights and colors different
 from those used by Desjobert)
B.S. in box, lower left
Printed by Cuno
FLP; PMA

Catalogue Raisonné
45

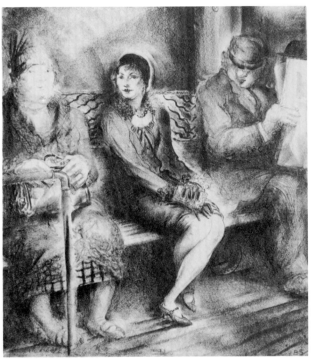

13

14

13. *Madonna of the Subway; Subway
 Madonna*, 1929
Edition 22
29.7 × 23.3
(11⅝ × 9¼)
Black ink
BS lower right
Printed by Cuno?
FLP; PMA

14. *Conductor*, 1929; 1930
Edition unknown
21 × 18
(8¼ × 7⅛)
Black ink
B.S. lower left
Printed by Cuno?
FLP; PMA

15

15. *Rock of Ages*, 1929
Edition unknown
22.5 × 29.9
(8⅞ × 11¾)
Black ink
Stone unsigned
Printed by Cuno?
PMA

16. *They Beheld Him Their Baker*, 1929
Edition unknown
29 × 21.4
(11⁷⁄₁₆ × 8⁷⁄₁₆)
Black ink
S lower right
Printed by Cuno?
PMA

Catalogue Raisonné

17

18

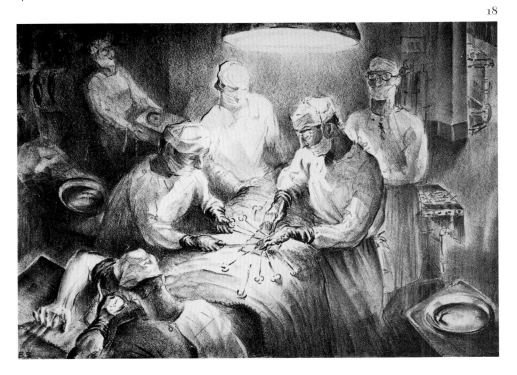

17. (Head study), 1929
Edition unknown
25.7 × 22.7
(10⅛ × 8¹⁵⁄₁₆)
Black ink
Stone unsigned
Printed by Cuno?
PMA
Note: Fletcher cites Breuker and Kessler as the
 printers (see note to cat. no. 8).

18. *Abdominal Clinic*, 1929
Edition unknown
24.2 × 34.5
(9⅝ × 13½)
Black ink
BS lower left
Printed by Cuno?
PMA; BPL
Note: Fletcher cites Breuker and Kessler as the
 printers (see note to cat. no. 8).

19

20

19. *Football Sketch*, 1929
Edition unknown
28.2 × 21.7
(11⅛ × 8½)
Black ink
B.S in box, upper right
Printed by Cuno?
PMA
Note: Fletcher cites Breuker and Kessler as the
printers (see note to cat. no. 8).

20. *Winter Flowers*, 1929
Edition unknown
27.5 × 20.4
(10¾ × 8⅛)
Black ink
B.S. upper right
Printed by Cuno?
PMA
Note: Fletcher cites Breuker and Kessler as the
printers (see note to cat. no. 8).

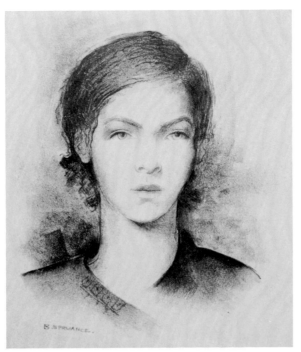

21

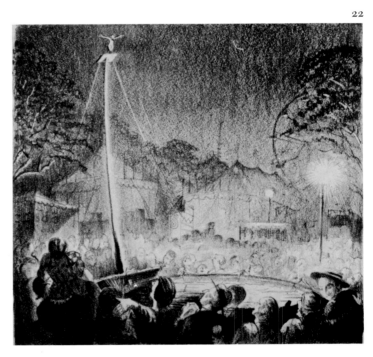
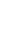

21. (Portrait of a young girl); *Head of Joanne Krusen?* 1929?
Edition unknown
23.3 × 18.2
(9¼ × 7¼)
Black ink
B. Spruance lower left
Printed by Cuno?
FLP
Note: The print is a transfer lithograph.

22. *The Last Event,* 1929; 1930
Edition unknown
23.3 × 24
(9⅛ × 9½)
Two colors (tan, simulating chine collé, and black)
Stone unsigned
Printed by Cuno?
FLP; PMA
Note: Fletcher cites Breuker and Kessler as the printers (see note to cat. no. 8).

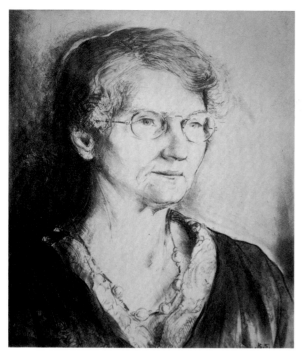

23

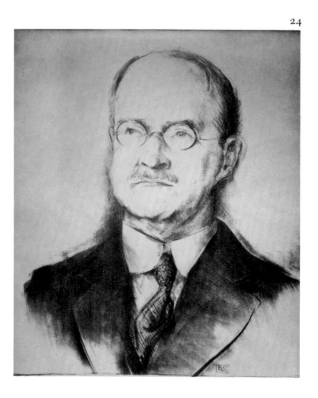

24

23. *Mrs. Thornton*, 1929
Edition 10
32.4 × 26.4
(12¾ × 10⅜)
Black ink
 B.S. lower right
Printed by Cuno?
Private collection

24. *Mr. T.; Portrait of Mr. Thornton*, 1929?
Edition 13
32.4 × 26.7
(12¾ × 10½)
Black ink
B.S. in box, lower right
Printed by Cuno?
Private collection

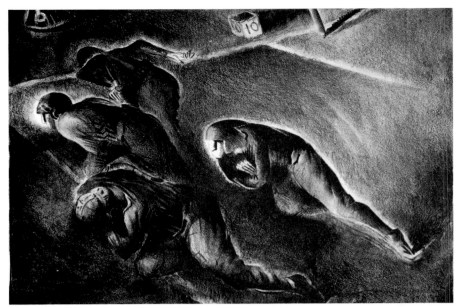

25

26

25. *Night Football*, 1930
Edition unknown
22.4 × 32
(8⅞ × 12⅝)
Black ink
Stone unsigned
Printed by Cuno?
PMA

26. *Study of Frank Krusen*, 1930?
Edition 30
29.8 × 22.8
(11⅝ × 9)
Black ink
B.S. in oval, lower left
Printed by Cuno
FLP

27

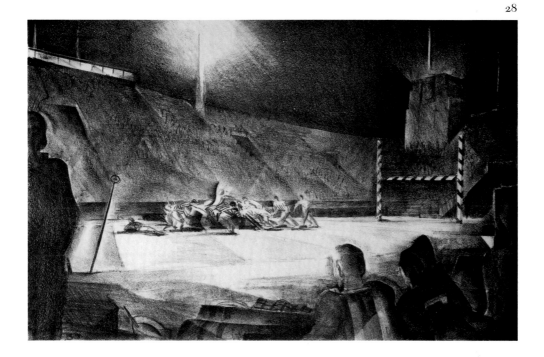

27. *Seldon Cary*, 1930
Edition unknown
29.5 × 26
(11⅝ × 10¼)
Black ink
BS in oval, lower right
Printed by Cuno?
FLP; PMA
Note: The print is a transfer lithograph.

28. *Night Football, No. 2*, 1930
Edition 34
25.4 × 37.5
(10 × 14¾)
Black ink
BS lower left
Printed by Cuno?
PMA

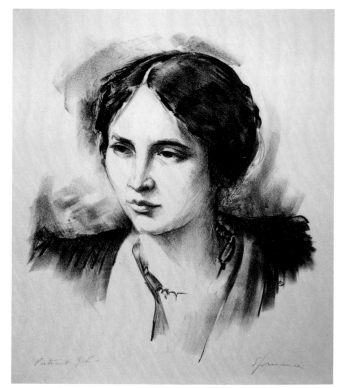

29

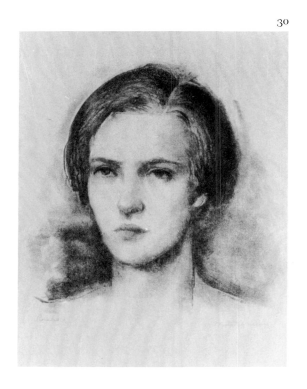

29. *Portrait—J.L.; Julia Lee,* 1930
Edition unknown
32 × 25.7
(12⅜ × 10⅛)
Black ink
⸱r right
by Cuno?

30. *Rosalie; Rosalie Gwathmey,* 1930
Edition unknown
20.7 × 19.5
(8⅛ × 7¾)
Black ink
B. Spruance lower right
Printed by Cuno?
FLP

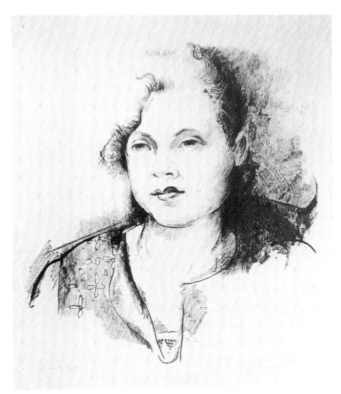

31

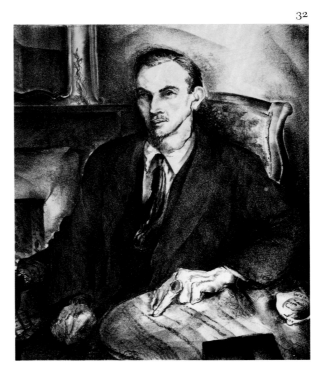

32

31. *Blond Model; Blond Head*, 1930
Edition 15
32.5 × 28
(12¾ × 11¼)
Black ink
B.S. lower center
Printed by Cuno?
FLP; PMA
Note: The print is a transfer lithograph.

32. *Portrait—R.A.; Ralph Affleck*, 1930
Edition 23
29 × 24.3
(11⅜ × 9⁹⁄₁₆)
Black ink on cream chine collé
Stone unsigned
Printed by Desjobert
PMA

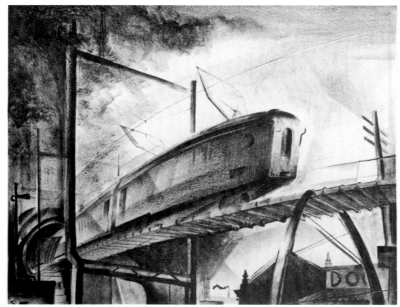

33

34

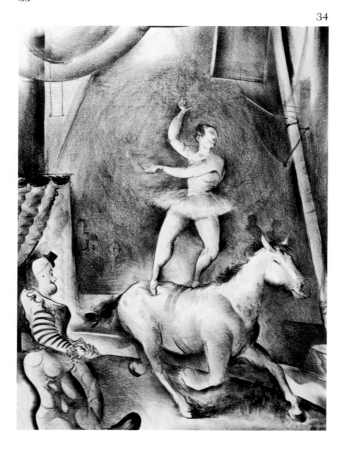

33. *Out of the City*, 1930
Edition 28
25.5 × 31.5
(10⅛ × 12⅜)
Black ink on cream chine collé
S lower left
Printed by Desjobert
FLP

34. *Circus; Breton Circus—Bareback Rider*,
 1930
Edition 28
34.5 × 25
(13⅝ × 9⅞)
Black ink on cream chine collé
BS lower right
Printed by Desjobert
FLP; PMA

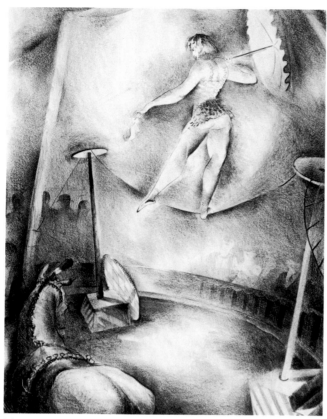

35

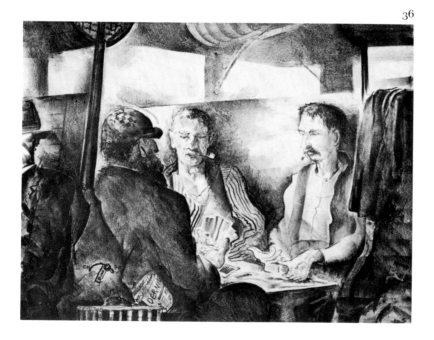

35. *Slack Rope Artist; Breton Circus—*
 Slackrope, 1930
Edition 30
34.7 × 25.9
(13⅝ × 10³⁄₁₆)
Black ink on cream chine collé
Stone unsigned
Printed by Desjobert
FLP; PMA

36. *Card Players*, 1930
Edition unknown
24.2 × 31.1
(9½ × 12¼)
Black ink on cream chine collé
BS lower right
Printed by Desjobert
FLP; PMA

Catalogue Raisonné
57

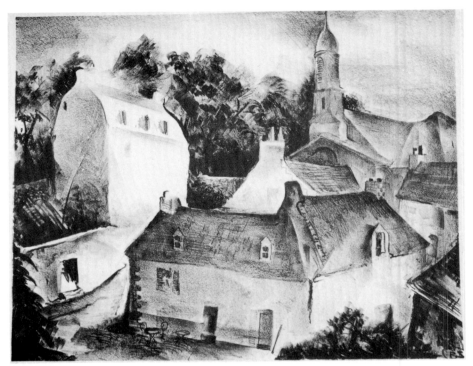

37

38

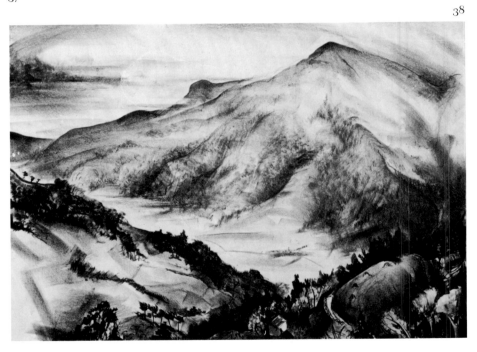

37. *Breton Town; Walled Town*, 1930
Edition 27
28.3 × 35.8
(11⅛ × 14⅛)
Black ink
BS lower right
Printed by Desjobert?
FLP; PMA

38. *Pyrenees No. 1*, 1930
Edition 26
36.2 × 49.5
(14¼ × 19⅝)
Black ink
BS lower left
Printed by Desjobert?
FLP; PMA

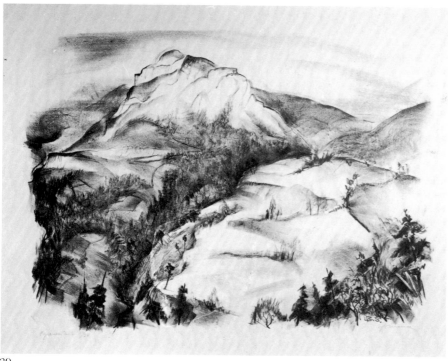

39

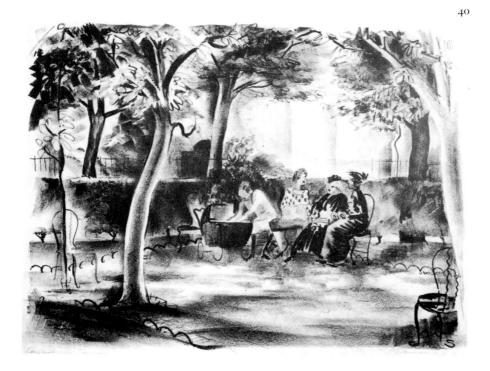

39. *Pyrenees No. 2,* 1930
Edition 26
36.9 × 49.6
(14¾ × 19½)
Black ink
B.S. lower right
Printed by Desjobert?
FLP; PMA

40. *Luxemburg Gardens,* 1930
Edition 30; 31
25.5 × 35
(10 × 13½)
Black ink
S lower right
Printed by Cuno?
FLP; PMA

Note: Fletcher notes impressions with color additions
(possibly printed); no such impressions have been
located by the present cataloguers.

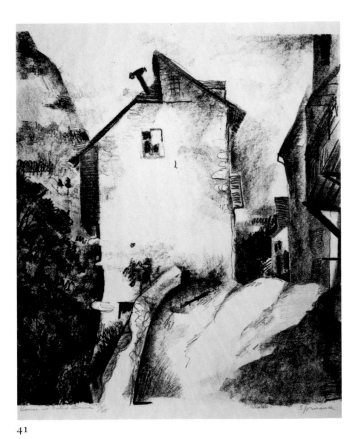

41

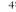

41. *House at Eaux Bonnes*, 1930
Edition 28
34.7 × 28.8
(13¾ × 11⁵⁄₁₆)
Three colors (black, green, brown)
Stone unsigned
Printed by Cuno?
PMA
Note: The black stone is a transfer lithograph.

42. *City Tree*, 1930
Edition unknown
30.2 × 36.3
(11¹⁵⁄₁₆ × 14¼)
Black ink
BS upper right
Printed by Cuno?
FLP

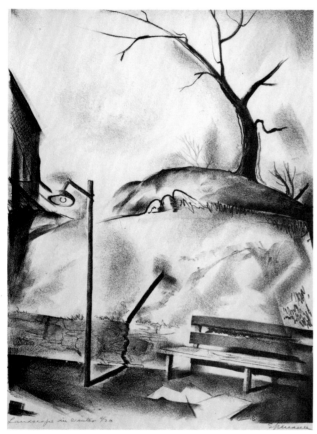

43

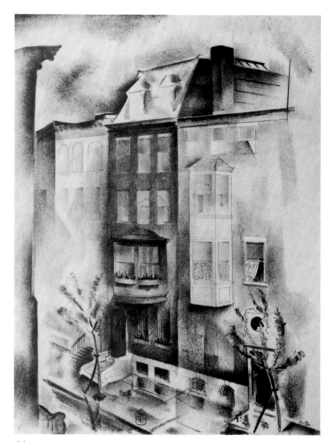

44

43. *Landscape in Winter*, 1931
Edition 20
31.5 × 21.5
(12⅜ × 8½)
Black ink
.S. lower right
Printed by Cuno?
PMA

44. *April—Wet*, 1931
Edition 27
31.7 × 21.7
(12½ × 8½)
Three colors (black, pink, yellow)
B.S. lower right
Printed by Cuno?
FLP; PMA

Catalogue Raisonné
61

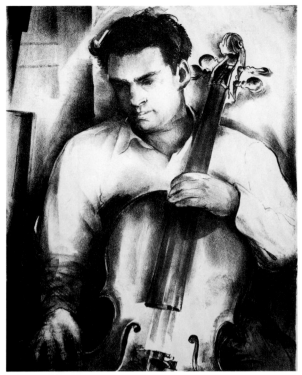

45

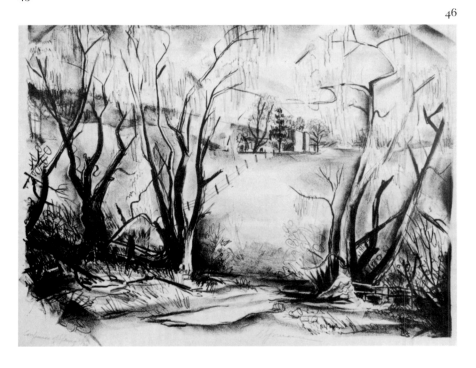

45. *Cellist—Adrian Siegel*, 1931
Edition 26
37.1 × 27.5
(14⅝ × 10⅞)
Black ink
Stone unsigned
Printed by Cuno?
PMA

46. *Confusion of Spring*, 1931
Edition 26
28 × 37.8
(11½ × 14¾)
Black ink
BS lower right
Printed by Cuno?
FLP; PMA

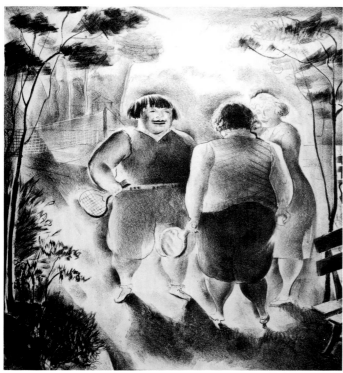

47

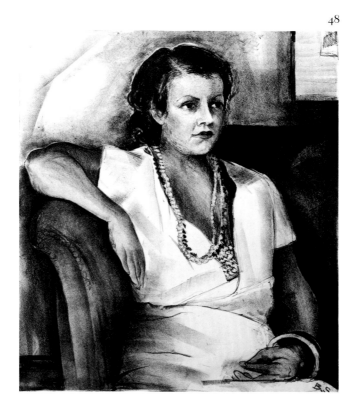

48

47. *Summer in the Park*, 1931
Edition 31
29.5 × 25.9
(11⅝ × 10³/₁₆)
Black ink
Stone unsigned
Printed by Cuno?
PMA

48. *Julia in White*, 1931
Edition 25
33 × 28
(13 × 11)
Four colors (light orange, yellow, rose, black)
B.S. lower right
Printed by Cuno?
PMA

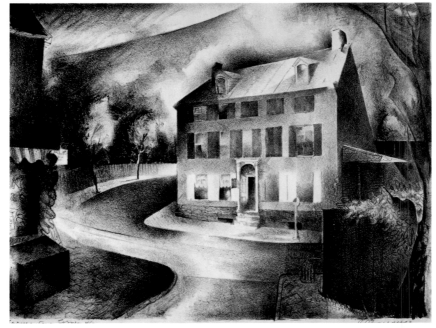

49

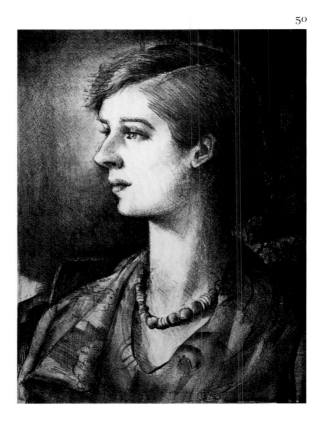

49. *Germantown Corner*, 1931
Edition 31
23 × 35
(9 × 12)
Black ink
Stone unsigned
Printed by Cuno?
PMA

50. *Portrait Study, Mrs. S.; Portrait of W.G.S.*,
 1931
Edition unknown
31 × 22.8
(12¼ × 9)
Black ink
B.S. in oval, lower right
Printed by Cuno?
PMA
Note: The subject is the artist's wife, Winifred Glover
 Spruance.

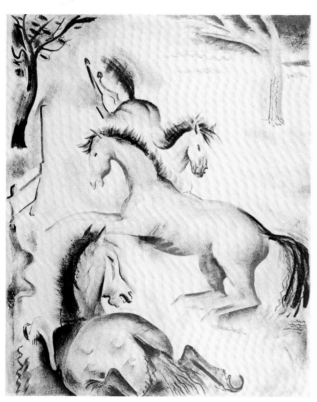

51

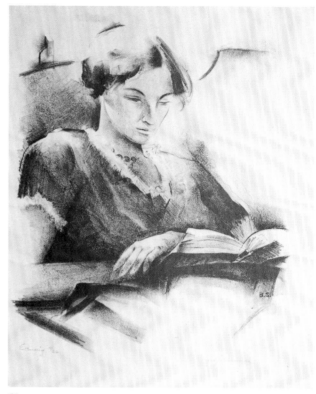

52

51. *Horses and Approaching Storm*, 1931?
Edition 30
39 × 29
(15¼ × 11⅜)
Three colors (black, sepia, blue)
Stone unsigned
Printed by Cuno?
FLP

52. *Evening*, 1931
Edition 26
31 × 23.5
(12 × 9¼)
Black ink
B.S. lower right
Printed by Cuno?
FLP; PMA

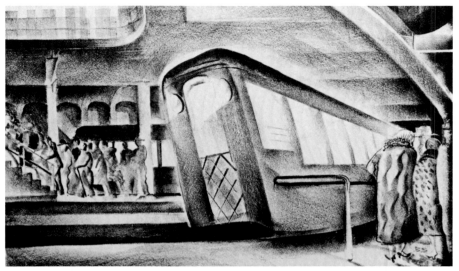

53

54

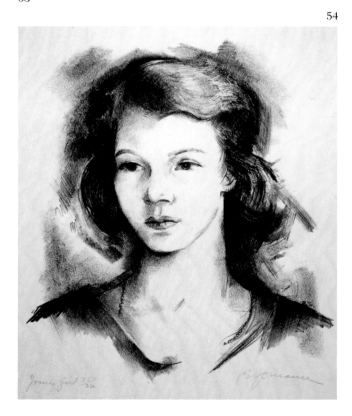

53. *Subway*, 1931
Edition 25
19.5 × 28.5
(7⅝ × 11¼)
Black ink
BS lower right
Printed by Cuno?
FLP; PMA

54. *Young Girl; Mary Frances?* 1931
Edition 26
26 × 22.5
(10³⁄₁₆ × 8¾)
Black ink
B.S. lower right
Printed by Cuno?
PMA

55

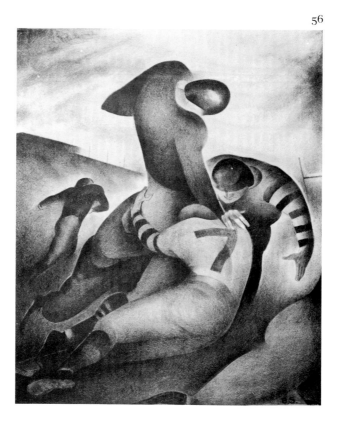

55. *Street Scene—Germantown*, 1931
Edition 28
29.1 × 25
(11½ × 9⅞)
Black ink
Stone unsigned
Printed by Cuno?
FLP; PMA

56. *The Flashy Back*, 1931
Edition 34
31.5 × 24.3
(12½ × 9⁹⁄₁₆)
Black ink
B.S. lower right
Printed by Cuno?
FLP; PMA

Catalogue Raisonné
67

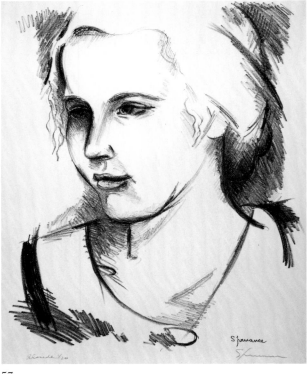

57

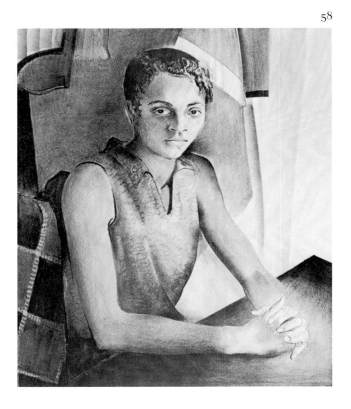

58

57. *Blond; Eleanor?* 1931
Edition 20
32.5 × 26.3
(12⅞ × 10⅜)
Black ink
Spruance lower right
Printed by Cuno?
PMA

58. *Young Colored Girl,* 1932
Edition 23
33.5 × 27.2
(13¼ × 10¾)
Black ink
BS lower right
Printed by Cuno?
FLP; PMA

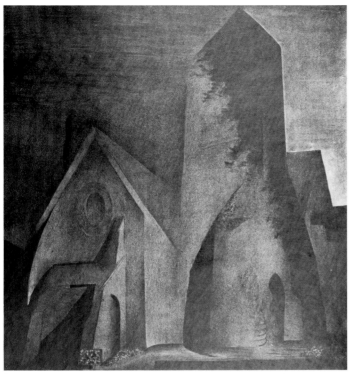

59

60

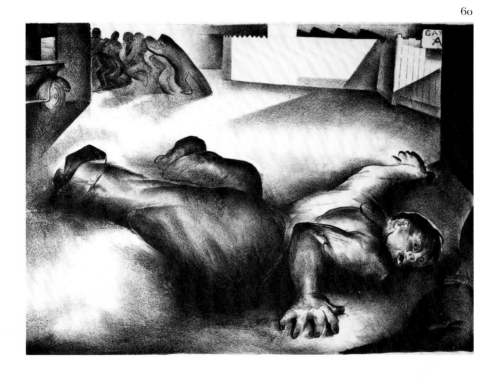

59. *Church at Night*, 1932
Edition 40
33.4 × 29.2
(13⅛ × 11½)
Black ink
B.S. (S reversed) lower right
Printed by Cuno
FLP; PMA

60. *Disturbance in Dearborn*, 1932
Edition 25
27.3 × 36.5
(10¹¹⁄₁₆ × 14⅜)
Black ink
Stone unsigned
Printed by Cuno?
PMA

Catalogue Raisonné
69

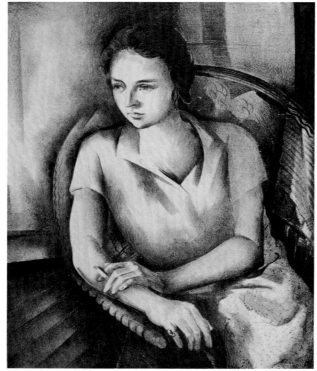

61

62

61. *Girl with Cigarette*, 1932
Edition 26
31.3 × 24.7
(12⅜ × 9¾)
Black ink
*B*S lower right
Printed by Cuno?
FLP; PMA

62. *Portrait A.O.; Albert Oliensis*, 1932
Edition 6
26.9 × 21
(10⁹/₁₆ × 8¼)
B.S. lower center
Black ink
Printed by Cuno?
PMA

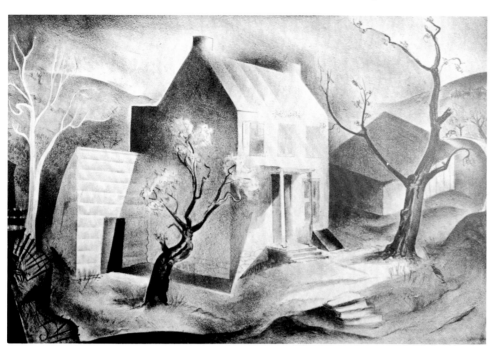

63

64

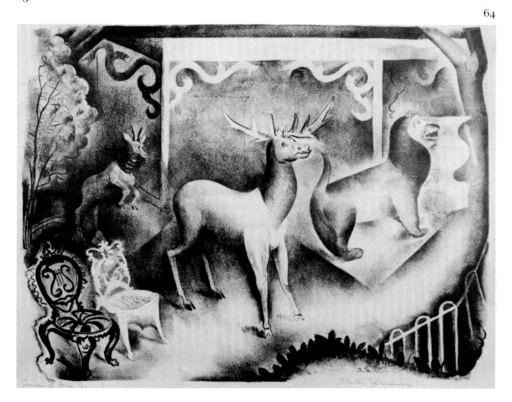

63. *Pangs of Earth*, 1932
Edition 28
22.8 × 32.2
(9 × 12⅝)
Black ink
BS lower right
Printed by Cuno?
FLP; PMA

64. *Garden of Eden*, 1932
Edition 22
24.5 × 31.6
(9⅝ × 12⅜)
Black ink
B.S. lower right
Printed by Cuno?
FLP; PMA

Catalogue Raisonné
71

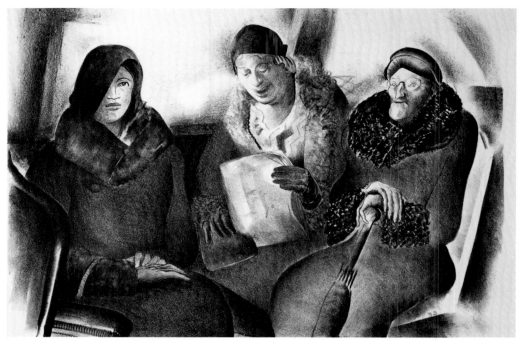

65

66

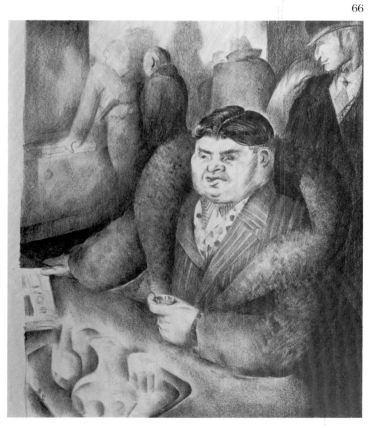

65. *Three Women*, 1932
Edition 30
21.7 × 31.4
(8⅝ × 12⅜)
Black ink
BS lower right
Printed by Cuno?
PMA

66. *Of the People—By the People*, 1932
Edition 28
28.7 × 22.7
(11¼ × 9)
Black ink
B.S. lower left
Printed by Cuno?
FLP; PMA

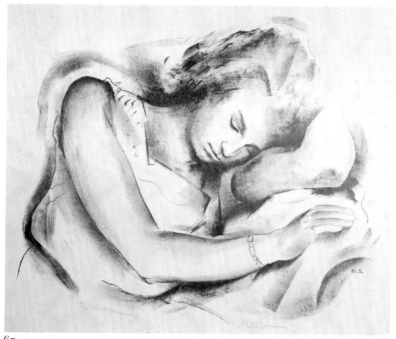

67

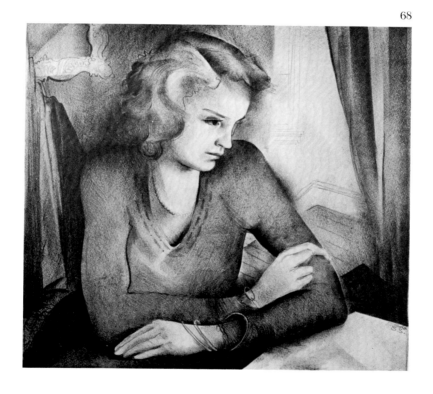

67. *Child Sleeping,* 1932
Edition 25
22.5 × 25.7
(8¾ × 10)
Black ink
B.S. lower right
Printed by Cuno?
FLP; PMA

68. *Mary in the Studio,* 1932
Edition 23
27 × 29.4
(10⅝ × 11⅝)
Black ink
B.S. lower right
Printed by Cuno?
FLP; PMA

Catalogue Raisonné
73

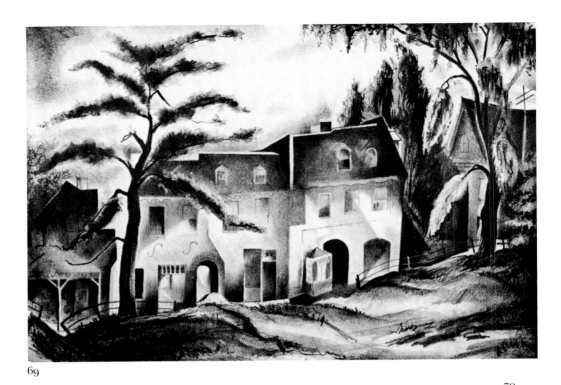

69

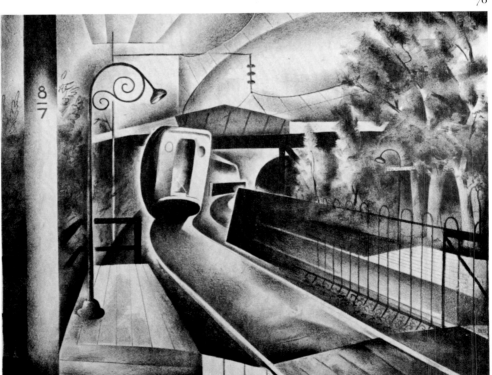

69. *Blue Bell Hill; Bluebell Hill; Bluebell*, 1932
Edition 36
25.9 × 36.9
(10⅛ × 14½)
Black ink
B.S. lower right
Printed by Cuno?
FLP; PMA

70. *Approach to the Station*, 1932
Edition 28
28 × 35.5
(11 × 13⅞)
Black ink
BS lower right
Printed by Cuno?
FLP; PMA

The Prints of Benton
Murdoch Spruance
74

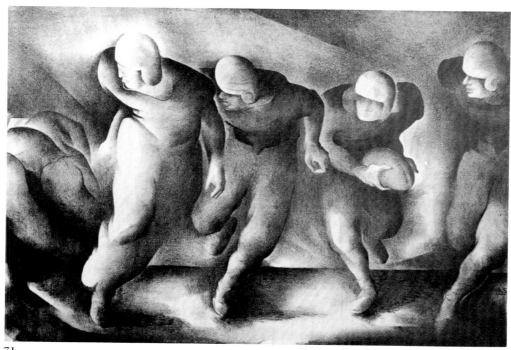

71

72

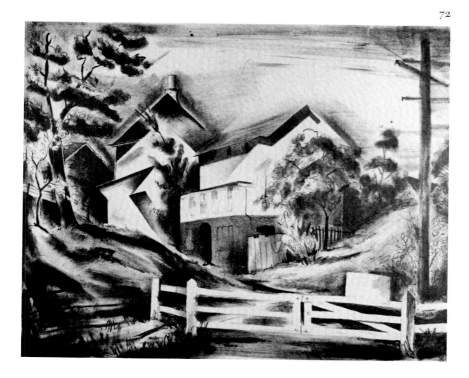

71. *Backfield in Motion*, 1932
Edition 30
26.1 × 37.8
(10¼ × 14⅞)
Black ink
BS lower right
Printed by Cuno
FLP; PMA

72. *Closed Road*, 1932
Edition 25; 20
26.5 × 33.5
(10⅜ × 13¼)
Black ink
B.S. lower right
Printed by Cuno?
FLP; PMA

Catalogue Raisonné
75

73

74

73. *Father and Son*, 1932
Edition 23
23 × 21.7
(9⅛ × 8⅝)
Black ink
B.S. upper left
Printed by Cuno?
FLP; PMA
Note: The print is a self-portrait with elder son, Peter
Benton.

74. *Self Portrait*, 1932
Edition 30
31.3 × 23.9
(12¼ × 9½)
Black ink
BS on side of lithograph stone, lower left
Printed by Cuno?
FLP; PMA; BPL

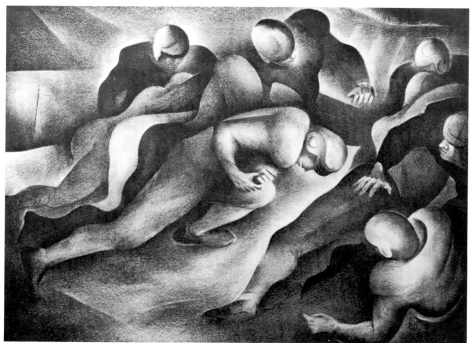

75

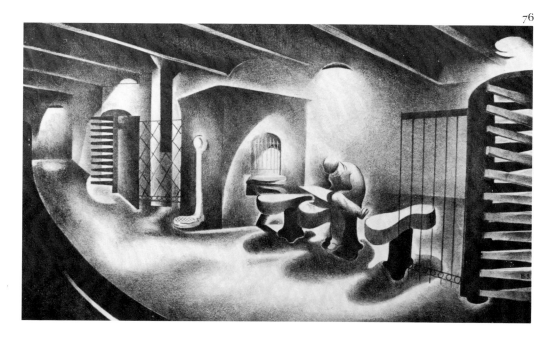

75. *Spinner*, 1932
Edition 30
26.7 × 34.8
(10½ × 13¾)
Black ink
BS lower right
Printed by Cuno?
FLP; PMA

76. *Bulldog Edition*, 1932
Edition 30
22.7 × 36.7
(8⅞ × 14½)
Black ink
B.S. lower right
Printed by Cuno
FLP; PMA

Catalogue Raisonné
77

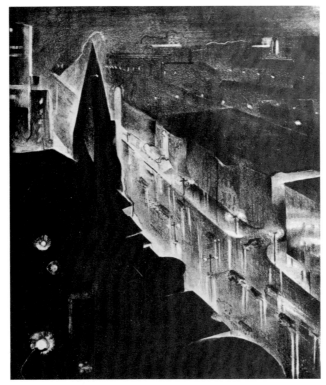

77

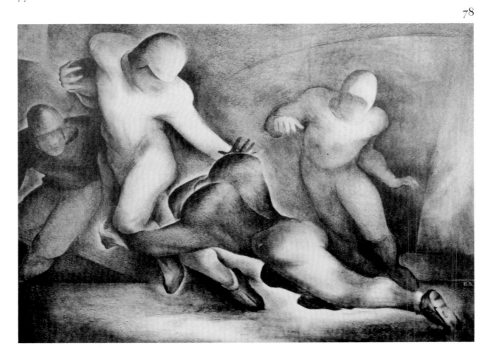

77. *City in the Rain*, 1932
Edition 30
28.8 × 22.5
(11⅜ × 8¾)
Three colors (black, yellow, light red)
Stone unsigned
Printed by Cuno?
FLP; PMA; BPL

78. *The Driving Tackle*, 1933
Edition 40
27.3 × 37
(10¾ × 14⁹⁄₁₆)
Black ink
B.S. lower right
Printed by Cuno?
FLP; PMA

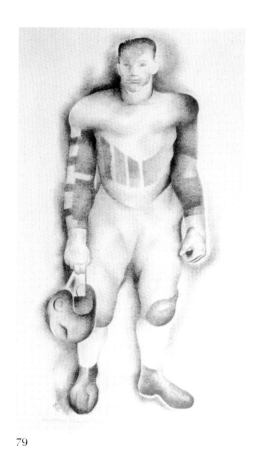

79

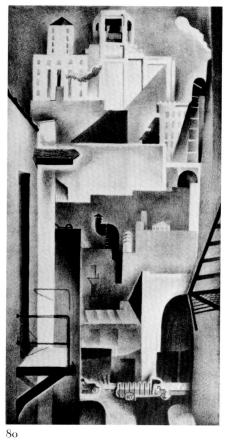

80

79. *Football Player*, 1933
Edition 25
33 × 15.2
(13 × 6)
Black ink
B.S. lower left
Printed by Cuno?
FLP; PMA
Note: Fletcher notes two states; only one has been
 located by the present cataloguers.

80. *Shells for the Living*, 1933
Edition 28
39.2 × 18.8
($15\frac{7}{16}$ × $7\frac{7}{16}$)
Black ink
BS lower right
Printed by Cuno
FLP; PMA

81

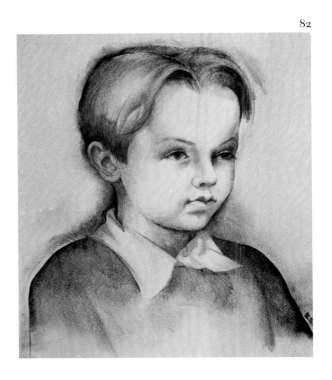

82

81. *Torso*, 1933
Edition 30
30.5 × 23.8
(12⅛ × 9⅜)
Black ink
B.S. lower right
Printed by Cuno?
FLP; PMA

82. (Young boy); *Walter Sangree?* 1933
Edition unknown
24.1 × 20.7
(9½ × 8⅛)
Black ink
B.S. lower right
Printed by Cuno?
PMA

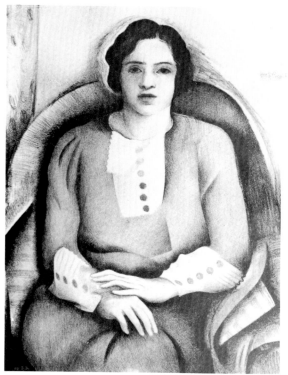

83

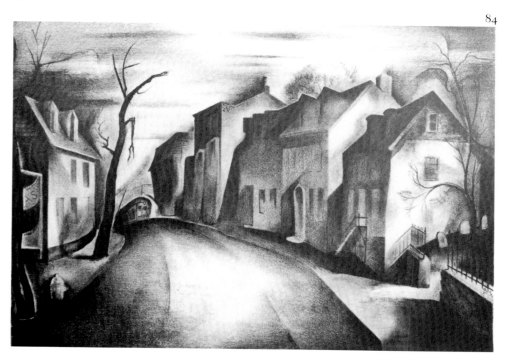

84

83. *Sophie; Portrait of Sophie; Sophie Siegel,*
 1933
Edition 15
29.3 × 21.2
(11½ × 8⅜)
Black ink
B.S. lower right; *To* S.S. lower left
Printed by Cuno?
FLP

84. *Entrance to Germantown,* 1933
Edition 35
25 × 35.2
(9⅞ × 13⅞)
Black ink
B.S. lower right
Printed by Cuno?
FLP; PMA
Note: Fletcher notes two states; only one has been
 located by the present cataloguers.

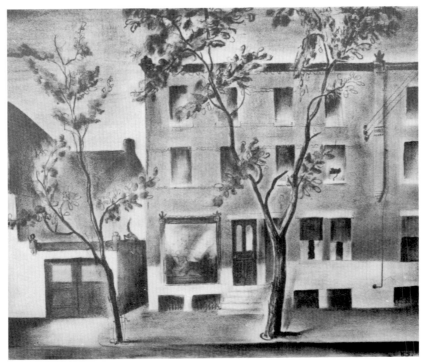

85

86

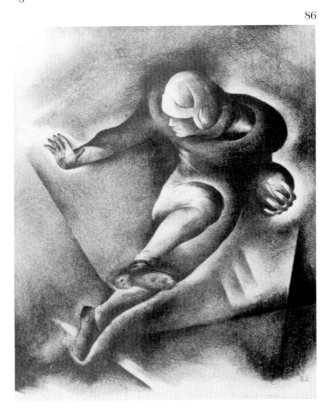

85. *Cat and Busybody*, 1933
Edition 33
27.4 × 33.5
(10¾ × 13⁵⁄₁₆)
Black ink
B.S. lower right
Printed by Cuno?
FLP; PMA

86. *Ball Carrier*, 1933
Edition 21
31.5 × 24.5
(12⅜ × 9^f¹⁄₁₆)
Black ink
B.S. lower right
Printed by Cuno?
FLP; PMA

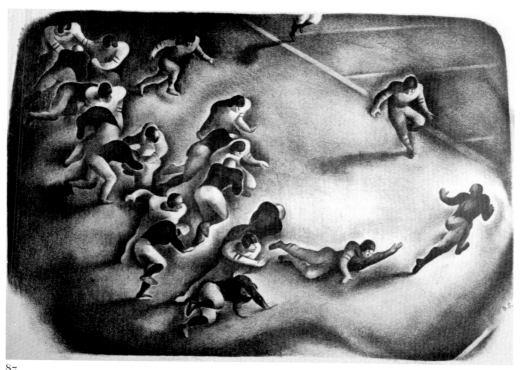

87

88

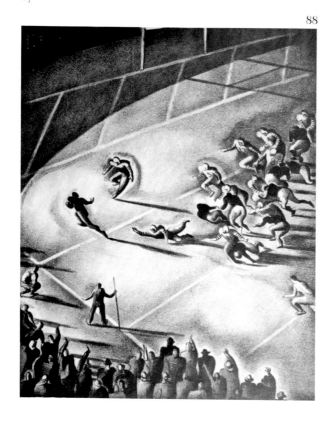

87. *Touchdown Play*, 1933
Edition 40
29.4 × 42
(11⁹⁄₁₆ × 16½)
Black ink
B.S. lower right
Printed by Cuno?
FLP; PMA

88. *Thrill of the Game*, 1933
Edition 35
29.1 × 22.1
(11⁷⁄₁₆ × 8¾)
Black ink
BS lower right
Printed by Cuno?
FLP; PMA

Catalogue Raisonné
83

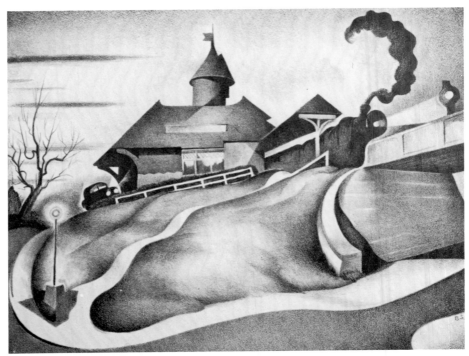

89

90

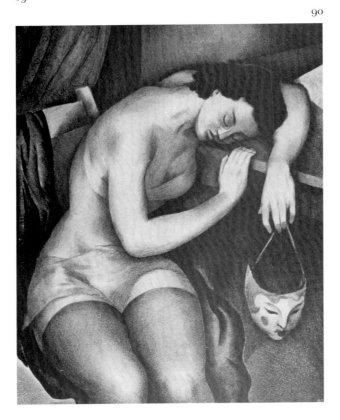

89. *Late Departure*, 1933
Edition 30
24.8 × 31.7
(9¾ × 12½)
Black ink
B.S. lower right
Printed by Cuno?
FLP; PMA

90. *Player Unmasked*, 1933
Edition 35
31.7 × 23.7
(12½ × 9⅜)
Black ink
B.S. lower right
Printed by Cuno?
FLP; PMA

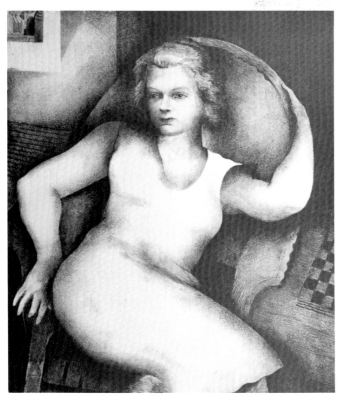

91

92

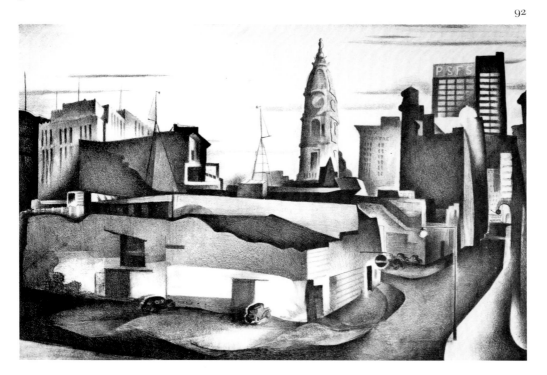

91. *Adolescent*, 1933; 1932
Edition 28
32.5 × 26.3
(12⅞ × 10⅜)
Black ink
Stone unsigned
Printed by Cuno?
FLP; PMA

92. *City from the West*, 1933
Edition 38
25.4 × 37.6
(10 × 14¾)
Black ink
Stone unsigned
Printed by Cuno?
PMA

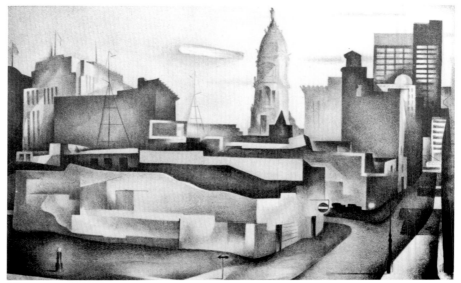

93

94

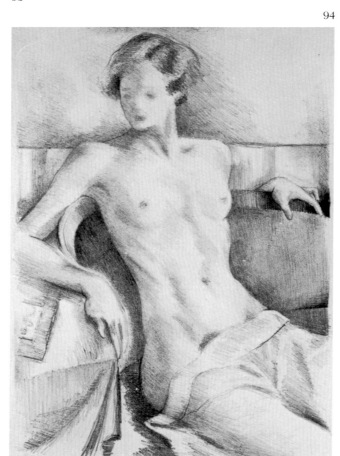

93. *Changing City*, 1934
Edition 36
24.5 × 36.9
(9³⁄₁₆ × 14⁹⁄₁₆)
Black ink
Stone unsigned; *To J L* lower right
Printed by Cuno?
FLP; PMA

94. *Marge Resting*, 1934
Edition 35
35.2 × 23.6
(13⅝ × 9⅜)
Black ink
B.S. lower right
Printed by Cuno?
FLP; PMA

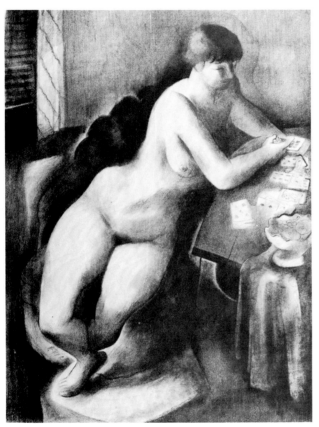

95

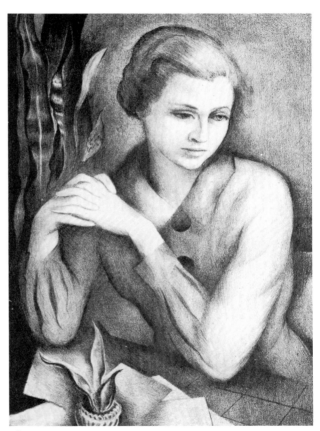

96

95. *Brief Diversion*, 1934
Edition 38
30.3 × 21.4
(12 1/16 × 8 9/16)
Black ink
Stone unsigned
Printed by Cuno?
FLP; PMA

96. *Harriet*, 1934
Edition 25
29.5 × 21.8
(11 5/8 × 8 5/8)
Black ink
Stone unsigned
Printed by Cuno?
FLP; PMA

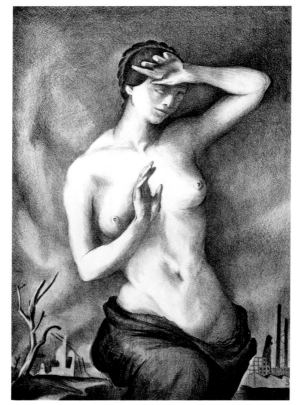

97

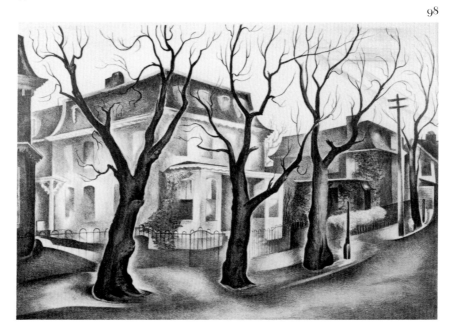

98

97. *Annunciation*, 1934
Edition 25
31.6 × 21.4
(12½ × 8⁷⁄₁₆)
Black ink
S lower right
Printed by Cuno?
PMA

98. *Middle Germantown*, 1934
Edition 30
25.3 × 34.9
(10 × 13¾)
Black ink
Stone unsigned
Printed by Cuno?
FLP; PMA
Note: The subject is the Spruance home; the FLP
 impression is inscribed "first state" by Spruance;
 no second state has been located.

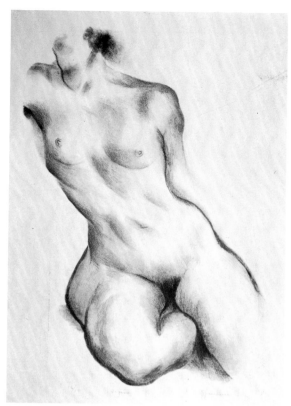

99

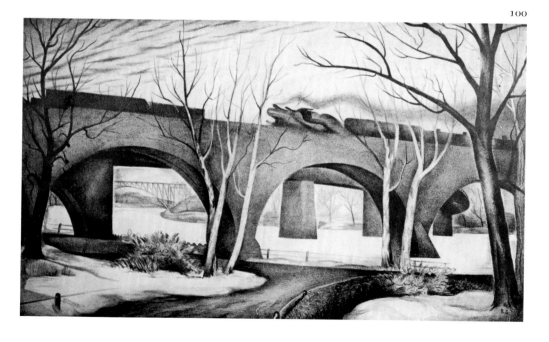

99. *Figure*, 1934
Edition 34
30.5 × 19.6
(12 × 7¾)
Black ink
Stone unsigned
Printed by Cuno?
FLP; PMA

100. *Schuylkill Bridges*, 1934
Edition 36
23 × 37.1
(9¹⁄₁₆ × 14⅝)
Black ink
B.S. and *To K* lower right
Printed by Cuno?
FLP; PMA

Catalogue Raisonné
89

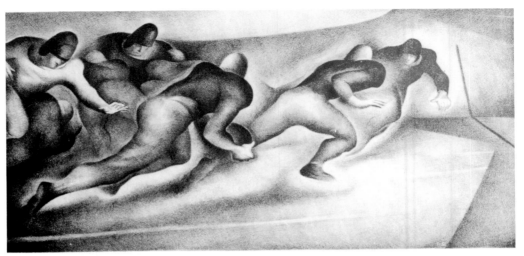

101

102

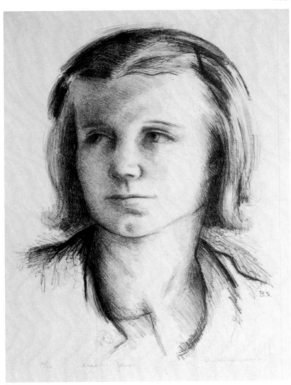

101. *End Sweep*, 1934
Edition 30
17.4 × 36.5
(6⅞ × 14⅜)
Black ink
B.S. lower right
Printed by Cuno?
FLP; PMA

102. *Head—Janet*, 1934
Edition 30
27 × 19.5
(10⅞ × 7¾)
B.S. lower right
Printed by Cuno
FLP; PMA

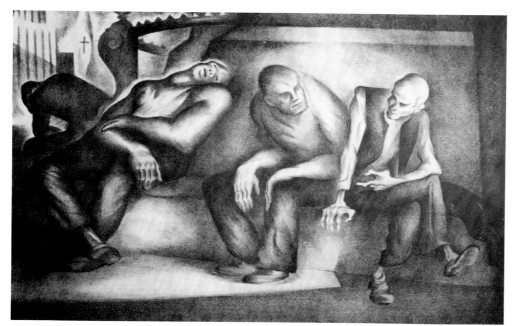

103

104

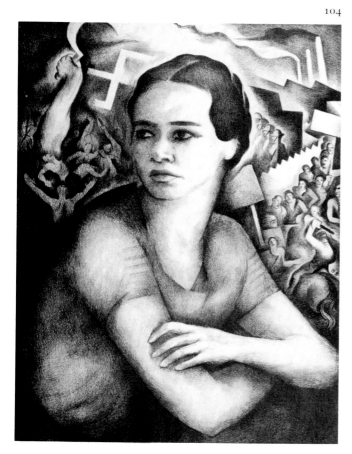

103. *Conversation with Death*, 1934
Edition 40
24.9 × 38.1
(9¹³⁄₁₆ × 15)
Black ink
Stone unsigned
Printed by Cuno
FLP; PMA

104. *Young Socialist*, 1934
Edition 30
34.6 × 25.3
(13⅜ × 10)
Black ink
BS lower right
Printed by Cuno
FLP; PMA

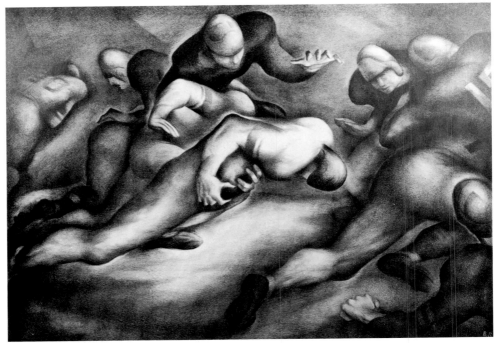

105

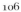

106

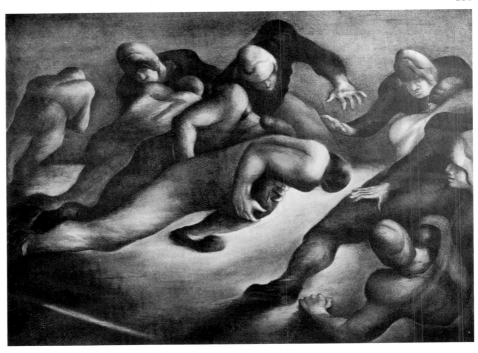

105. *Spinner Play*, 1934; 1935
Edition 50
35.3 × 49
(13⅞ × 19⁵⁄₁₆)
Black ink
BS lower right
Printed by Cuno
FLP; PMA
Note: The FLP impression is inscribed "first state" by
 Spruance; no second state has been located, and it
 is likely that cat. nos. 105 and 106 were considered
 two states of the same image.

106. *Spinner Play*, 1934
Edition 50
35.6 × 47.2
(14 × 18⅝)
Black ink
BS lower right
Printed by Cuno
FLP; PMA
Note: The FLP impression is inscribed "second state"
 by Mrs. Spruance; no first state has been located,
 and it is likely that cat. nos. 105 and 106 were
 considered two states of the same image.

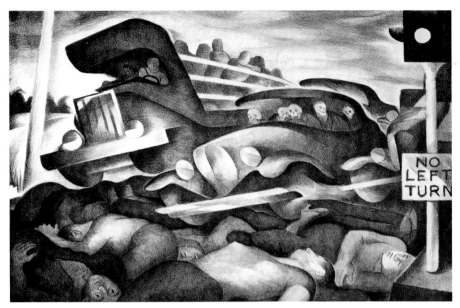

107

108

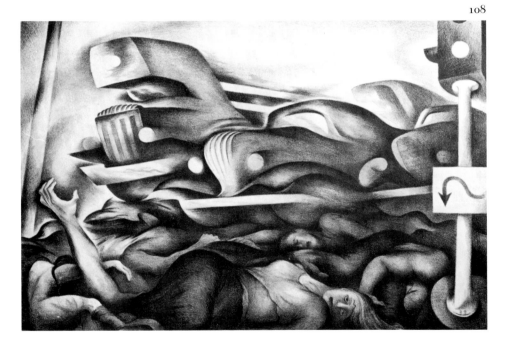

107. *Highway Holiday*, 1935; 1934
Edition unknown
24.4 × 36.4
(9⅝ × 14⁵⁄₁₆)
Black ink
Stone unsigned
Printed by Cuno?
PMA

108. *Highway Holiday*, 1935; 1934
Edition 35
26 × 38.1
(10¼ × 15)
Black ink
BS lower right
Printed by Cuno?
FLP; PMA

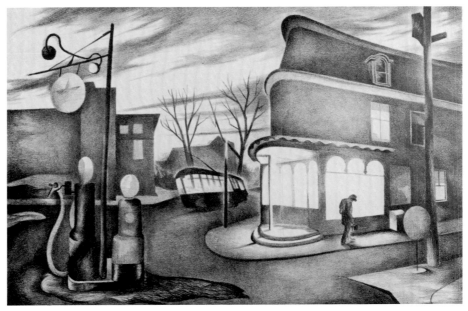

109

110

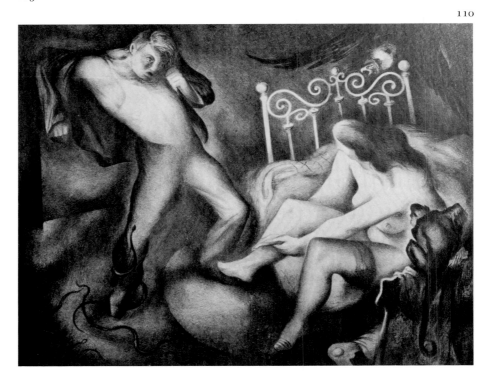

109. *Prelude to Rest*, 1935
Edition 32
22.6 × 33.5
(8¹⁵⁄₁₆ × 13³⁄₁₆)
Black ink
Stone unsigned
Printed by Cuno?
FLP; PMA

110. *Introduction to Love*, 1935
Edition 35
26.3 × 34.2
(10³⁄₈ × 13½)
Black ink
BS lower right
Printed by Cuno?
FLP; PMA

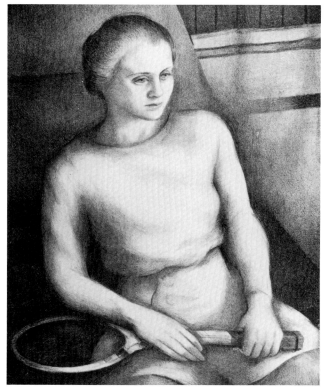

111

112

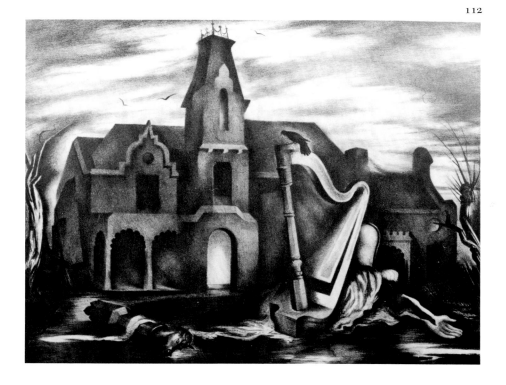

111. *College Student*, 1935
Edition 21
32.1 × 24.9
(12 11/16 × 9 13/16)
Black ink
BS lower right
Printed by Cuno?
FLP; PMA

112. *Harps Once Played*, 1935; 1936
Edition 30
27.3 × 35.1
(10¾ × 13⅞)
Black ink
B.S. lower right
Printed by Cuno?
FLP; PMA

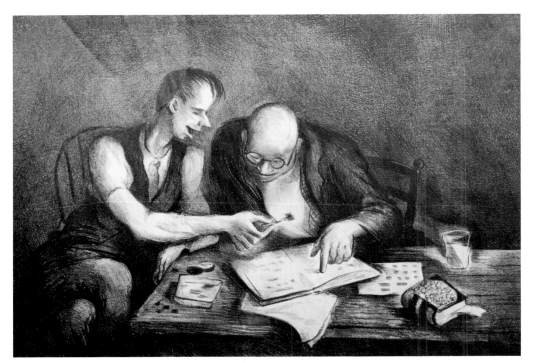

113

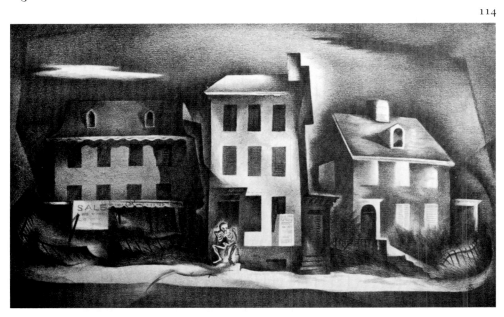

113. *The Philatelists*, 1935
Edition 25
25.1 × 36.5
(9⅞ × 14⅜)
Black ink
BS lower right
Printed by Cuno?
FLP; PMA

114. *Visitor to Germantown*, 1935
Edition 30
21.4 × 35
(8⁷⁄₁₆ × 14)
Black ink
.S. lower right
Printed by Cuno?
FLP; PMA

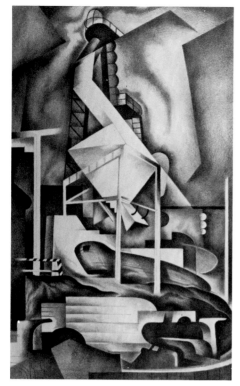

115

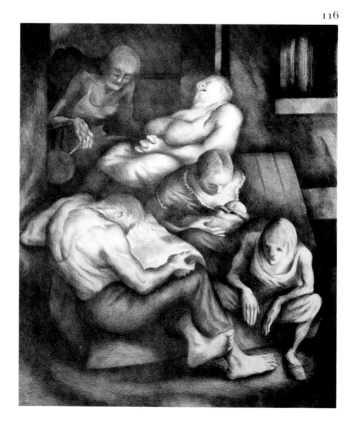

115. *Design for America, No. 1*, 1935
Edition 40
41.8 × 24
(16½ × 9½)
Black ink
B/S lower right
Printed by Cuno?
FLP; PMA

116. *August on 10th Street*, 1935
Edition 40
42.3 × 33.5
(16¹¹⁄₁₆ × 13⅛)
Black ink
Stone unsigned
Printed by Cuno?
PMA

Catalogue Raisonné
97

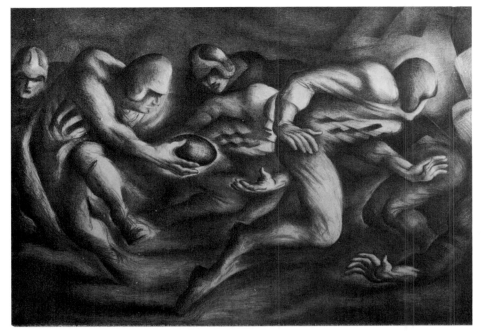

117

118

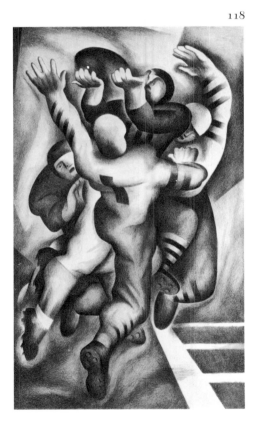

117. *Shovel Pass*, 1935
Edition 40
33.8 × 47.3
(13⁵⁄₁₆ × 18⁵⁄₈)
Black ink
Stone unsigned
Printed by Cuno?
FLP; PMA

118. *Design for America, No. 2*, 1935
Edition 40
41.6 × 24.1
(16³⁄₈ × 9½)
Black ink
BS lower right
Printed by Cuno?
FLP; PMA

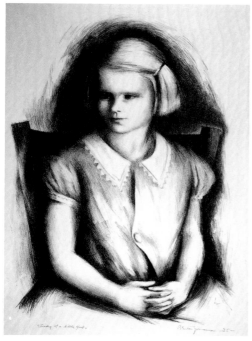

119

120

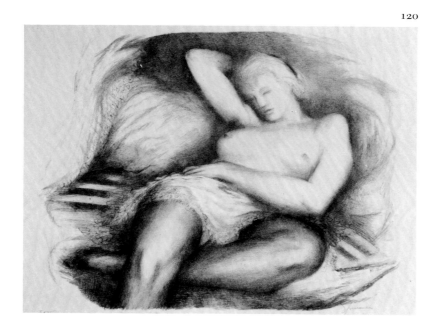

119. *Study of a Little Girl; Sophie Elkins?*
 1935; 1936?
Edition unknown
34.2 × 23.8
(13⅜ × 9¼)
Black ink
b.s. lower right
Printed by Cuno?
PMA

120. *Model at Rest; Girl in Repose,* 1935
Edition 25
27.8 × 35.5
(11 × 14)
Black ink
B.S. lower right
Printed by Cuno?
FLP; PMA

Catalogue Raisonné

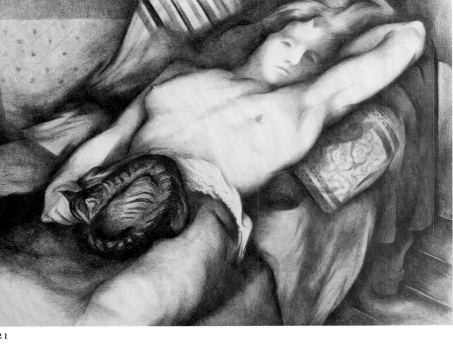

121

122

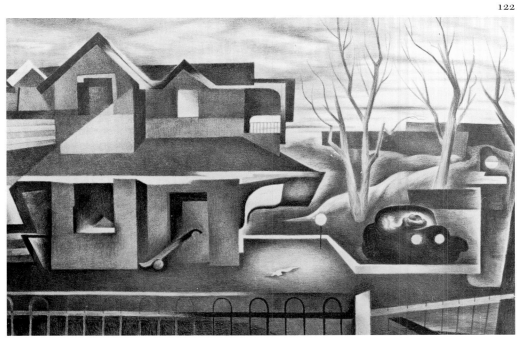

121. *Girl and Cat; Girl with Cat*, 1935
Edition 33
26.2 × 34.6
(10⁵⁄₁₆ × 13⅝)
Black ink
B.S. lower right
Printed by Cuno?
FLP; PMA

122. *The Homecoming*, 1935
Edition 30; 28
22.9 × 35.2
(9 × 13⅞)
Black ink
.*S.* lower right
Printed by Cuno
FLP; PMA

123

124

123. *Dreamer*, 1936
Edition 30
32.4 × 21.3
(12¾ × 8⅜)
Black ink
BS lower right
Printed by Cuno?
FLP; PMA
Note: The subject is the artist's wife, Winifred.

124. *Siren Song*, 1936
Edition 31
34.5 × 24.7
(13⅝ × 9¾)
Black ink
Stone unsigned
Printed by Cuno?
FLP; PMA

Catalogue Raisonné
101

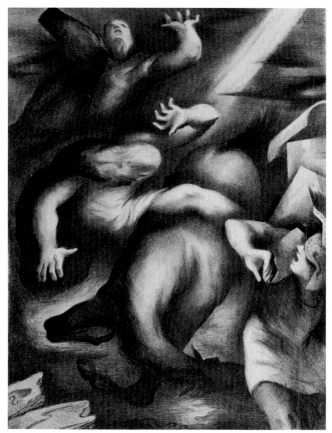

125

126

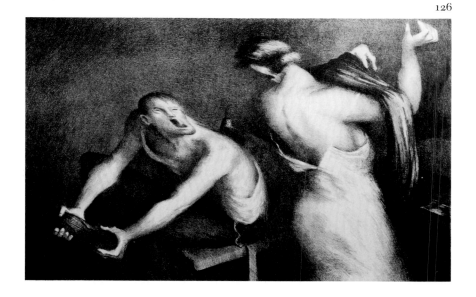

125. *Destiny Near Damascus*, 1936
Edition 30; 31
36.8 × 26.3
(14½ × 10⅜)
Black ink
S, reversed, lower left
Printed by Cuno?
FLP; PMA

126. *Caustic Comment*, 1936
Edition 30
24.7 × 36.7
(9¾ × 14½)
Black ink
Stone unsigned
Printed by Cuno?
FLP; PMA

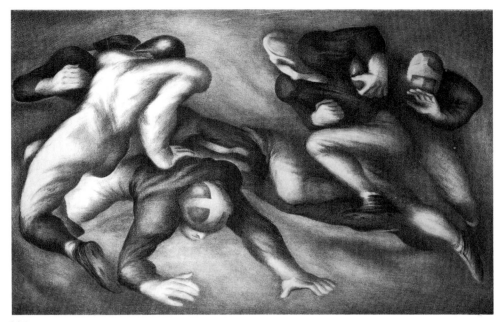

127

128

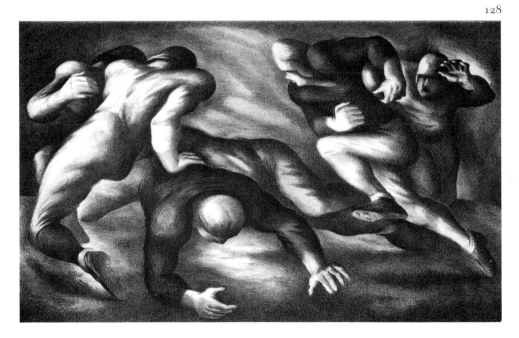

127. *Short Gain*, 1936
Edition unknown
24.5 × 37.9
(9⁷⁄₁₆ × 14⁷⁄₈)
Black ink
Stone unsigned
Printed by Cuno or George C. Miller
PMA

Note: The PMA impression is inscribed, not by
Spruance or Mrs. Spruance, "2nd stone" and
"Cuno printing."

128. *Short Gain*, 1936
Edition unknown
24.2 × 37.2
(9½ × 14⁵⁄₈)
Black ink
Stone unsigned
Printed by George C. Miller?
PMA

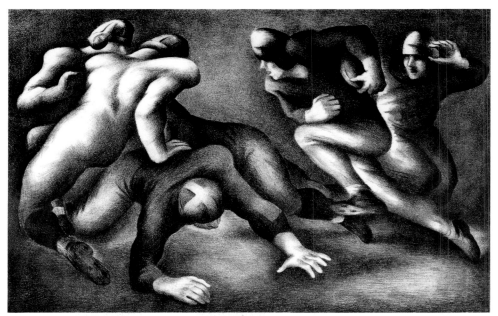

129

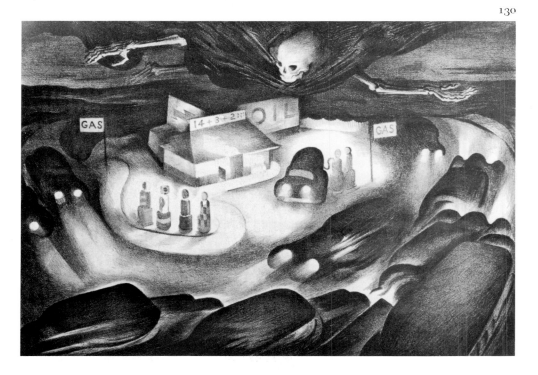

129. *Short Gain*, 1936
Edition 30
23.6 × 37
(9¼ × 14⁹⁄₁₆)
Black ink
Stone unsigned
Printed by George C. Miller?
FLP; PMA
Note: The print was published by the American
 Artists Group, Inc., New York.

130. *Road from the Shore*, 1936
Edition 25
25.6 × 36.5
(10⅛ × 14⅜)
Black ink
Stone unsigned
Printed by Cuno
FLP; PMA

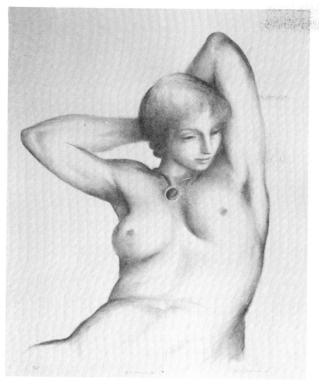

131

132

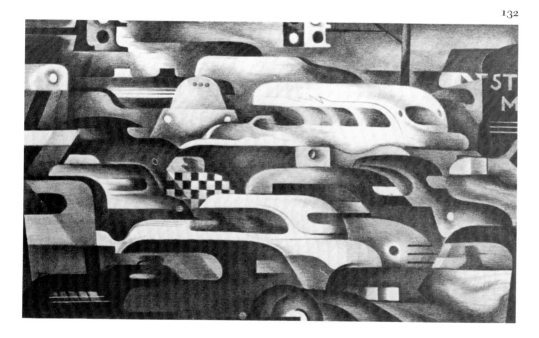

131. *Girl with Locket*, 1936
Edition 35
36 × 26
(14¼ × 9¾)
Black ink
Stone unsigned
Printed by Cuno?
FLP; PMA

132. *Traffic Control*, 1936
Edition 35; 30
22.6 × 36.5
(8⅞ × 14⅜)
Black ink
BS lower right
Printed by Cuno
FLP; PMA

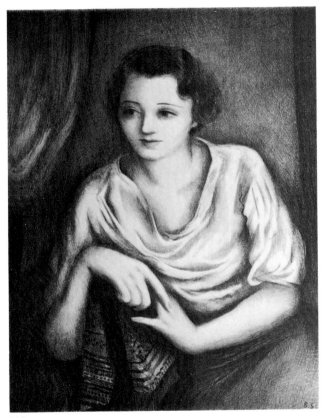

133

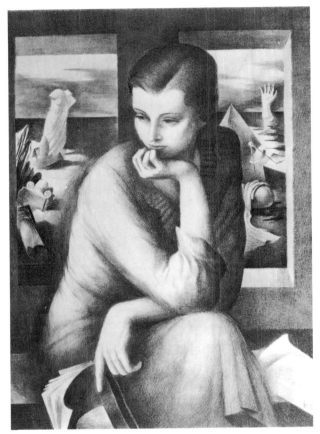

134

133. *Portrait of Dorothy Price*, 1936
Edition 10
34.2 × 24.8
(13⁷⁄₁₆ × 9¾)
Black ink
B.S. lower right
Printed by Cuno?
FLP; PMA

134. *Portrait of a Teacher*, 1936; 1938
Edition 30
37.3 × 25.5
(14¾ × 10¹⁄₁₆)
Black ink
b.s. lower right
Printed by Cuno?
FLP; PMA

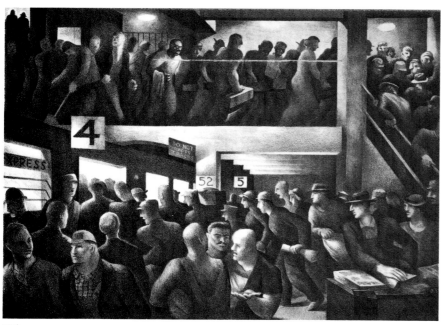

135

136

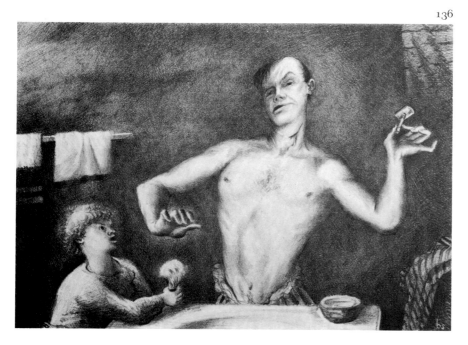

135. *The People Work—Morning*, 1936
Edition unknown
35.5 × 48.3
(14 × 19)
Black ink
BS lower right
Printed by Cuno?
PMA

136. *Man's Estate*, 1937; 1936
Edition unknown
25 × 35
(9⅞ × 13¹³⁄₁₆)
Black ink
b.s. lower right
Printed by Cuno?
FLP; PMA

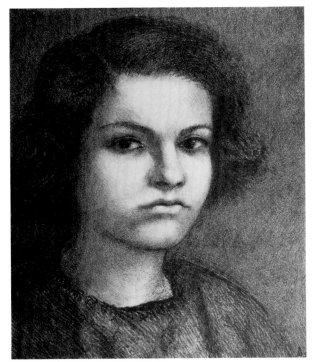

137

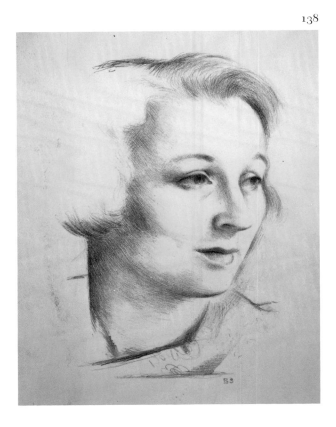

138

137. *Portrait of a Sullen Girl,* 1937
Edition 30; 20
27.5 × 22
(10¹³⁄₁₆ × 8¾)
Black ink
b.s. lower right
Printed by Cuno?
FLP; PMA

138. *Portrait—Vivian Kling,* 1937
Edition unknown
23 × 15.5
(9⅛ × 6)
Black ink
BS lower right
Printed by Cuno?
PMA

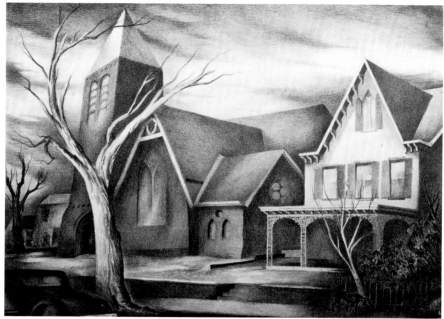

139

140

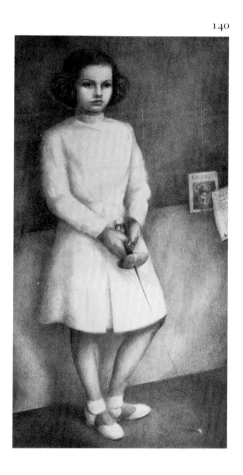

139. *Symbols of Grace*, 1937
Edition 30
25.8 × 35.1
(10⅛ × 13⅞)
Black ink
bs lower right
Printed by Cuno?
FLP; PMA

140. *Little Fencer*, 1937; 1936
Edition 30
41.6 × 20.9
(16⁷⁄₁₆ × 8¼)
Black ink
b.s. right center
Printed by Cuno?
FLP; PMA

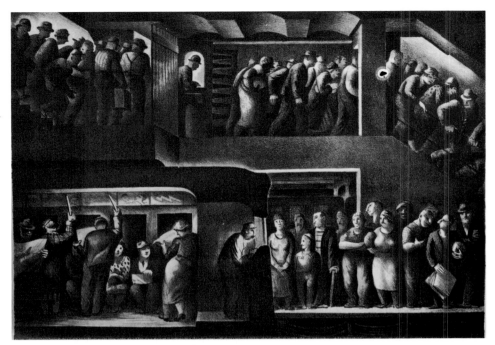

141

142

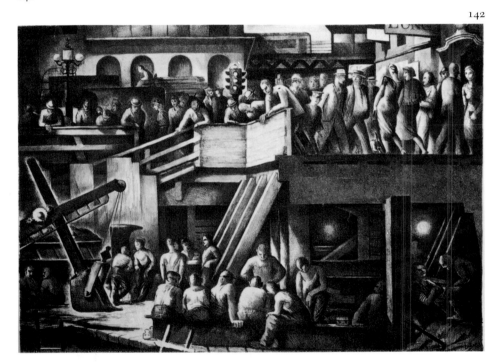

The People Work
A series of four lithographs (cat. nos. 141–44) issued in portfolio with a foreword by Henri Marceau; a prospectus with a reproduction of

The People Work—Evening indicates, in error, that the editions will be limited to one hundred.

141. *The People Work—Morning*, 1937
Edition 40
34·7 × 47·9
(13¹¹⁄₁₆ × 18⅞)
Black ink
b.s. lower right
Printed by Cuno
FLP; PMA; BPL; NGA; LC

142. *The People Work—Noon*, 1937
Edition 40
35 × 47·9
(13⅞ × 19⅞)
Black ink
b.s. lower right
Printed by Cuno
FLP; PMA; NGA; LC

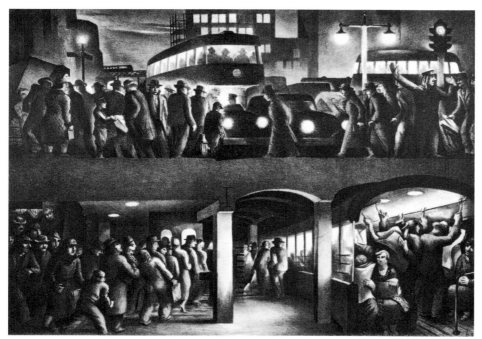

143

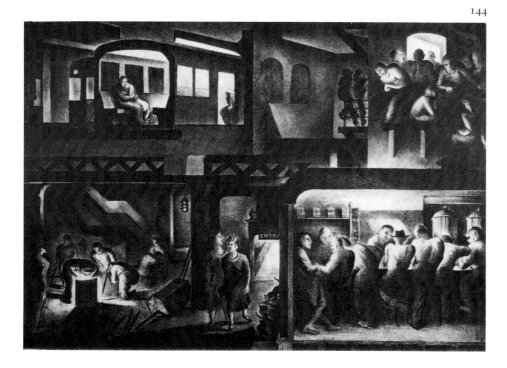

143. *The People Work—Evening,* 1937
Edition 40
34.5 × 48
(13⅝ × 19⅞)
Black ink
b.s. lower right
Printed by Cuno
FLP; PMA; NGA

144. *The People Work—Night,* 1937
Edition 40
34.7 × 48
(13¹¹⁄₁₆ × 18⅞)
Black ink
bs lower right
Printed by Cuno
FLP; PMA; BPL; NGA

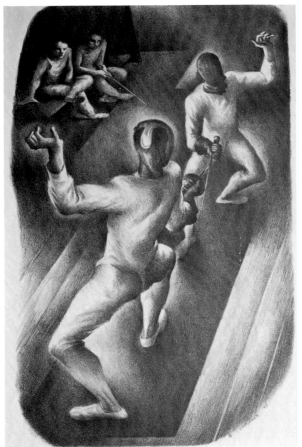

145

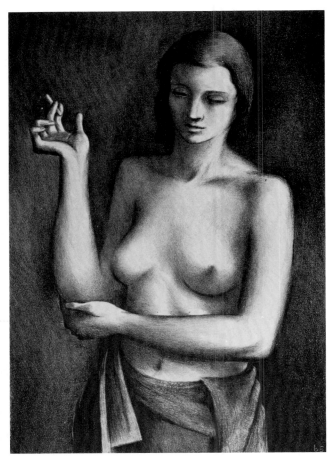

146

145. *Fencers*, 1937
Edition unknown
32.3 × 19.4
(12¾ × 7¹¹⁄₁₆)
Black ink
© *Spruance* 37 lower right
Printed by George C. Miller?

FLP; PMA

Note: Published by American Artists Group, Inc.,
 New York.

146. *Retrospect*, 1937; 1938
Edition 25
35.5 × 23
(14 × 9¼)
Black ink
BS lower right
Printed by Cuno?

FLP

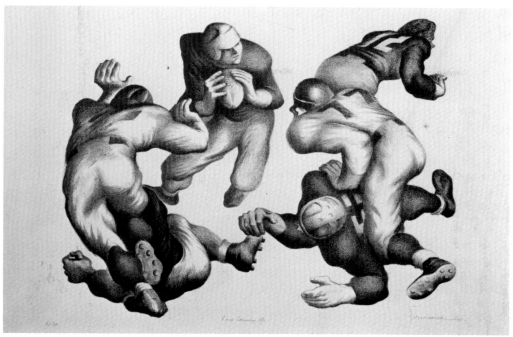

147

148

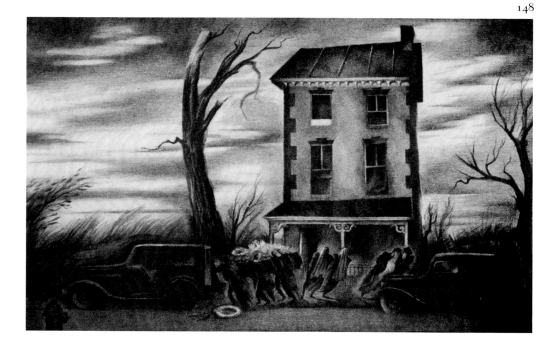

147. *Pass Coming Up*, 1938
Edition 30; 40
24.4 × 31.7
(9⅝ × 12½)
Black ink
Stone unsigned
Printed by Cuno?
FLP; PMA
Note: Fletcher also notes color version; no such
 impression has been located by the present
 cataloguers.

148. *Macbeth—Act V*, 1938
Edition 30; 35
24.6 × 37.4
(9¹¹⁄₁₆ × 14¾)
Black ink
Stone unsigned
Printed by Cuno?
FLP; PMA; NGA

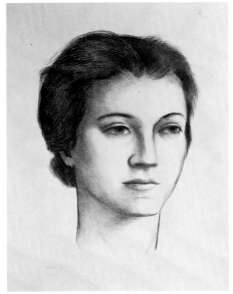

149

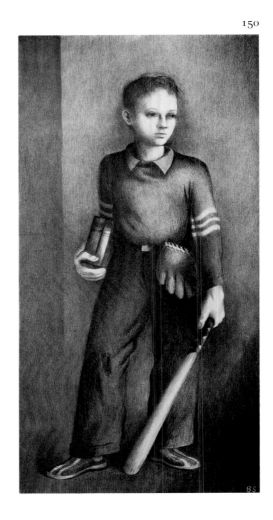

150

149. *Head—Jean T.*; *Head—Jean Tompkins*;
 Head J.T., 1938
Edition 12
29.2 × 20
(11½ × 7¾)
Black ink
Stone unsigned
Printed by Cuno?

150. *Peter*, 1938
Edition unknown
40.5 × 20
(15¹⁵⁄₁₆ × 7⅞)
Black ink
BS lower right
Printed by Cuno?
Note: The subject is the artist's elder son.

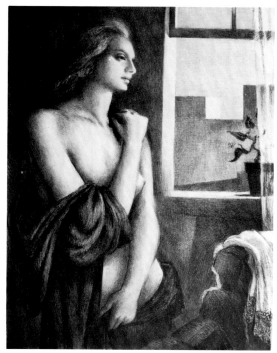

151

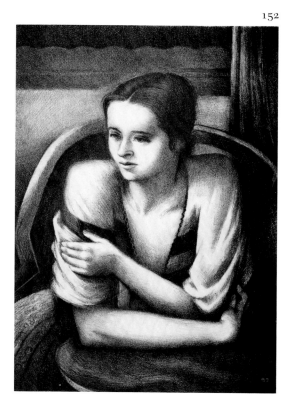

152

151. *Morning in Babylon; City Morning*, 1938
Edition 30; 33
33.1 × 24.2
(13 × 9⅝)
Black ink
Stone unsigned
Printed by Cuno?
FLP; PMA

152. *Arrangement for Jenny*, 1938
Edition 20
33 × 22.8
(13 × 8⁹⁄₁₆)
Black ink
BS lower right
Printed by Cuno?
PMA

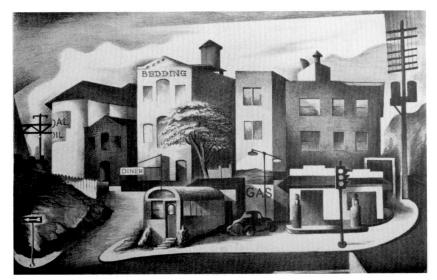

153

154

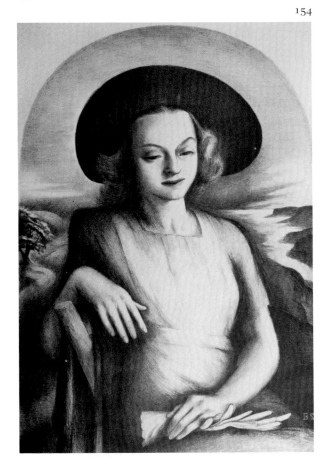

153. *Supplies for Suburbia*, 1938
Edition 30
25.2 × 38
(9⁹⁄₁₆ × 15)
Black ink
BS lower right
Printed by Cuno?
FLP; PMA
Note: Fletcher notes two states; only one has been
located by the present cataloguers.

154. *Girl with Gloves*, 1938
Edition 25; 30
39.3 × 25.4
(15⁷⁄₁₆ × 10)
Black ink
BS lower right
Printed by Cuno?
FLP; PMA

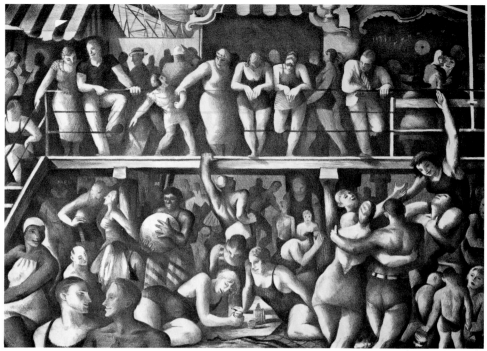

155

156

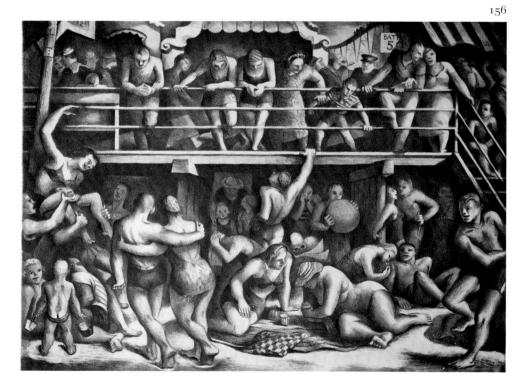

155. *The People Play—Summer*, 1938
Edition unknown
35.2 × 48.3
(13⅞ × 19)
Black ink
BS lower right
Printed by Cuno?
PMA

156. *The People Play—Summer*, 1938
Edition unknown
35.4 × 48
(14 × 18⅞)
Black ink
Stone unsigned
Printed by Cuno?
PMA

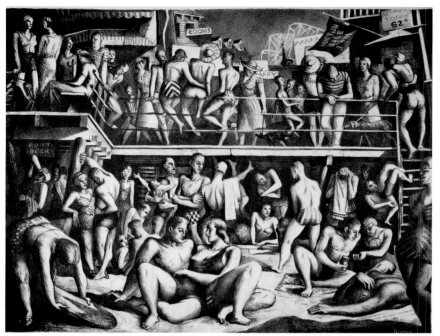

157

158

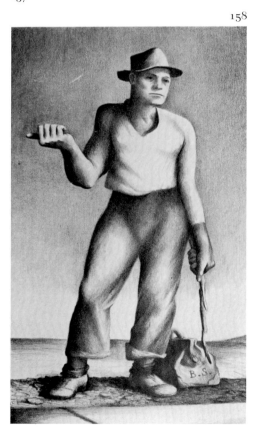

157. *The People Play—Summer*, 1938
Edition 40
35.2 × 45.7
(13⅞ × 18)
Black ink
Spruance lower right
Printed by Cuno?
PMA

158. *Vagrant*, 1938
Edition 35; 30
36.8 × 21.5
(14⁹⁄₁₆ × 8½)
Black ink
B.S. on carpetbag, lower right
Printed by Cuno?
FLP; PMA; NGA

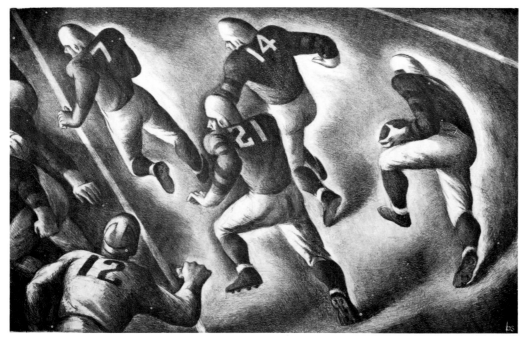

159

160

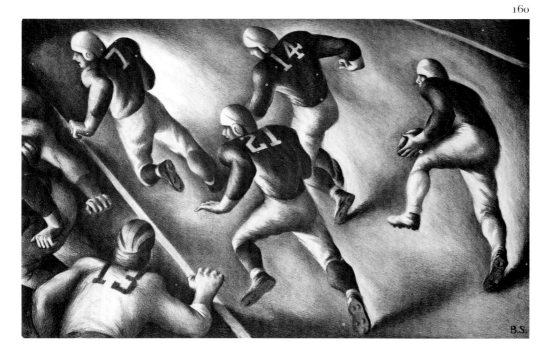

159. *The Backs Move In*, 1938
Edition unknown
30.9 × 47.9
(12³⁄₁₆ × 18⅞)
Black ink
bs lower right
Printed by Cuno?
FLP

160. *The Backs Move In*, 1938
Edition 40
30.5 × 47.5
(12 × 18⅝)
Black ink
B.S. lower right
Printed by Cuno?
PMA

Catalogue Raisonné
119

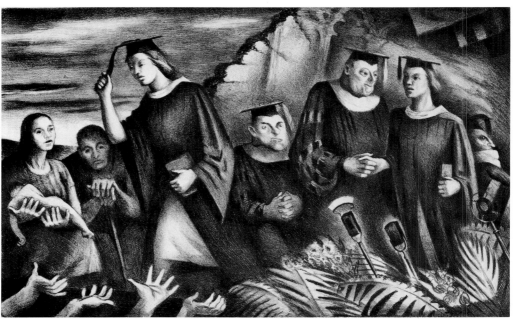

161

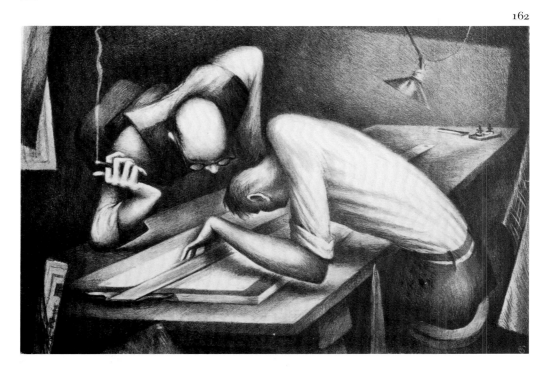

162

161. *Graduation—The 30s*, 1938
Edition 30
23.4 × 38.2
(9³⁄₁₆ × 15)
Black ink
Stone unsigned
Printed by Cuno?
PMA

162. *Plans for the Future*, 1939
Edition 30
25 × 36.5
(9⅞ × 14⅜)
Black ink
BS lower right
Printed by Cuno?
FLP; PMA

163

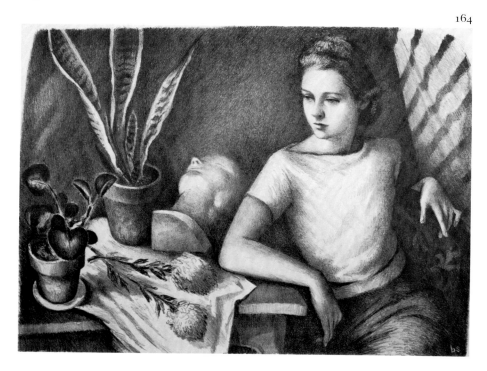

163. *Seated Nude*, 1939
Edition 25
36.5 × 26.5
(14⅜ × 10½)
Black ink
B.S. to C.H. lower right
Printed by Cuno?
FLP; PMA

164. *Figure with Still Life*, 1939
Edition 25
28.2 × 39.2
(11¼ × 15½)
Black ink
b.s. lower right
Printed by Cuno?
FLP; PMA; LC

Catalogue Raisonné
121

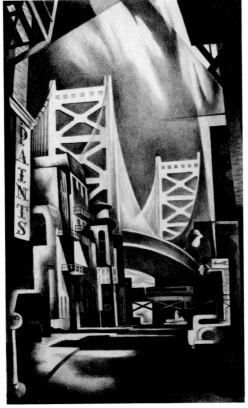

165

166

165. *The Bridge from Race Street*, 1939
Edition 30; 35
39 × 21.5
(15⁵⁄₁₆ × 8½)
Black ink
bs lower right
Printed by Cuno
PMA

166. *Girl with Pigtails*, 1939
Edition 20
41.6 × 22
(16⅜ × 8¾)
Black ink
Stone unsigned
Printed by Cuno?
FLP; PMA

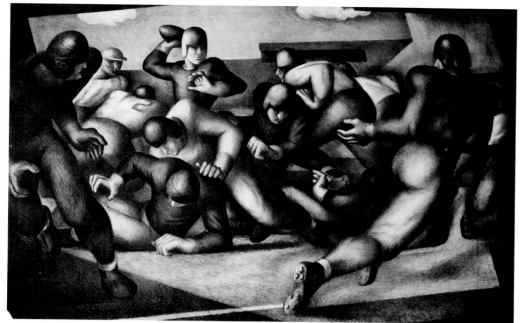

167

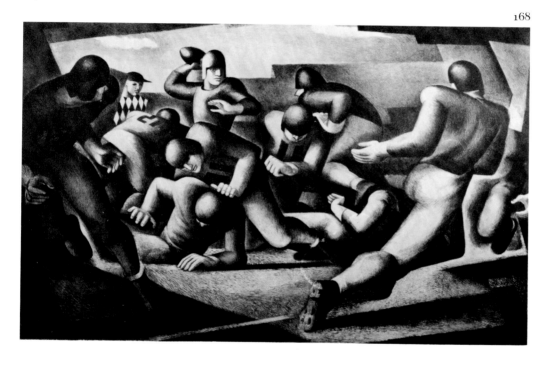

167. *Pass to the Flat*, 1939
Edition 45; 40
35.3 × 53.2
(13⅞ × 20⅞)
Black ink
BS lower right
Printed by Cuno
PMA

168. *Pass to the Flat*, 1939
Edition 50
35.3 × 55.6
(13⅞ × 21⅞)
Black ink
BS lower right
Printed by Cuno?
FLP; PMA

Catalogue Raisonné
123

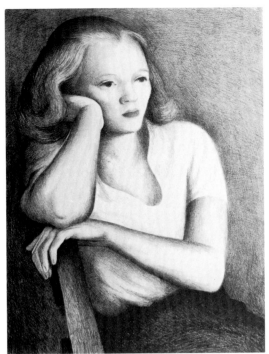

169

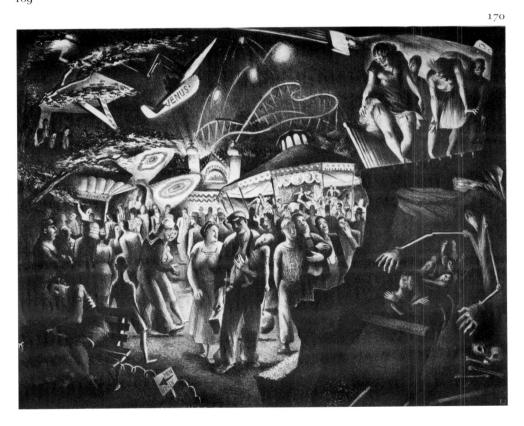

169. *Portrait of Mary*, 1939
Edition 20
29.5 × 21.4
(11⅝ × 8⁷⁄₁₆)
Black ink
Stone unsigned
Printed by Cuno?
FLP; PMA

170. *The People Play—Spring*, 1939
Edition 40
35.7 × 45.4
(14 × 17⅞)
Black ink
B.S. lower right
Printed by Cuno?
PMA

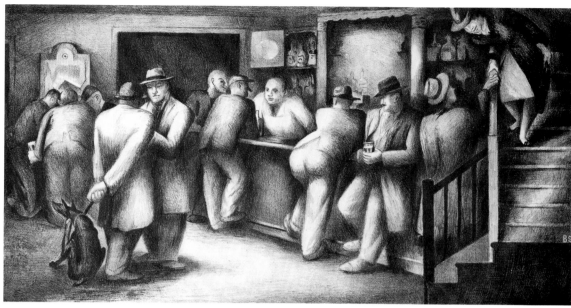

171

172

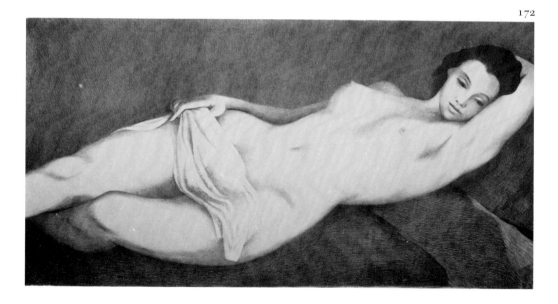

171. *The Bar at Doyles*, 1939
Edition 18
19.4 × 36.1
(7⅝ × 14³⁄₁₆)
Black ink
BS lower right
Printed by Cuno?
PMA

172. *Figure of a Woman*, 1939
Edition 25
22.5 × 41.9
(8⅞ × 16½)
Black ink
BS lower right
Printed by Cuno?
FLP; PMA

Catalogue Raisonné

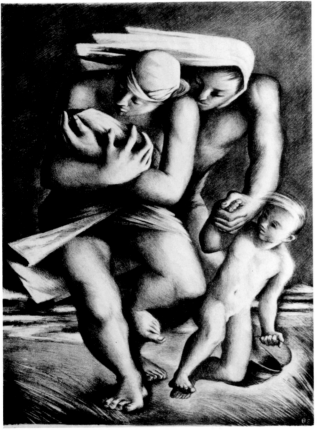

173

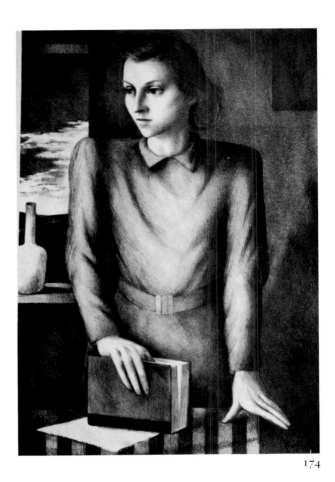

174

173. *Flight from the Beach*, 1939
Edition 35
34.9 × 24.4
(13¾ × 9⅝)
Black ink
BS lower right
Printed by Cuno?
FLP; PMA

174. *Portrait at Dusk*, 1939
Edition 20; 30
39.9 × 25.7
(15¾ × 10⅛)
Black ink
bs lower right
Printed by Cuno
FLP; PMA

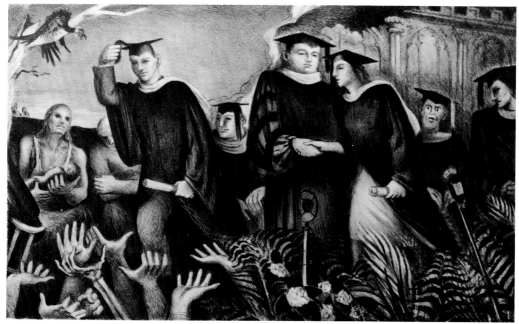

175

176

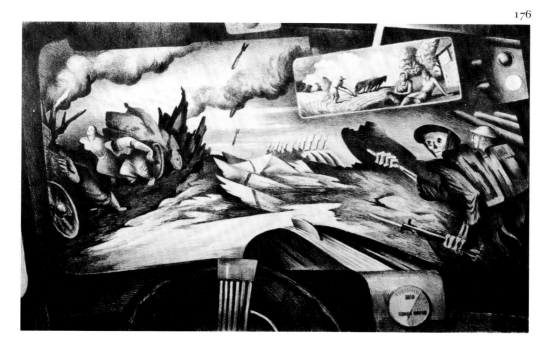

175. *The 30s—Graduation; The 1930s—*
 Graduation; The Thirties—Graduation,
 1939; 1938
Edition 35; 30
22.7 × 36.2
(9 × 14¼)
Black ink
bs lower right
Printed by Cuno?
PMA

176. *The 30s—Windshield; The 1930s—*
 Windshield; The Thirties—Windshield,
 1939
Edition 35; 30
22.7 × 36.2
(9 × 14¼)
Black ink
S lower right
Printed by Cuno
FLP; PMA

Catalogue Raisonné

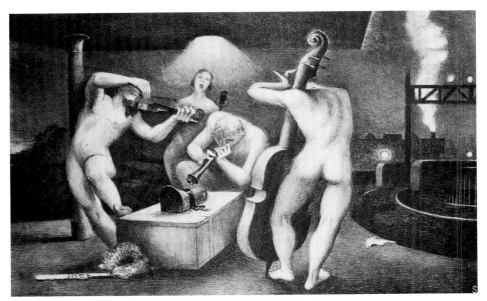

177

178

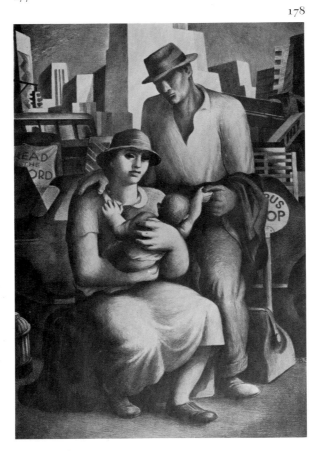

177. *The 30s—Requiem; The 1930s—*
 Requiem; The Thirties—Requiem,
 1939
Edition 35
22.4 × 35.5
(8¹³⁄₁₆ × 14)
Black ink
S lower right
Printed by Cuno?
PMA

178. *Repose in Egypt*, 1940
Edition 30
38.6 × 25.6
(15¼ × 10⅛)
Two colors (tan and black)
BS lower right
Printed by Cuno?
FLP; PMA

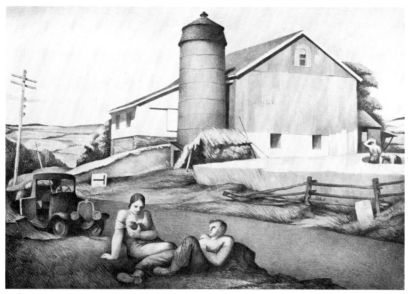

179

180

179. *Landscape with Figures*, 1940
Edition 30; 35
25.1 × 34
(9⅞ × 13⅜)
Black ink
B.S/1940 lower right
Printed by Cuno?
FLP; PMA; LC

180. *Girl with Hands to Face*, 1940
Edition 30
40.4 × 25.5
(15¹⁵⁄₁₆ × 10¹⁄₁₆)
Two colors (tan and black)
Stone unsigned
Printed by Cuno?
FLP; PMA; LC

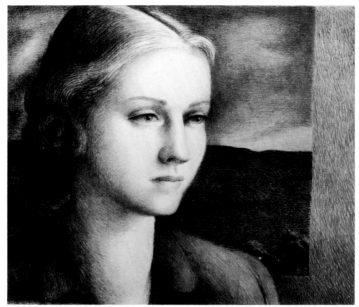

181

182

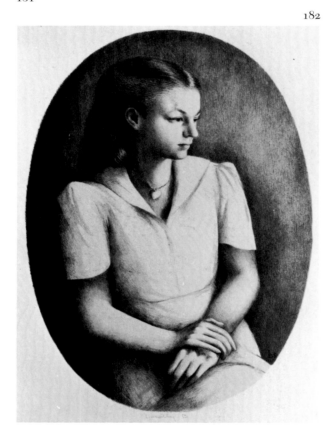

181. *Portrait*, 1940
Edition 20
20.9 × 25
(8¼ × 8⅞)
Two colors (tan and black)
BS lower right
Printed by Cuno?
FLP; PMA

182. *Portrait of Dorothy B.*; *Portrait*; *Portrait
 of Dorothy*; *Dorothy Berner*, 1940
Edition unknown
38.8 × 27.3 oval
(15¼ × 10¾) oval
Two colors (tan and black); also impressions
 of black stone alone
b.s. lower right
Printed by Cuno?
PMA

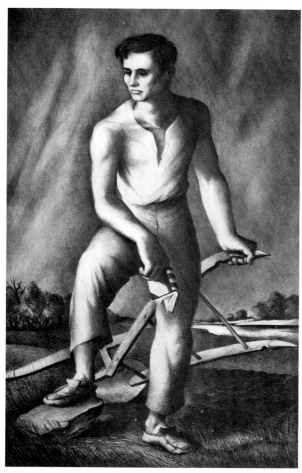

183

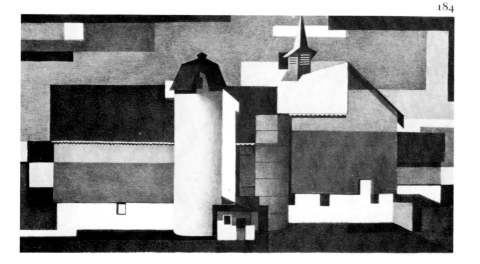

184

183. *Young Lincoln*, 1940
Edition 50
46.3 × 29
(18¼ × 11⁷⁄₁₆)
Two colors (tan and black); also impressions
 of black stone alone
BS lower right
Printed by Cuno?
FLP; PMA

184. *American Pattern—Barn*, 1940
Edition 45
19.4 × 35.5
(7⅜ × 14)
Two colors (tan and black)
BS lower right
Printed by Cuno
FLP; PMA

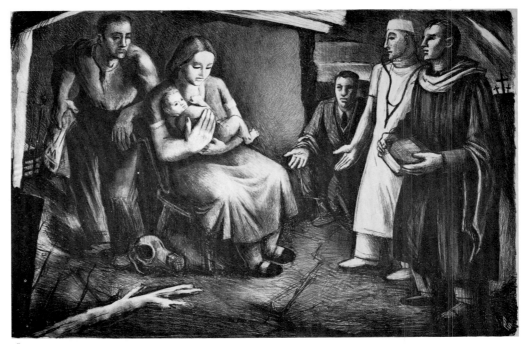

185

186

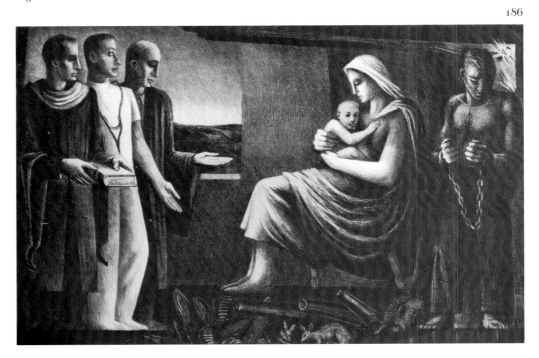

185. *Gifts from the Kings*, 1940
Edition unknown
26.7 × 40.4
(10½ × 15⅞)
Black ink
BS lower right
Printed by Cuno
PMA
Note: The PMA impression is inscribed by Spruance
 "first version"; proof of subject by another artist is
 on the verso.

186. *Gifts from the Kings*, 1940; 1941
Edition 30
21.8 × 34
(8⅝ × 13⅜)
Two colors (tan and black)
BS. lower right
Printed by Cuno
FLP; PMA

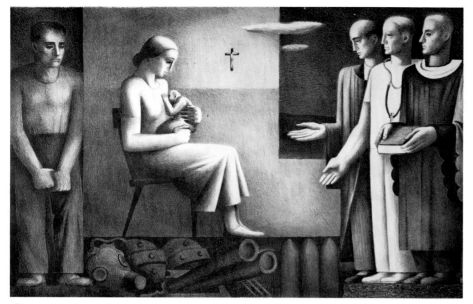

187

188

187. *Gifts from the Kings*, 1940
Edition 30
22.2 × 34.7
(8¾ × 13⅝)
Black ink
BS lower right
Printed by Cuno?
FLP; PMA

188. *Portrait—Jean Stewart*, 1941
Edition 30
37.7 × 20.3
(13¹³⁄₁₆ × 8)
Two colors (tan and black)
BS lower right; *JS* lower left
Printed by Cuno?
PMA

Catalogue Raisonné

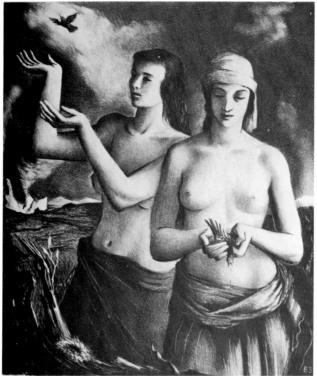

189

190

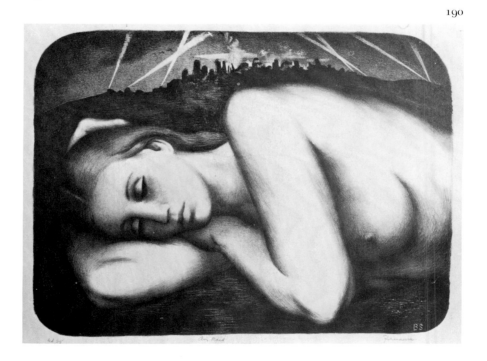

189. *Brief Balance*, 1941
Edition 30; 35
36.6 × 29.4
(14½ × 11⁹⁄₁₆)
Black ink
BS lower right
Printed by Cuno?
FLP; PMA

190. *Air Raid*, 1941
Edition 25
22.6 × 30.4
(8⅞ × 12)
Black ink
BS lower right
Printed by Cuno?
FLP; PMA

Note: Fletcher notes two states; only one has been
 located by the present cataloguers.

191

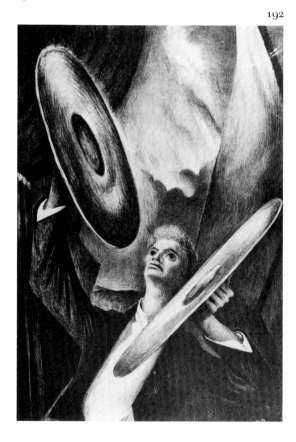

191. *Arrangement for Drums*, 1941
Edition 30; 40
23.9 × 37.3
(9⅜ × 14⅝)
Two colors (tan and black)
Stone unsigned
Printed by Cuno
FLP; PMA (with related drawings)

192. *Opening Note*, 1941
Edition 25; 30
32.5 × 20.5
(12⅞ × 8⅛)
Black ink
BS lower right
Printed by Cuno?
FLP; PMA (with related drawings)

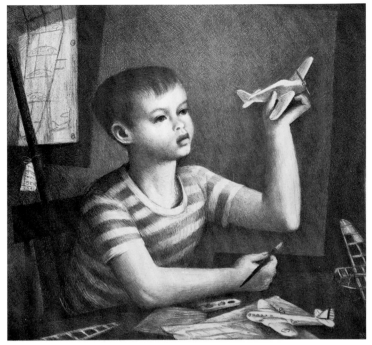

193

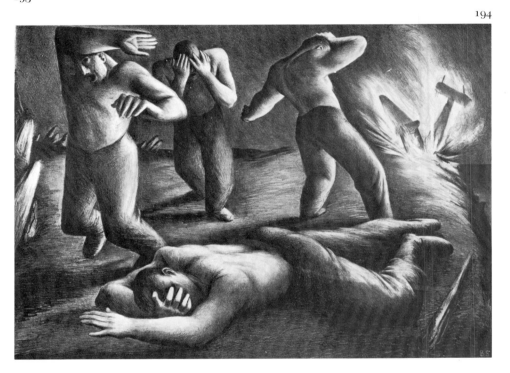

194

193. *Portrait of Toby*, 1941
Edition 25
32.6 × 33.2
(12⅞ × 13⅛)
Black ink
BS lower right
Printed by Cuno?
PMA

194. *The Conversion of Paul; Paul's Conversion; The Conversion*, 1941
Edition 35
29.1 × 39.8
(11½ × 15¾)
Black ink
BS lower right
Printed by Cuno?
FLP; PMA
Note: The PMA impression is inscribed "1st state," but presumably means first version.

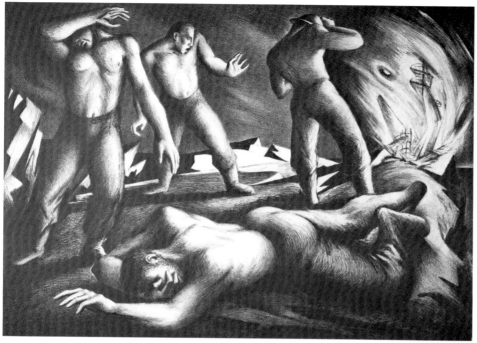

195

196

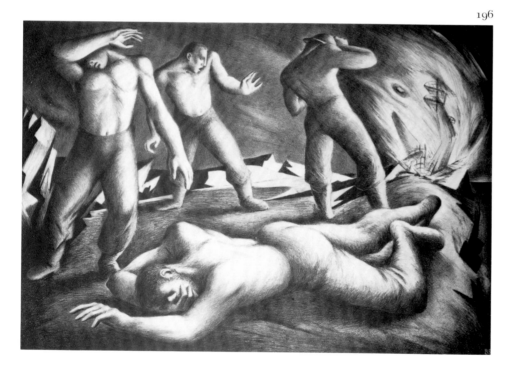

195. *The Conversion of Paul; Paul's
 Conversion; The Conversion*, 1941; 1942
Edition 30
29.5 × 40
(11½ × 15¾)
Black ink
BS lower right
Printed by Cuno?
PMA

196. *The Conversion of Paul; Paul's
 Conversion; The Conversion*, 1941
Edition 30
29.1 × 40
(11½ × 15¾)
Two colors (tan and black)
BS lower right
Printed by Cuno?
FLP

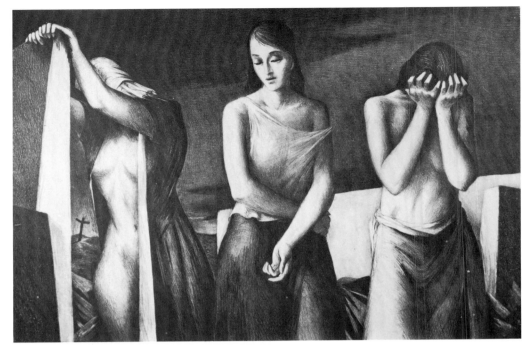

197

198

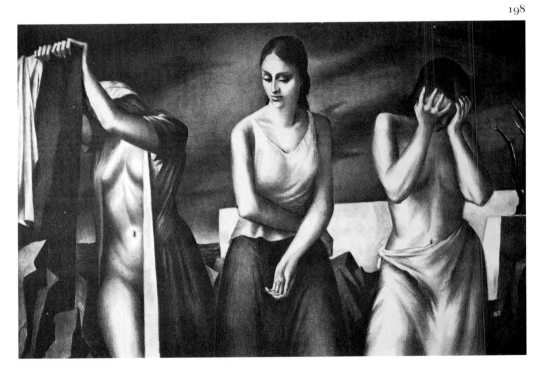

197. *The Lamentation*, 1941
Edition 40
31.8 × 46.5
(12⅛ × 18⁵⁄₁₆)
Black ink
BS lower right
Printed by Cuno?
PMA

198. *The Lamentation*, 1941
Edition 35
31.3 × 46.2
(12¼ × 18⅛)
Black ink
BS lower right
Printed by Cuno?
PMA

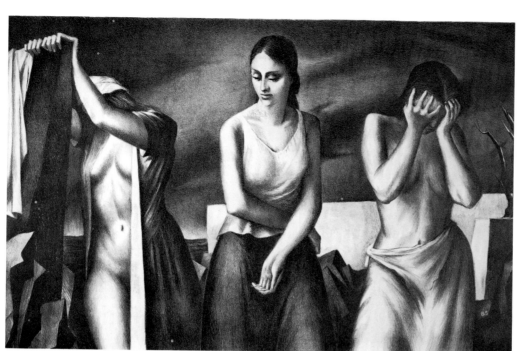

199

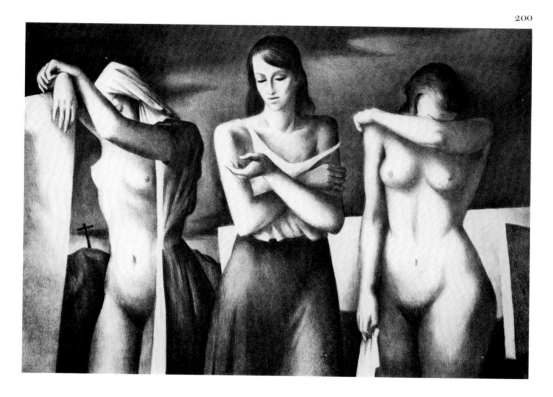

199. *The Lamentation*, 1941
Edition 40
31.3 × 46
(12⅜ × 18⁵⁄₁₆)
Black ink
BS lower right
Printed by Cuno?
FLP; PMA

200. *The Lamentation*, 1941
Edition unknown
32.5 × 46
(12¾ × 18⅛)
Two colors (tan and black)
B.S. lower right
Printed by Cuno?
PMA

Catalogue Raisonné
139

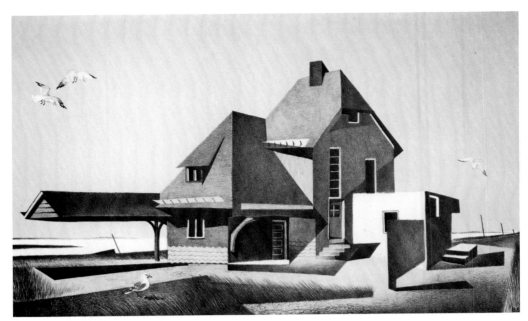

201

202

201. *Last Stop—Beach Haven*, 1941
Edition 30
23 × 38.4
(9 × 15³⁄₁₆)
Two colors (light green and black)
BS lower right
Printed by Cuno?
PMA

202. *Democracy; Democracy—Warn the Disunited*, 1941
Edition 30; 40
52.6 × 35.2
(20¾ × 13⅞)
Black ink
B.S. lower right
Printed by Cuno?
FLP; PMA

203

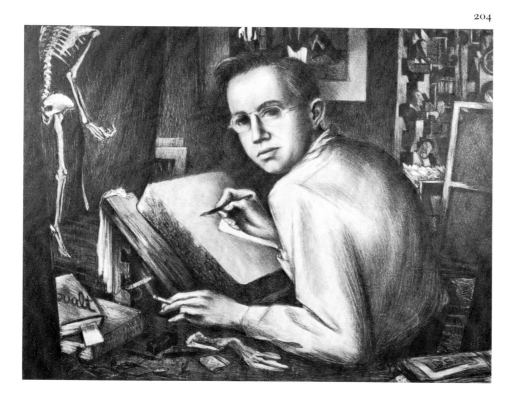

204

203. *Warn the Disunited*, 1942
Edition 30
30.8 × 46
(12⅛ × 18⅛)
Black ink
Stone unsigned
Printed by Cuno?
FLP

204. *Portrait of the Artist as Model; Self
 Portrait at Stone; The Artist as Model;
 Artist at Stone*, 1942
Edition 25; 35
28.8 × 37
(11⅜ × 14⁹⁄₁₆)
Black ink
BS lower right
Printed by Cuno?
FLP; PMA

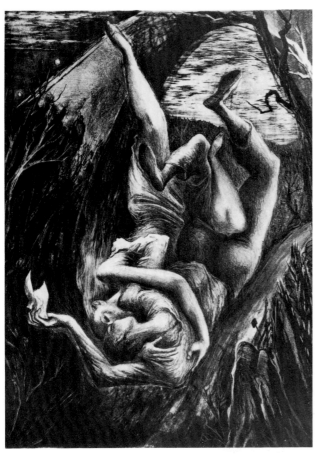

205

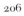

205. *Farewell in the Dawn*, 1942
Edition 30; 35
37.7 × 25.6
(14⅞ × 10⅛)
Black ink
Spruance lower right
Printed by Cuno?
FLP; PMA

206. *The Lovers*, 1942
Edition 40
38.8 × 25.7
(15⁵⁄₁₆ × 10)
Black ink
S in box and *BS* lower right
Printed by Cuno?
FLP

The Prints of Benton
Murdoch Spruance

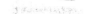

207

208

The Credo Triptych
A series of three lithographs (cat. nos. 207, 209, 211)

207. *Credo 1: The Rescue*, 1942
Edition 35
40.5 × 23.4
(15¹⁵⁄₁₆ × 9¼)
Black ink
Stone unsigned
Printed by Cuno?
FLP; PMA

208. *Credo 2: The Resurrection*, 1942
Edition unknown
43.7 × 27.5
(17¼ × 10¾)
Black ink
To/CZ/B.S. lower right
Printed by Cuno?
PMA

Catalogue Raisonné
143

209

210

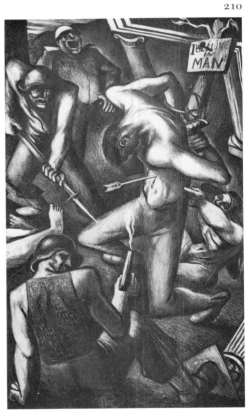

209. *Credo 2: The Resurrection,* 1942
Edition 35; 30
43.3 × 27.1
(17¹⁄₁₆ × 10⅛)
Black ink
To C.Z./B.S. lower right
Printed by Cuno?
FLP; PMA

210. *The People's War; Credo 3: I Believe in Man,* 1942
Edition unknown
40.6 × 23.4
(16 × 9³⁄₁₆)
Black ink
BS lower right
Printed by Cuno?
PMA
Note: The PMA impression is inscribed "1st version—rejected" by Spruance.

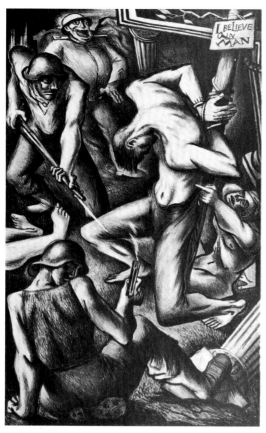

211

212

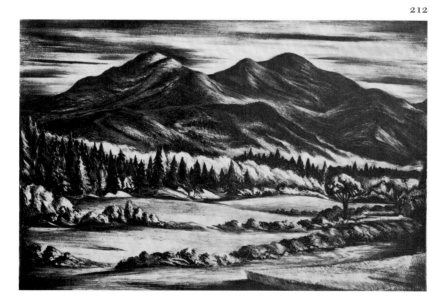

211. *Credo 3: I Believe in Man*, 1942
Edition 35; 30
40.4 × 23.1
(15⅞ × 9⅛)
Black ink
Stone unsigned
Printed by Cuno?
FLP; PMA

212. *The Adirondacks—The Sentinels*, 1942
Edition 30
25.1 × 36
(9¹⁵⁄₁₆ × 14¼)
Black ink
BS lower right
Printed by Cuno?
FLP; PMA

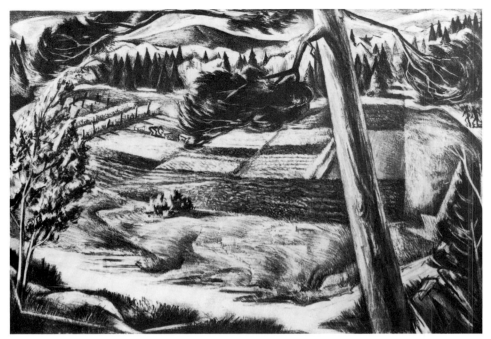

213

214

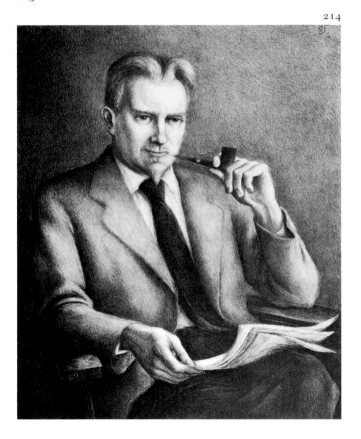

213. *Adirondacks Garden*, 1942
Edition unknown
27.4 × 38.1
(10¹³⁄₁₆ × 15¼)
Black ink
BS lower right
Printed by Cuno?
FLP

214. *Carl Zigrosser*, 1942
Edition 30; 35
36.7 × 28.6
(14½ × 11⁵⁄₁₆)
Black ink
BS upper right
Printed by Cuno?
FLP; PMA

215

216

215. *The Artist as Model*, 1942
Edition 25
27.8 × 19.4
(11⅛ × 7¹¹/₁₆)
Black ink
BS lower right
Printed by Cuno?
FLP; PMA

216. *Souvenir of Lidice*, 1943
Edition 35
30.8 × 46.6
(12⅛ × 18⅜)
Black ink
BS lower right
Printed by Cuno
FLP; PMA; LC

Catalogue Raisonné
147

217

218

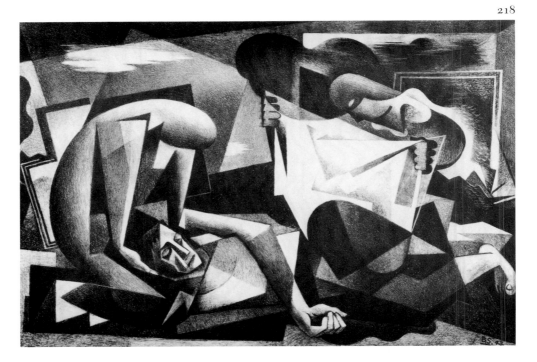

217. *Portrait of Henri Marceau*, 1943
Edition 35; 25; 30
28.3 × 41.2
(11⅛ × 6¼)
Black ink
BS lower right
Printed by Cuno?
FLP; PMA

218. *From the Sea*, 1943
Edition unknown
27.8 × 40.9
(10¾ × 16⅛)
Black ink
B.S. 43. lower right
Printed by Cuno?
Beaver College (Eunice Leopold Collection)
Note: The only known impression is inscribed "Trial"
by Mrs. Spruance.

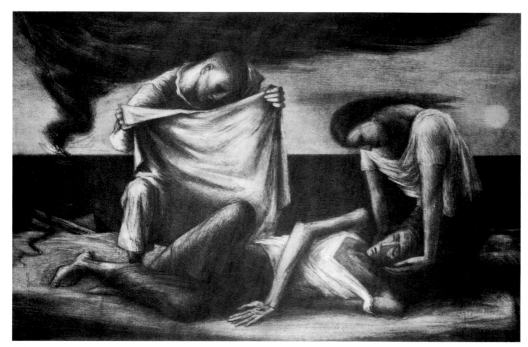

219

220

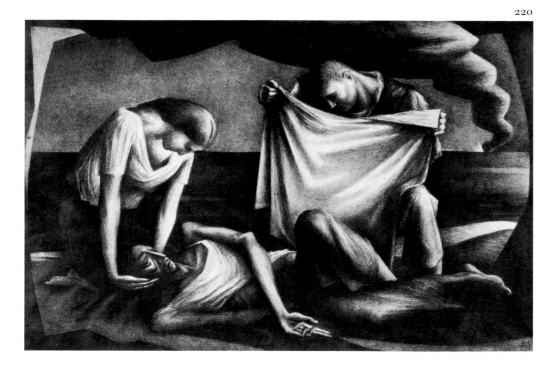

219. *From the Sea*, 1943
Edition unknown
26.1 × 38.4
(10¼ × 15⅛)
Black ink
BS lower right
Printed by Cuno?
FLP

220. *From the Sea; From the Sea—Pieta*, 1943
Edition 35; 30
25.6 × 38.4
(10⅛ × 15⅛)
Black ink
BS lower right
Printed by Cuno?
FLP; PMA

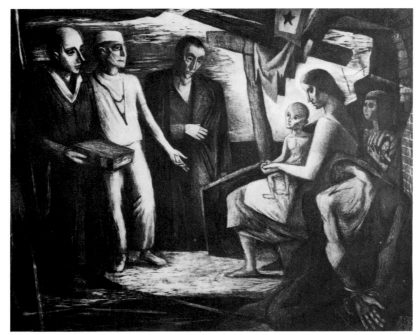

221

222

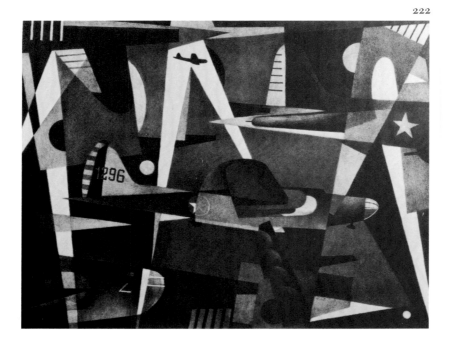

221. *The Epiphany; Where Is He That Is Born
 King?* 1943
Edition 35; 30
30.2 × 36.9
(11⅞ × 14½)
Black ink
BS/43 lower right
Printed by Cuno?
FLP; PMA
Note: The print is known in two states; the impres-
 sion in PMA, inscribed "first state" by Spruance,
 shows the area at right, surrounding the child with
 a doll, as much lighter, with a brushstroke-like
 surface.

222. *Riders of the Apocalypse,* 1943
Edition 35
32.2 × 41.6
(12¹¹⁄₁₆ × 16⅜)
Black ink
BS lower left
Printed by Cuno
FLP; PMA

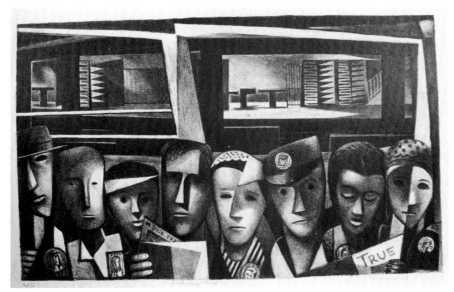

223

224

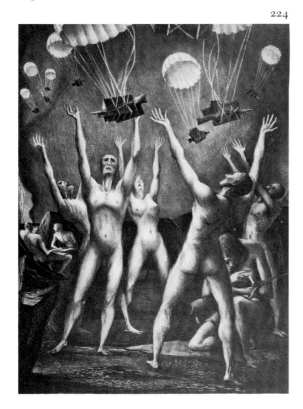

223. *Subway Shift; The Second Front*, 1943
Edition 35; 30
25.8 × 41.2
(10³⁄₁₆ × 16¼)
Black ink
BS lower right
Printed by Cuno?
FLP; PMA

224. *Deliverance*, 1943
Edition 10
40.4 × 28.4
(15¹⁵⁄₁₆ × 11³⁄₁₆)
Black ink
S lower right
Printed by Cuno?
FLP; PMA

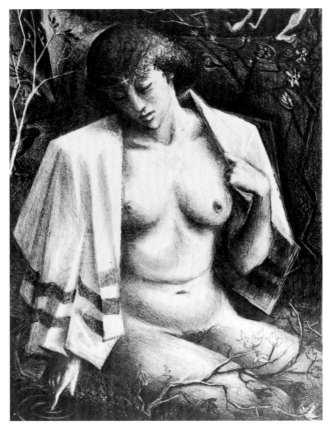

225

226

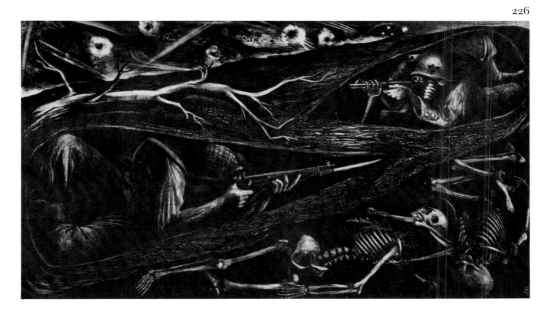

225. *Susanna and the Elders*, 1943
Edition 25
29.9 × 20.8
(11⅞ × 8¼)
Black ink
S lower right
Printed by Cuno?
FLP; PMA

226. *Fathers and Sons*, 1943
Edition 40
28.4 × 51.3
(11⅛ × 20³/₁₆)
Black ink
BS 43 lower right
Printed by Cuno
FLP; PMA; BPL

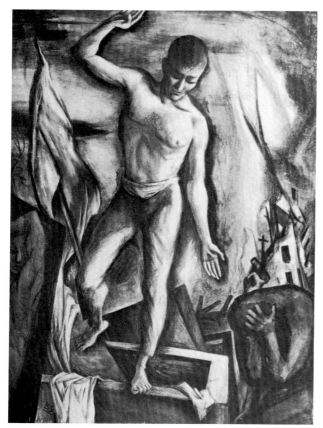

227

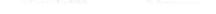

228

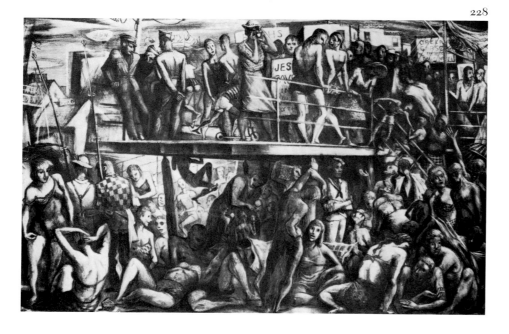

227. *Resurrection*, 1944
Edition 32; 35
47.6 × 33.6
(18¾ × 13¼)
Black ink
BS lower left
Printed by Cuno?
FLP; PMA

228. *The People Play—Summer*, 1944
Edition 40; 50
33 × 50
(13 × 19¹¹⁄₁₆)
Black ink
BS lower right
Printed by Cuno?
FLP; PMA

Catalogue Raisonné
153

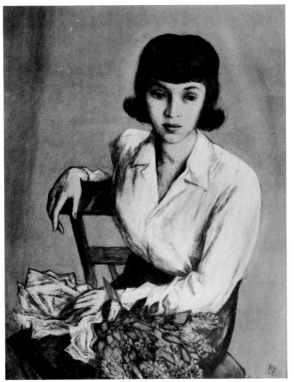

229

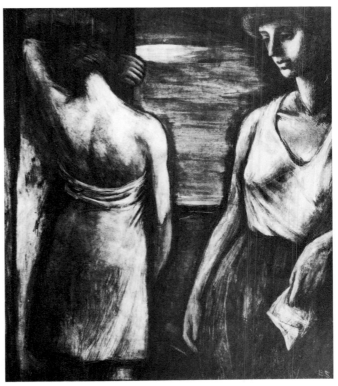

230

229. *Portrait—Miss M.H.*, 1944
Edition 30
43.9 × 31.4
(17⁵⁄₁₆ × 12⅜)
Five colors (green, light blue-violet, light
 orange, yellow, black)
BS/44 lower right
Printed by Cuno?
FLP (with related proof material); PMA (with
 related proof material)

230. *End of Waiting*, 1944
Edition 30; 25
36.1 × 30.6
(14¼ × 12⅙)
Black ink
BS/44 lower right
Printed by Cuno?
FLP; PMA

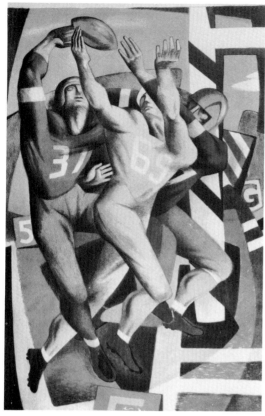

231

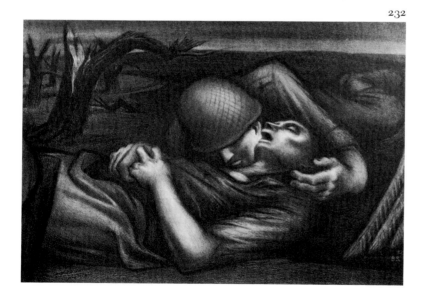

232

231. *Forward Pass; Football*, 1944
Edition 35
51 × 31.6
(20¹⁄₁₆ × 12½)
Five colors (tan, green, yellow, orange, black)
Stone unsigned
Printed by Cuno
FLP; PMA (with related proof material)
See color plate, frontispiece
Note: Fletcher notes an edition printed in black
 ink; no such impression has been located by the
 present cataloguers.

232. *Soldier and Chaplain; Untitled*, 1944
Edition 35; 40
31.4 × 44.3
(12³⁄₈ × 17½)
Black ink
44/BS lower right
Printed by Cuno?
FLP; PMA

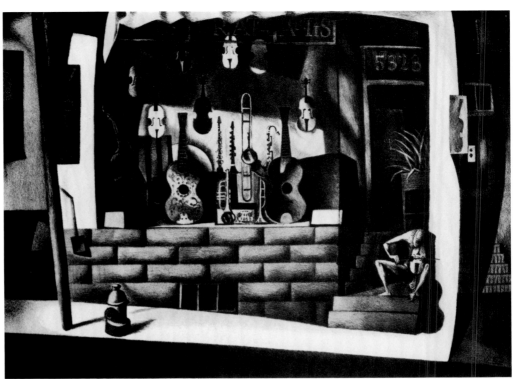

233

234

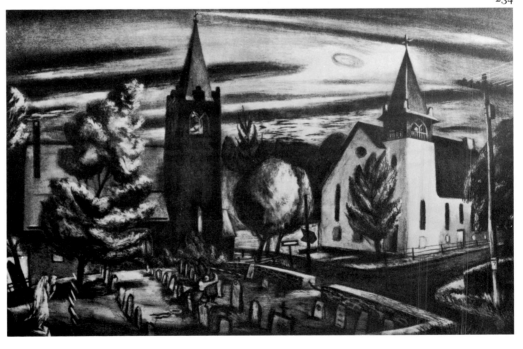

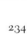

233. *Nero*, 1944
Edition 35
29.5 × 39.1
(11⅝ × 15⅜)
Two colors (tan and black); also impressions of
　black stone alone
BS lower right
Printed by Cuno?
FLP; PMA; NGA

234. *Ridge Valley Churches*, 1944
Edition 30
31.7 × 47
(12½ × 18½)
Black ink
Stone unsigned
Printed by Cuno?
FLP

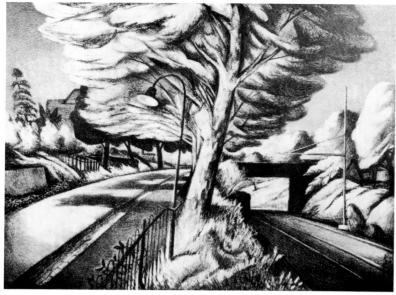

235

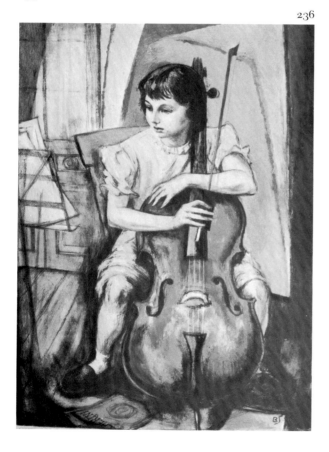

235. *Tulpehocken Road*, 1944
Edition 30; 35
30.5 × 40.6
(12 × 16)
Black ink
BS lower right
Printed by Cuno?
FLP; PMA

236. *Sonia and Her Cello*; *Sonia Fogg*, 1944;
 1945
Edition 30
50.3 × 34.3
(19 × 13½)
Six colors (two browns, yellow, blue-gray, light
 orange, brown-red)
BS lower right
Printed by Cuno?
FLP; PMA (with related proof material)

237

237. *Dead Little Bird; Little Dead Bird; Blue Jay*, 1945
Edition 20; 25
20 × 31.2
(7⅞ × 12¼)
Black ink
Stone unsigned
Printed by Cuno?
FLP; PMA

238. *Kim and Art; Miss Kim Sutro; Miss Kim Sutro—and Art*, 1945
Edition 50; 40
37 × 45.6
(14⅜ × 18)
Six colors (yellow, tan, green, pink, brown-red, black)
BS lower right
Printed by Cuno
FLP; PMA (with related proof material)

239

240

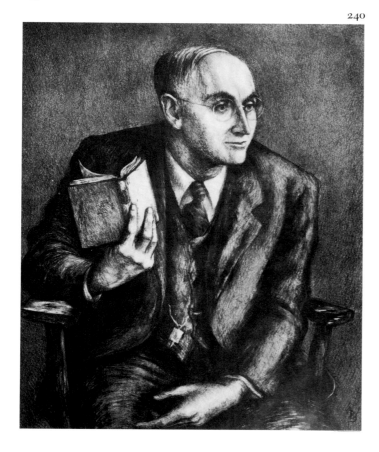

239. *Portrait—William Coale, Esq.*, 1945
Edition 25; 30
30.4 × 44.6
(12 × 17⅝)
Black ink
Stone unsigned
Printed by Cuno?
FLP; PMA

240. *Irvin Poley, Esq.—Man Reading a Play;*
 Man Reading a Play, 1945
Edition 25
41.2 × 34
(16¼ × 13⅜)
Black ink
BS lower right
Printed by Cuno?
FLP; PMA

241

242

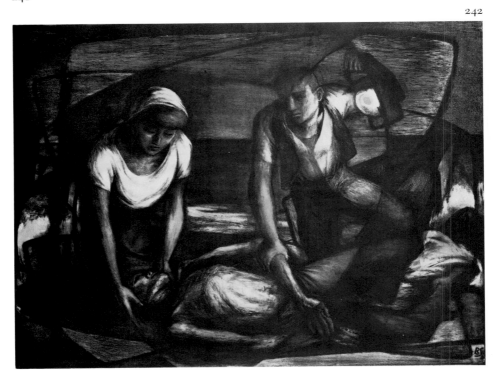

241. *A Wind Is Rising and the Rivers Flow,*
 1945
 Edition 30; 40
 36.4 × 48.8
 (14⅜ × 19¼)
 Black ink
 BS lower right
 Printed by Cuno?
 FLP; PMA

242. *A Wind Is Rising and the Rivers Flow,*
 1945
 Edition 40
 36.8 × 48.7
 (14½ × 19⅜)
 Six colors (two blues, yellow, orange, brown-
 red, black)
 BS lower right
 Printed by Cuno
 FLP; PMA; NGA

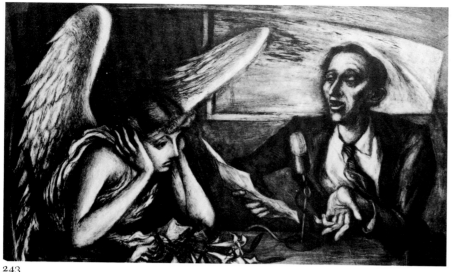

243

244

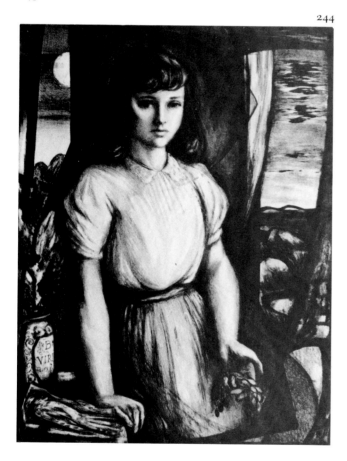

243. *Annunciation*, 1945
Edition 35
23.8 × 40.1
(9⅜ × 15¾)
Black ink
BS lower right
Printed by Cuno
FLP

Ecclesiastes
A series of five lithographs (cat. nos. 244–48)

244. *Ecclesiastes: Essay V (Return to the
 Earth)*, 1945
Edition 35
44.3 × 32.2
(17⅝ × 12¾)
Black ink
Stone unsigned
Printed by Cuno
PMA

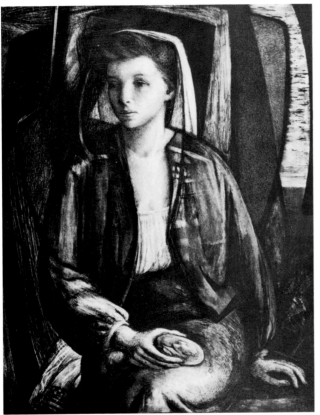

245

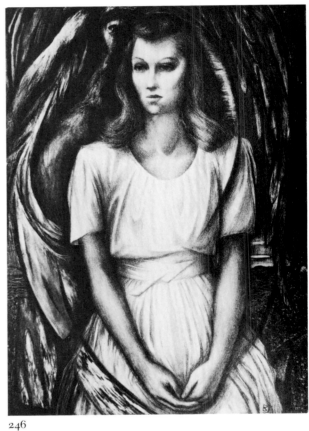

246

245. *Ecclesiastes: Essay I (Vanity and a
 Striving)*, 1945; 1946
Edition 30
46 × 33.7
(18⅛ × 13¼)
Black ink
BS lower right
Printed by Cuno
FLP; PMA

246. *Ecclesiastes: Essay II (For Everything
 There Is a Season)*, 1945; 1946
Edition 30
45.5 × 32.7
(18 × 12⅞)
Black ink
BS lower right
Printed by Cuno
FLP; PMA

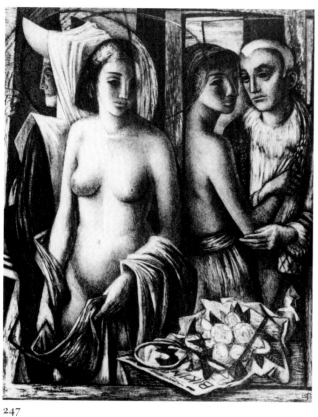

247

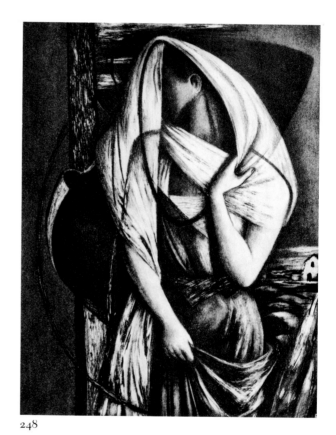

248

247. *Ecclesiastes: Essay III (There Is an Evil Which I Have Seen)*, 1946
Edition 40; 35
48.8 × 37
(19¼ × 14½)
Black ink
BS lower right
Printed by Cuno?
FLP; PMA

248. *Ecclesiastes: Essay IV*, 1946; 1945; 1947
Edition 40
44.8 × 32.3
(17⅝ × 12¾)
Black ink
BS lower right
Printed by Cuno
FLP; PMA

Catalogue Raisonné
163

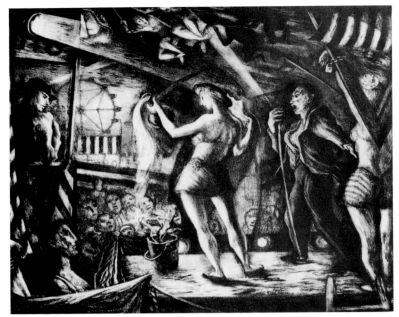

249

250

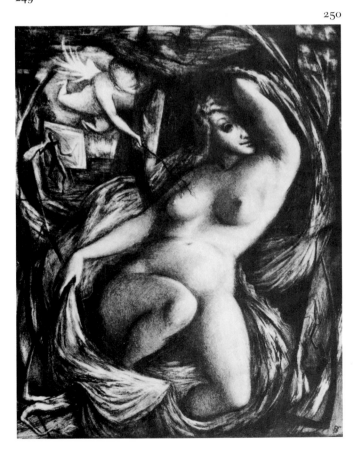

249. *Midsummer Spiel*, 1946
Edition 35; 30
34.5 × 44
(13⅝ × 17¼)
Black ink
BS lower right
Printed by Cuno?
FLP; PMA

250. *Venus—Awake!*, 1946
Edition 35; 30
43.7 × 33
(17¼ × 13¼)
Black ink
BS lower right
Printed by Cuno
FLP; PMA

The Prints of Benton
Murdoch Spruance
164

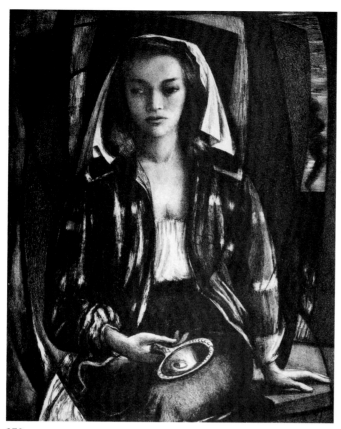

251

252

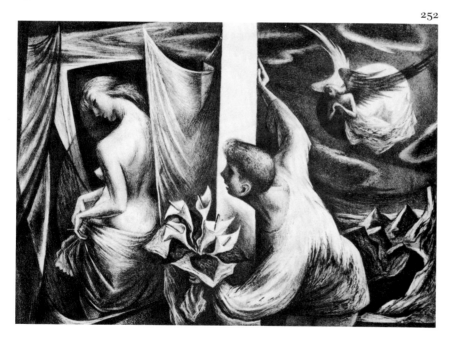

251. *Ecclesiastes: Essay I,* 1947
Edition 40; 35
44.7 × 33.4
(17½ × 13⅛)
Black ink
Stone unsigned
Printed by Cuno
PMA

252. *Dream of Love,* 1947
Edition 30; 35
31.6 × 43.5
(12⁷⁄₁₆ × 17)
Black ink
Stone unsigned
Printed by Cuno?
FLP; PMA

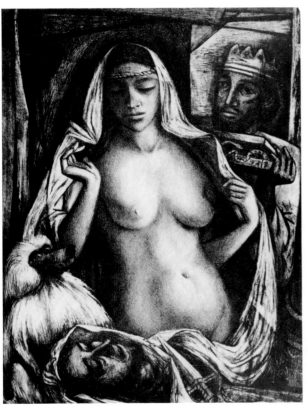

253

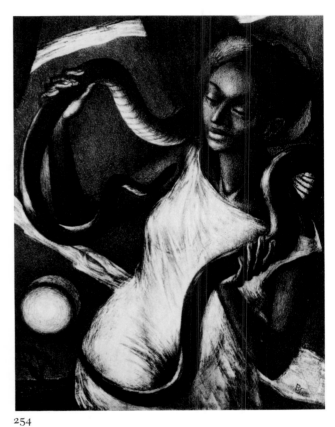

254

253. *Gift for Salome; Salome and John*, 1947
Edition 35; 40
44.7 × 31.5
(17¹¹⁄₁₆ × 12½)
Black ink
Stone unsigned
Printed by Cuno?
FLP; PMA

254. *Night in Eden*, 1947
Edition 35
41 × 31.2
(16⅛ × 12¼)
Black ink
BS lower right
Printed by Cuno?
FLP

Note: The subject is Mabel Turner, a housekeeper for
the Spruances and for lithographer Robert Riggs,
their neighbor, who kept numerous snakes as pets.

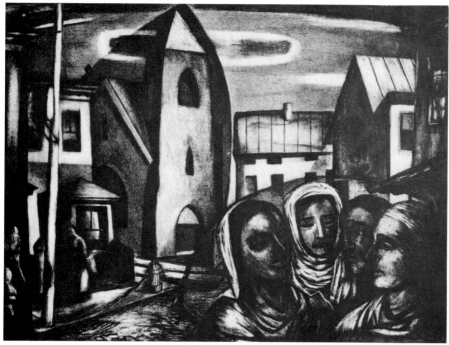

255

256

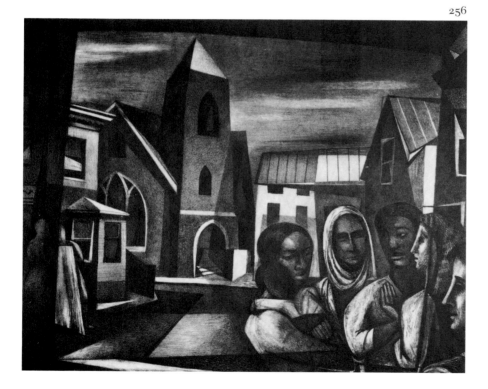

255. *The Women in Front of Their Houses,*
 1947; 1946
Edition unknown
32.8 × 42.3
(12 15/16 × 16¾)
Black ink
Stone unsigned
Printed by Cuno?
FLP

256. *The Women in Front of Their Houses,*
 1947
Edition unknown
33 × 39.4
(13 × 15½)
Black ink
BS lower right
Printed by Cuno?
FLP

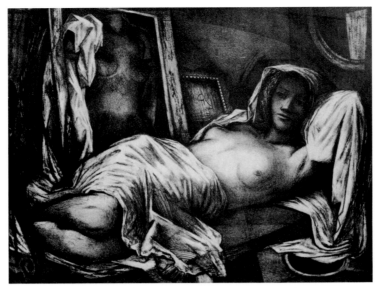

257

258

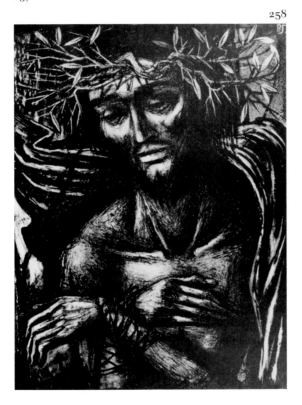

257. *Figure with Mirrors*, 1947
Edition 25
35.6 × 46.8
(14 1/16 × 18 1/2)
Black ink
Stone unsigned
Printed by Cuno?
FLP; PMA

258. *Behold the Man*, 1947
Edition 30; 35
35.9 × 25.5
(14 1/8 × 10 1/16)
Black ink
BS upper right
Printed by Cuno?
FLP; PMA

259

260

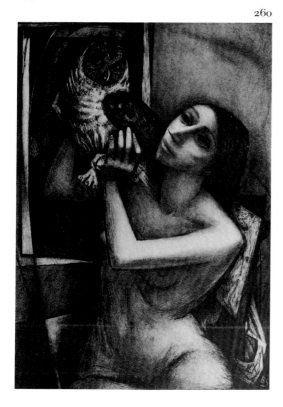

259. *String Quartet*, 1947
Edition 10
34.4 × 49.6
(13½ × 19⅝)
Black ink
Stone unsigned
Printed by Cuno?
FLP

Note: The print is known in two states: a first state
 (private collection) was made prior to the additions
 of the rhythmic line, which establishes the oval-
 shaped enclosure in the central background, and
 the shading above it; Fletcher notes this as a color
 print: no impression in color has been located by
 the present cataloguers.

260. *Eyes for the Night*, 1947
Edition 35; 40
48.3 × 32.3
(19 × 12¾)
Black ink
BS lower right
Printed by Cuno
FLP; PMA

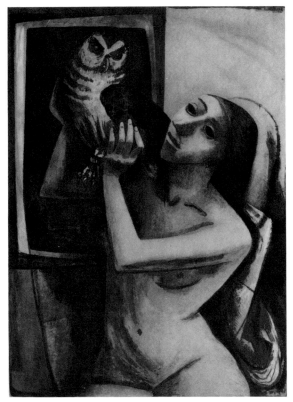

261

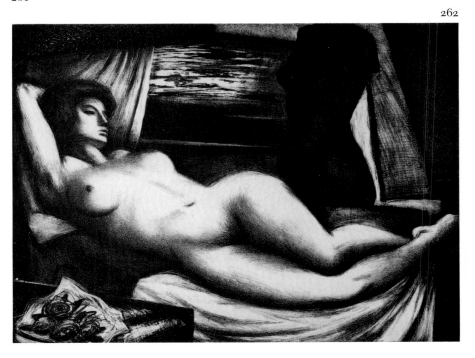

261. *Eyes for the Night*, 1948; 1947
Edition 35
48.2 × 32.6
(19 × 12⅞)
Four colors (light orange, tan, brown, green)
Stone unsigned
Printed by Cuno
FLP; PMA (with related proof material); BPL; LC

262. (Reclining nude with flowers);
 Narcissa? 1948?
Edition unknown
26.5 × 39.2
(10⅜ × 15½)
Black ink
BS lower right
Printed by Cuno?
PMA

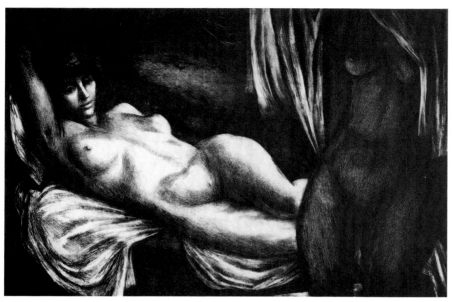

263

264

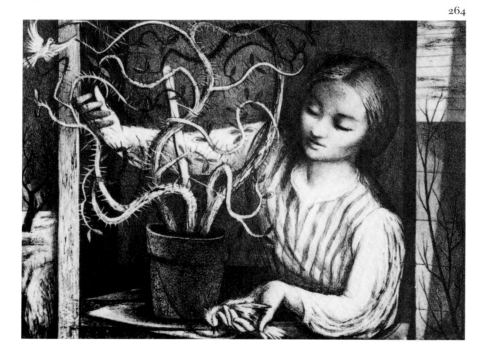

263. (Reclining nude with torso); *Narcissa?*
　1948?
Edition unknown
26.8 × 36.7
(10½ × 14⅜)
Black ink
BS lower right
Printed by Cuno?
PMA

264. *No Home for a Bird*, 1948
Edition 30
32.5 × 44.4
(12⅞ × 17½)
Black ink
BS upper right
Printed by Cuno?
FLP

265

266

265. *Asylum*, 1948
Edition 30; 35
39.2 × 33.3
(15½ × 13⅛)
Black ink
BS lower right
Printed by Cuno?
FLP; PMA

266. *World of One's Own*, 1948
Edition 30; 35
34.5 × 44.7
(13⅝ × 17⅝)
Black ink
BS lower right
Printed by Cuno?
FLP; PMA

267

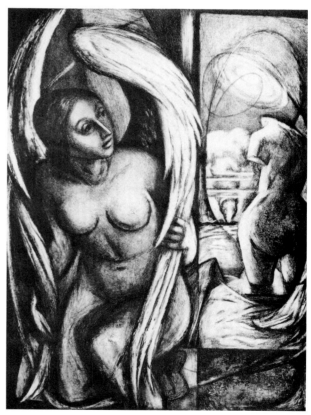

268

267. *Adolescent—Mary Sturgeon*, 1948
Edition 30
45 × 32.7
(17¾ × 12⅞)
Four colors (yellow, light orange, ochre, black);
 also impressions of black stone alone
BS lower right
Printed by Cuno?
FLP

268. *Lot's Wife*, 1948
Edition 35
48.3 × 35.1
(19¼ × 14 1/16)
Black ink
BS lower right
Printed by Cuno?
FLP

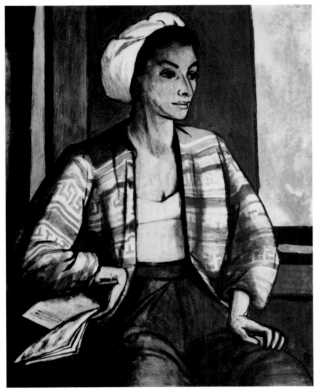

269

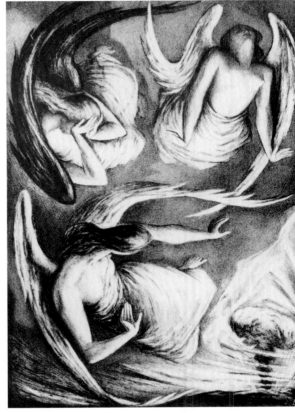

270

269. *Jeanne in a Seminole Blouse*, 1948
Edition unknown
48 × 37.5
(19 × 14¾)
Two colors (tan and black)
BS lower right
Printed by Cuno?
NGA (hand colored)

270. *Havoc in Heaven*, 1948
Edition 30; 35
47.5 × 32.9
(18¹¹⁄₁₆ × 13)
Black ink
BS lower right
Printed by Cuno?
FLP

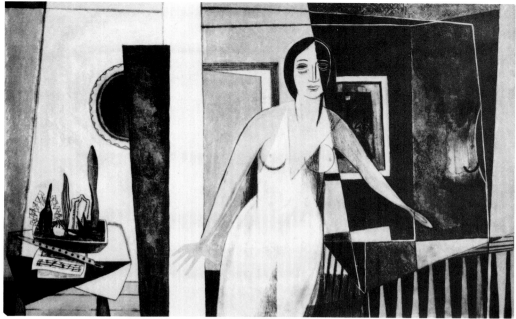

271

272

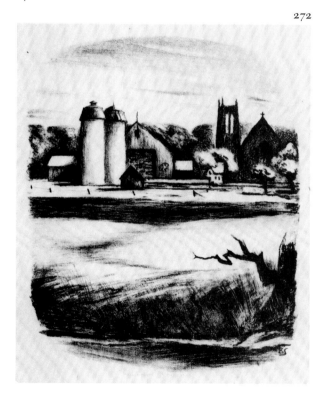

271. *Somnambulist*, 1948
Edition 30
31.2 × 49
(12⁵⁄₁₆ × 19½)
Four colors (tan, yellow, gray-green, black)
BS lower right
Printed by Cuno?
FLP

272. *Newtown Towers*, 1948
Edition unknown
24.7 × 19.3
(9¾ × 7⅝)
Black ink
BS lower right
Printed by Cuno?
FLP

Note: The print was published in *The New Colophon*, 1, part 4 (Oct. 1948), between pages 366 and 367. It was commissioned to celebrate the 150th anniversary of the invention of lithography.

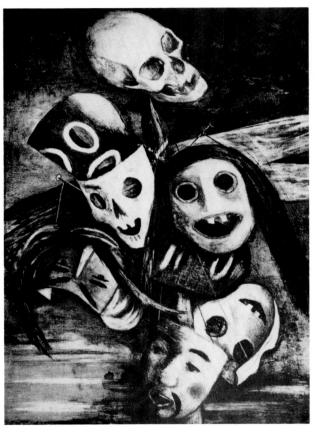

273

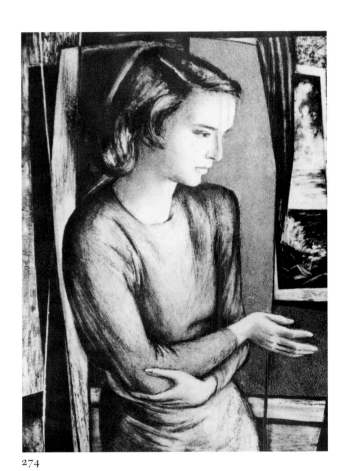

274

273. *Memorial to a Dead Child; To a Dead Child*, 1949; 1948
Edition 30
49.9 × 35.6
(19⅝ × 14)
Black ink
BS lower right
Printed by Cuno
FLP; PMA

Vanity I: Vanity of the Mind
A series of five lithographs (cat. nos. 275–77, 279, 281); issued in green portfolio with red title label; handwritten title page at FLP and NGA; editions printed in black only have been located for three of the five (cat. nos. 274, 278, 280)

274. *Soliloquy: Vanity of Decision*, 1949
Edition 30
47.4 × 33.2
(18⅝ × 13)
Black ink
Stone unsigned
FLP; PMA

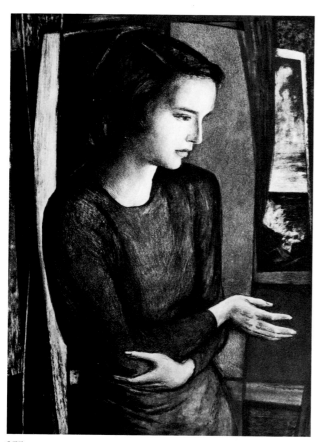

275

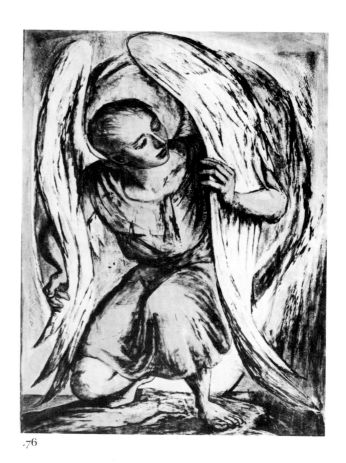

.76

275. *Soliloquy: Vanity of Decision*, 1949
Edition 40
47.8 × 33
(18¹³⁄₁₆ × 13)
Five colors (yellow, red-brown, blue-green,
 violet, black)
BS lower left
Printed by Cuno
FLP; PMA; NGA

276. *Fallen Angel: Vanity of Disagreement*,
 1949
Edition 40
47.4 × 33.1
(18⅝ × 13⅛)
Four colors (yellow, tan, red, black)
BS lower left
Printed by Cuno
FLP; PMA; NGA; LC

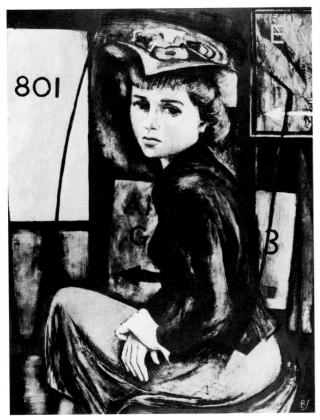

277

278

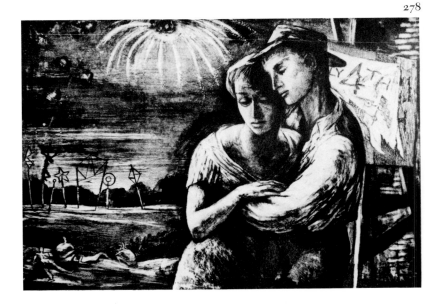

277. *Of Course He Will Come: Vanity of Hope*,
 1949
Edition 40
47.9 × 33.6
(18⅞ × 13¼)
Four colors (yellow, yellow-green, orange,
 black)
BS lower right
Printed by Cuno
FLP; PMA; NGA; LC

278. *Set Pieces: Vanity of Trust*, 1949
Edition 30
33.1 × 47.2
(13¹⁄₁₆ × 18⅝)
Black ink
Stone unsigned
Printed by Cuno?
FLP

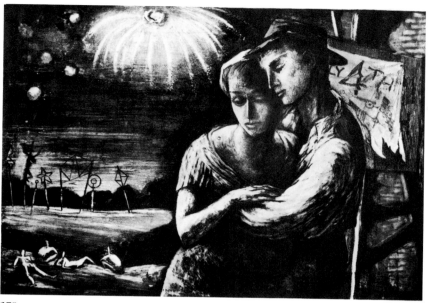

279

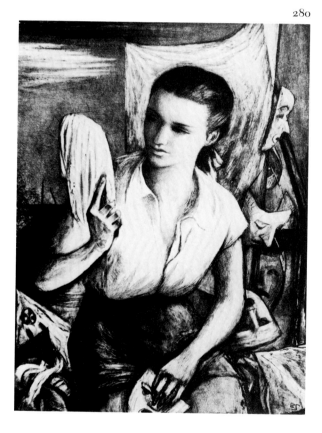

280

279. *Set Pieces: Vanity of Trust*, 1949
Edition 40
33 × 47.1
(13 × 18⁹⁄16)
Five colors (yellow, blue, green, orange, black)
Stone unsigned
Printed by Cuno
FLP; PMA; NGA

280. *I'll Be What I Choose: Vanity of Ambition*,
 1949
Edition 30
47.7 × 33.9
(18¾ × 13⅜)
Black ink
BS lower right
Printed by Cuno?
FLP; PMA

Catalogue Raisonné
179

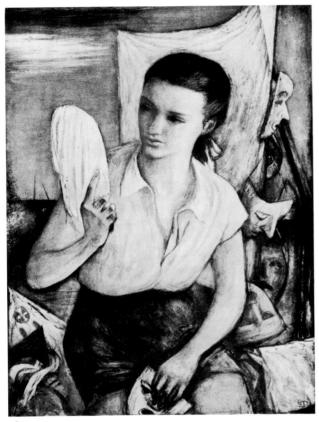

281

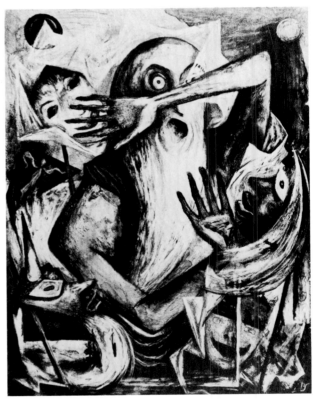

282

281. *I'll Be What I Choose: Vanity of Ambition,*
 1949
 Edition 40
 47.8 × 33.9
 (19¹³⁄₁₆ × 13¼)
 Four colors (yellow, gold, red-orange, black)
 BS lower right
 Printed by Cuno
 FLP; PMA; NGA

282. *Saint Anthony,* 1949
 Edition 30
 36 × 26.8
 (14⅛ × 10⁹⁄₁₆)
 Black ink
 BS lower right
 Printed by Cuno
 FLP

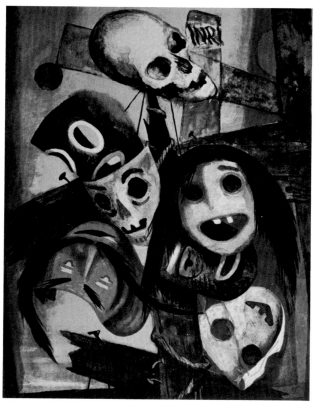

283

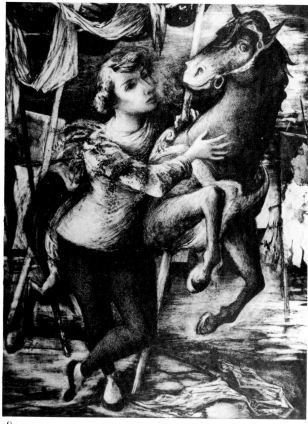

284

Vanities II
A series of five lithographs (cat. nos. 283, 286, 288, 289, 292)

283. Vanities II: *Memorial*, 1950
47.3 × 34.5
(18 9/16 × 13 5/8)
Edition 40
Five colors (yellow, brown, gray [or green], red-orange, black)
BS. lower right
Printed by Cuno
FLP; PMA; NGA (with related proof material)

284. *Broken Carousel*, 1950
Edition 35; 30
46.9 × 33.9
(18 3/8 × 13 7/16)
Black ink
BS lower right
Printed by Cuno?
FLP (with related drawings and proof material)

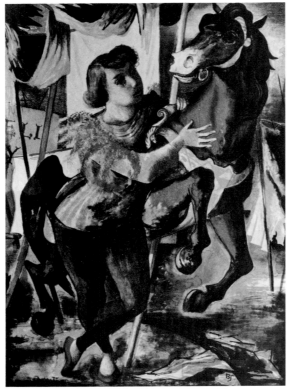

285

286

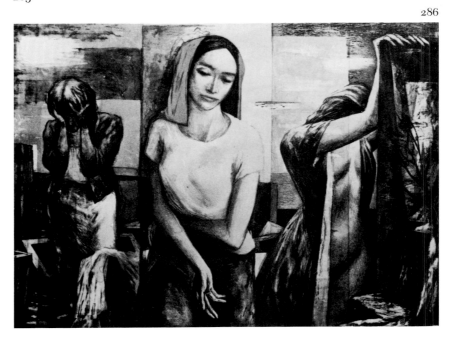

285. *Broken Carousel*, 1950
Edition 35
47 × 33.9
(18½ × 13⅜)
Six colors (yellow, gold, gray-green, pink,
 brown-red, black)
BS lower right
Printed by Cuno?
FLP (with related drawings and proof material);
 NGA (with related proof material)

286. Vanities II: *Lamentation*, 1950
Edition 40
33.9 × 47
(13⅜ × 18½)
Four colors (yellow, blue, light red, black)
BS lower right
Printed by Cuno
FLP; PMA; NGA (with related proof material); LC

287

288

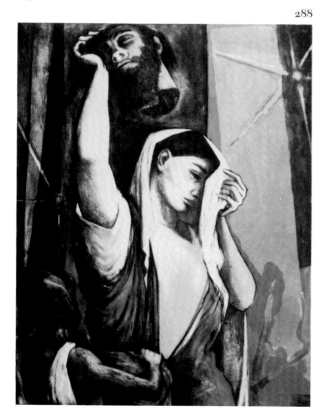

287. *Variation*, 1950
Edition 20
33.5 × 46.8
(13⁵⁄₁₆ × 18½)
Three colors (yellow, brown-red, blue)
Stone unsigned
Printed by Cuno
FLP; PMA; NGA (with related proof material); LC

288. Vanities II: *Judith*, 1950
Edition 40
47.1 × 34
(18½ × 13⅜)
Five colors (gray-rose, green, brown-red, light
 orange, black)
BS lower right
Printed by Cuno?
FLP; PMA; NGA (with related proof material)

Catalogue Raisonné
183

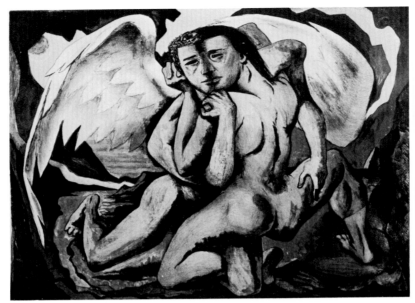

289

290

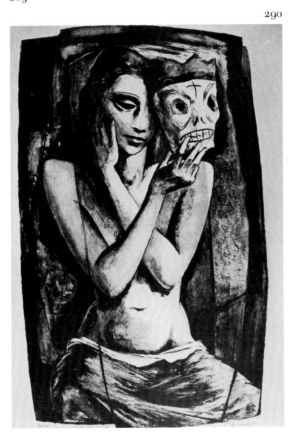

289. Vanities II: *Jacob and the Angel*, 1950
Edition 40
35.4 × 46.7
(14 × 18⅜)
Four colors (yellow, blue, red-brown, black)
BS lower right
Printed by Cuno?
FLP; PMA (with related drawings); NGA (with
 related proof material)

290. *Girl with Mask*, 1950
Edition 30
52.3 × 30.9
(20⅝ × 12⅛)
Black ink
BS lower right
Printed by Cuno?
FLP; PMA; BPL

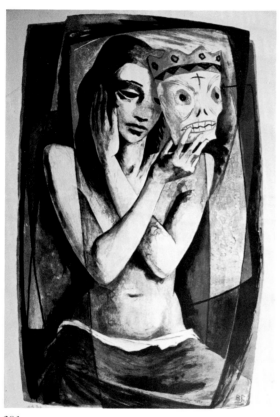

291

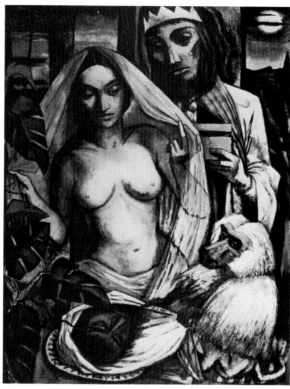

292

291. *Girl with Mask*, 1950
Edition 30
52.3 × 30.9
(20⅝ × 12⅛)
Three colors (tan, brown-red, black)
BS lower right
Printed by Cuno
FLP (with related proof material); NGA (with related proof material); BPL

292. Vanities II: *Salome—and John; Salome*, 1950
Edition 40
46.5 × 34
(18¼ × 13⅜)
Five colors (yellow, gray-violet, red, green, black)
BS lower right
Printed by Cuno
FLP; PMA; NGA (hand-colored black proof)

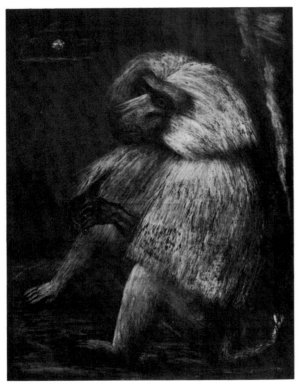

293

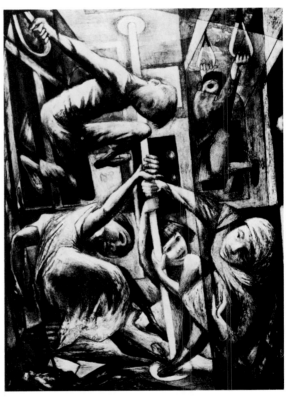

294

293. *Hamadryas Ape; Hamadryas Baboon;*
 Baboon, 1951
Edition 30; 25
42.2 × 31.2
(16⅝ × 12¼)
Black ink
BS lower left
Printed by Cuno
FLP; PMA

294. *Subway Playground,* 1951
Edition 30
48 × 34.7
(18¹⁵⁄₁₆ × 13¾)
Black ink
BS lower right
Printed by Cuno?
FLP; PMA

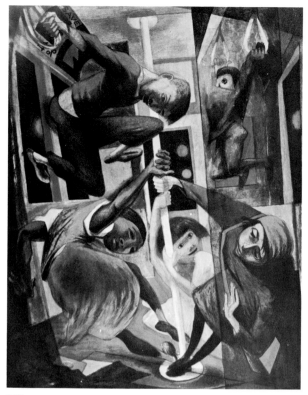

295

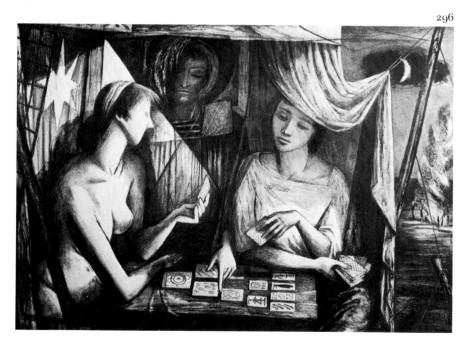

296

295. *Subway Playground*, 1951
Edition 40; 35
48.2 × 34.7
(19 × 13¾)
Six colors (tan, yellow, red, brown, light green,
 black)
BS lower right
Printed by Cuno?
FLP (with related proof material); PMA

296. *Tarot Pyramid; Tarot No. 1*, 1951
Edition 25; 30
36.7 × 51
(14½ × 20⅛)
Black ink
B.S. lower right
Printed by Cuno?
FLP
Note: Fletcher notes color version; none has been
 located by the present cataloguers.

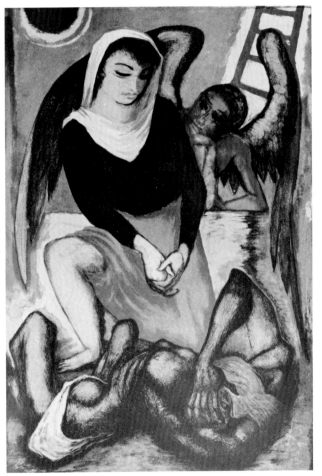

297

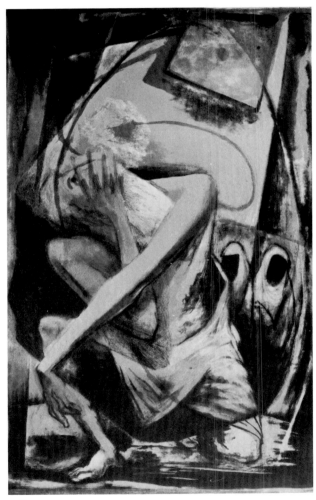

298

297. *"Curse God—and Die,"* 1951
Edition 25
46.2 × 29.1
(18⁵⁄₁₆ × 11½)
Five colors (light orange, yellow, red,
 brown-gray, black)
Stone unsigned
Printed by Spruance?
FLP; PMA

298. *"My Hand I Lay upon My Mouth"*—*Job,*
 1951
Edition 25; 22
46.2 × 29.2
(18¼ × 11½)
Five colors (two blues, tan, green, brown)
Stone unsigned
Printed by Spruance
FLP; PMA

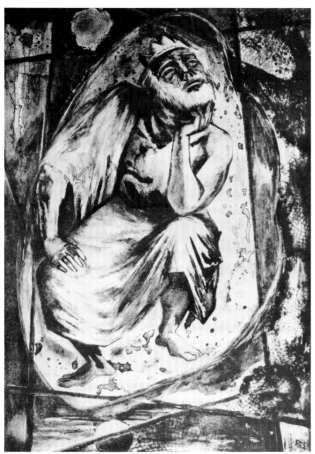

299

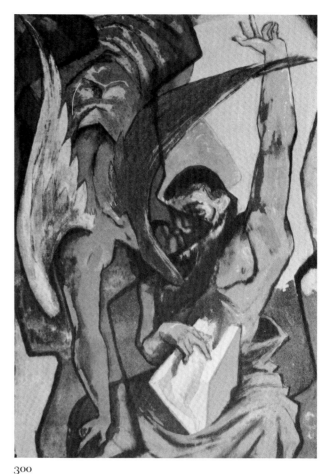

300

299. *"When I Laid the Earth's Foundation"*—
 Job, 1951
Edition 30; 35
46.4 × 29.2
(18¼ × 11¾)
Black ink
BS lower right
Printed by Cuno?
FLP; PMA

300. *"Hast Thou Observed My Servant Job?"*
 1951
Edition 27; 30
47.4 × 30.2
(18¾ × 12)
Six colors (three grays, yellow, tan, red-orange)
Stone unsigned
Printed by Spruance
FLP; PMA

Catalogue Raisonné
189

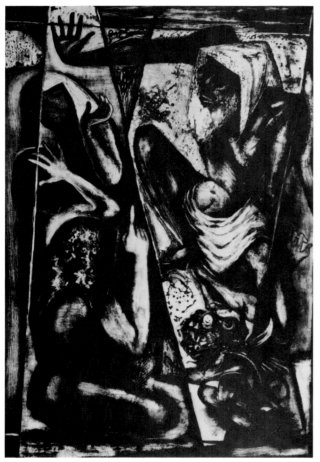

301

302

301. *"With You, Wisdom Will Die"—Job*, 1951
Edition 25, 30
46 × 29.7
(18⅛ × 11¹¹⁄₁₆)
Black ink
Stone unsigned
Printed by Spruance
FLP; PMA

302. *God Bless America*, 1951
Edition 30
53.2 × 32.2
(21 × 12¾)
Black ink
BS (S reversed) lower right
Printed by Cuno?
FLP

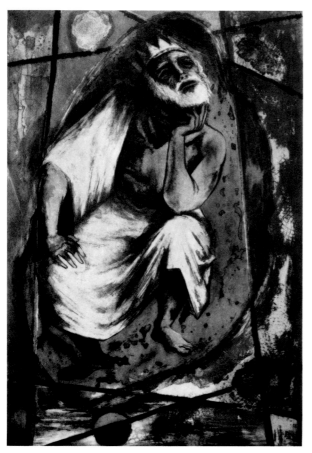

303

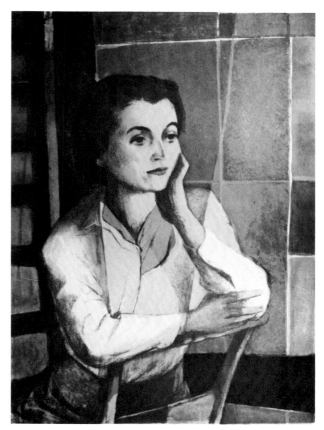

304

303. *"When I Laid the Earth's Foundation,"*
 1952; 1951
Edition 30
46.4 × 29.2
(18¼ × 11¾)
Four colors (gray-violet, ochre, red, blue)
BS lower right
Printed by Cuno
FLP; PMA; NGA

304. *Portrait; Portrait of Mrs. Curt Salmsson;*
 Portrait—Mrs. C.S., 1952
Edition 12; 15
48.7 × 37.2
(19¼ × 13⅝)
Eight colors (two greens, two browns, tan,
 orange, red, black)
BS lower right
Printed by Spruance
FLP; PMA

Catalogue Raisonné
191

305

306

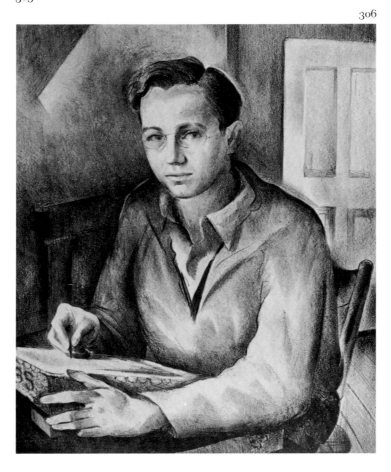

305. *Studio Piece; Studio Chair*, 1952
Edition 25
29 × 49.8
(11 7/16 × 19 5/8)
Black ink
BS lower right
Printed by Cuno?
FLP

306. *Self Portrait at Stone; Self Portrait; Self at Stone*, 1952
Edition 25
48.5 × 35.5
(19 1/8 × 14)
Black ink
Stone unsigned
Printed by Cuno?
FLP; NGA

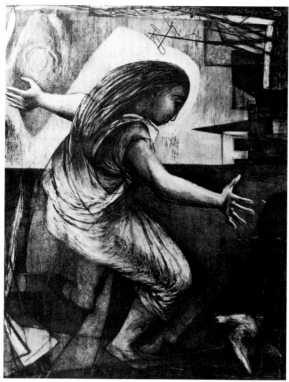

307

308

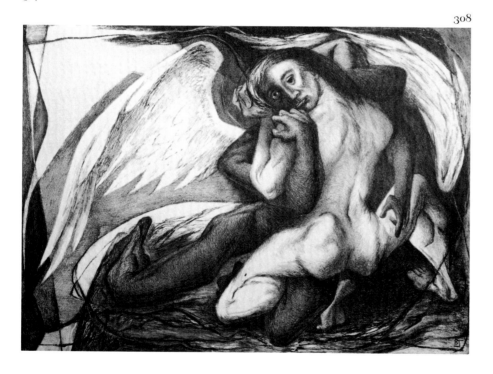

307. *To Freedom—XII August—1948*, 1952
Edition 30
36 × 50
(14¼ × 19⅝)
Black ink
BS lower right
Printed by Spruance?
PMA; NGA

308. *Eternal Jacob; Jacob and the Angel*, 1952
Edition 30
35 × 47·3
(14 × 18⅞)
Black ink
BS lower right
Printed by Cuno?
FLP; PMA; NGA

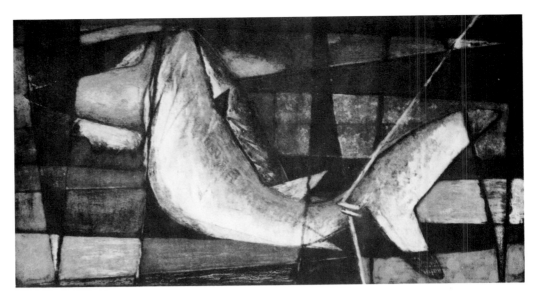

309

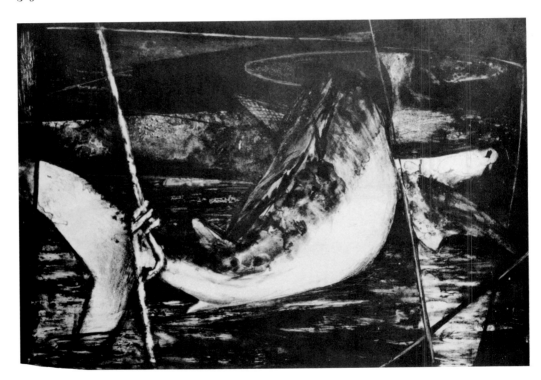

310

309. *Shark and Sonar* (larger version), 1952
Edition 25; 30
27 × 50
(10⅝ × 19¾)
Three colors (green, red, brown)
BS lower right
Printed by Spruance?
FLP; PMA; NGA; LC

310. *Shark and Sonar* (smaller version); *Ahab's Revenge*, 1952
Edition 20; 25
22.2 × 31.6
(8¾ × 12⁷⁄₁₆)
Green-black ink
BS lower right
Printed by Spruance?
FLP

311

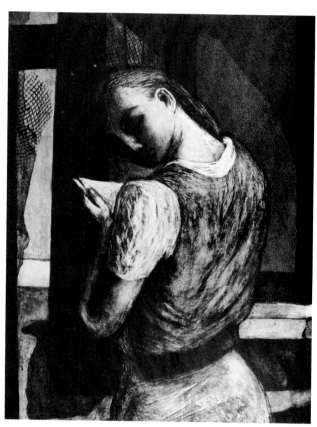

312

311. *Fire's Out*, 1952
Edition 30; 25
51.5 × 33.6
(20⁵⁄₁₆ × 13¼)
Five colors (green, olive, orange, tan [or pink],
 brown)
Stone unsigned
Printed by Cuno?
FLP; PMA; NGA

The Long Night
A series of three lithographs (cat. nos. 312–14)

312. The Long Night: *Climate of Fear*, 1952
Edition 30
48.7 × 34.7
(19³⁄₁₆ × 13⁵⁄₈)
Black ink
Stone unsigned
Printed by Cuno?
FLP; PMA; NGA

Catalogue Raisonné
195

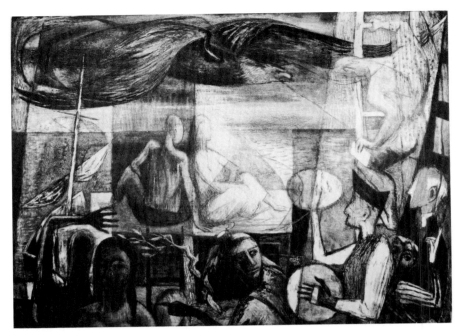

313

314

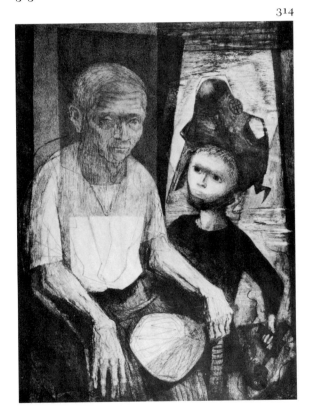

313. The Long Night: *Citizen; Citizen—1952*,
 1952
Edition 30; 20; 25
46.8 × 61
(18⁷⁄₁₆ × 24)
Black ink
BS lower right
Printed by Spruance?
FLP; PMA; NGA

314. The Long Night: *Space Mask*, 1952
Edition 30; 20
48.5 × 34
(19³⁄₁₆ × 13³⁄₈)
Black ink
BS lower right
Printed by Spruance?
FLP; PMA; NGA

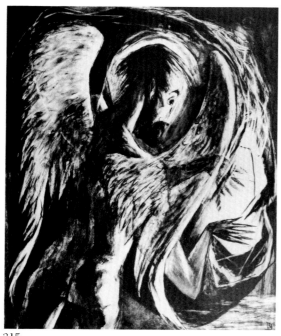

315

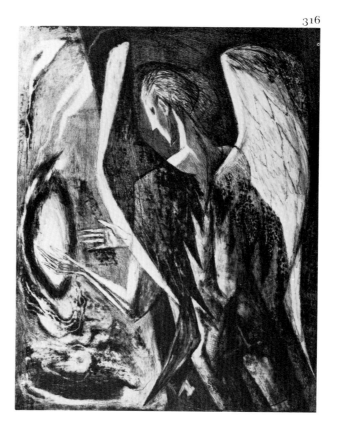

316

315. *Prometheus*, 1952; 1953
Edition 30
46.3 × 37.5
(18¼ × 14¾)
Black ink
BS lower right
Printed by Spruance?
FLP; PMA

316. *Prometheus II*, 1952
Edition 30
45.5 × 35.8
(18 × 14⅛)
Black ink
BS lower right
Printed by Spruance?
FLP

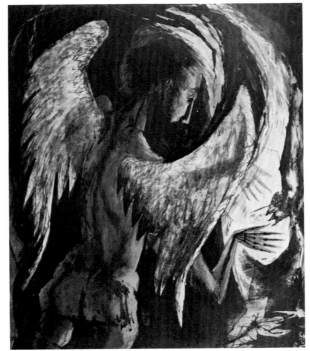

317

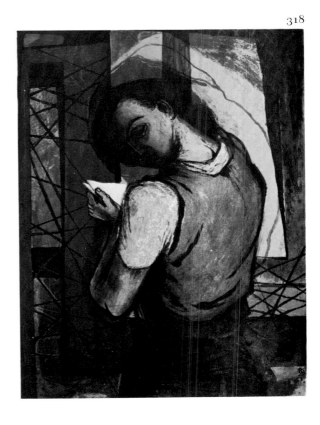

317. *Prometheus*, 1953
Edition 30; 20
46.5 × 37.5
(18⅜ × 14¾)
Six colors (brown, tan, yellow, red, blue, black)
BS lower right
Printed by Spruance?
FLP; PMA

318. *Climate of Fear*, 1953; 1952
Edition 30; 20; 25
48.3 × 34.9
(19 × 13⅞)
Six colors (two greens, brown-red, orange, brown, green-black)
BS lower right
Printed by Cuno?
FLP; PMA

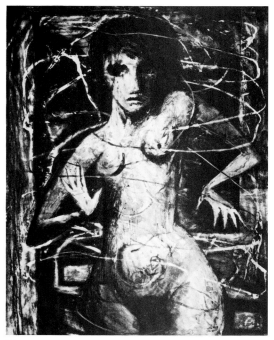

319

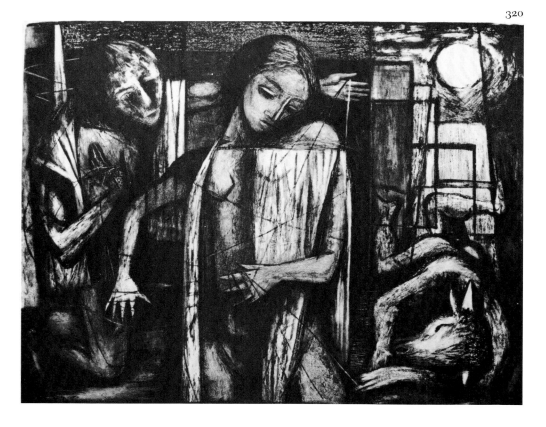

320

319. *Ariadne and the Skein*, 1953
Edition 30
44.5 × 34.5
(17⁹⁄₁₆ × 13⁹⁄₁₆)
Black ink
Stone unsigned
Printed by Spruance?
FLP

320. *Ariadne and Daedalus*, 1953
Edition 30
34 × 44.7
(13½ × 17⁹⁄₁₆)
Black ink
Stone unsigned
Printed by Spruance?
FLP; PMA

Catalogue Raisonné

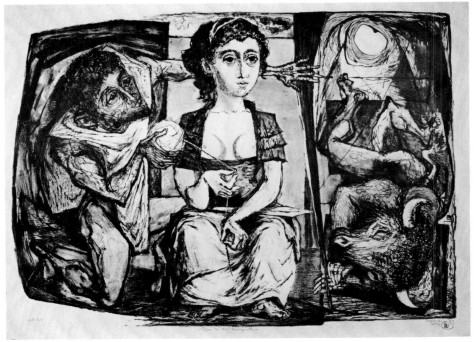

321

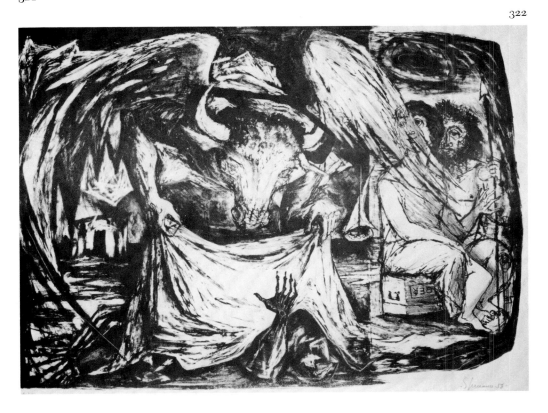

321. *Clue to the Labyrinth*, 1953
Edition 30; 20
41.3 × 56
(16¼ × 22⅜)
Black ink
BS lower right
Printed by Cuno
FLP; PMA

322. *Triumph of the Minotaur*, 1953
Edition 30; 20
42.4 × 57
(16¾ × 22½)
Black ink
BS lower right
Printed by Spruance?
FLP; PMA

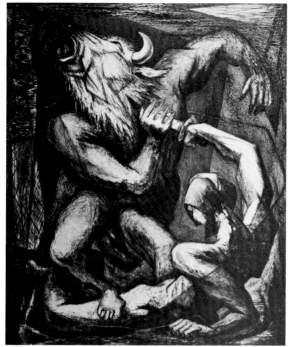

323

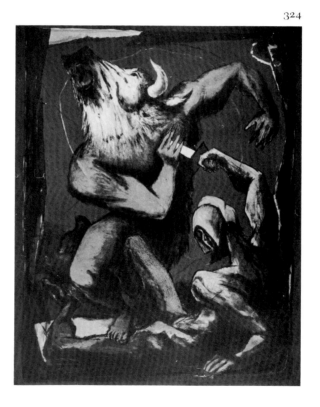

324

323. *Death of the Minotaur*, 1953
Edition 30; 25
45.9 × 34.5
(18 × 13⅝)
Black ink
BS lower right
Printed by Desjobert
FLP; PMA

324. *Death of the Minotaur*, 1953
Edition 30
48.6 × 36.8
(19⅛ × 14½)
Five colors (yellow, tan, gray-blue, brown,
 black)
BS lower right
Printed by Desjobert
FLP; PMA

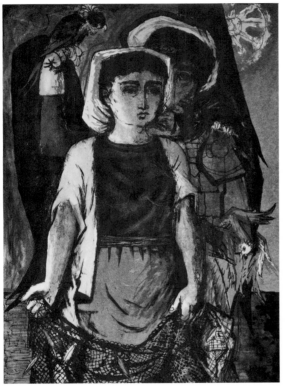

325

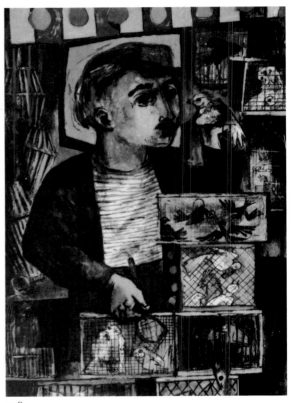

326

Saint Francis
A series of three lithographs (cat. nos. 325–27)

325. *Saint Francis—The Fields*, 1953
Edition 35
48.4 × 33.4
(19¼ × 13³⁄₁₆)
Four colors (tan, yellow, red-orange, black)
BS lower right
Printed by Spruance?
PMA; NGA; LC

326. *Saint Francis—The Market*, 1953
Edition 35
48.9 × 33.3
(19¼ × 13⅛)
Five colors (tan, gray, blue, red, black)
BS in circle, lower right
Printed by Spruance?
FLP (with related proof material); PMA; NGA

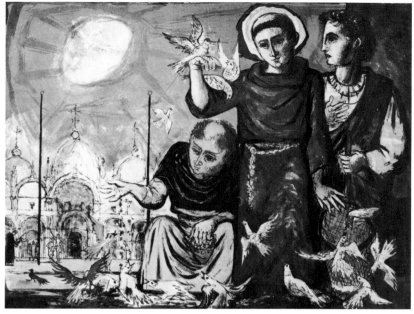

327

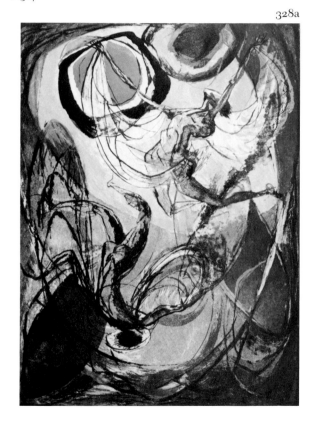

328a

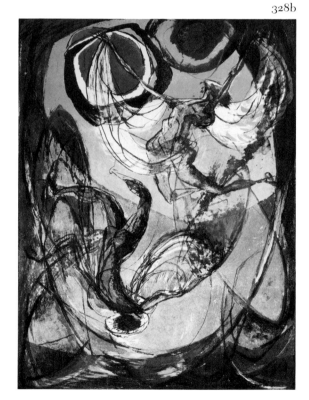

328b

327. *Saint Francis—The Piazza; The Piazza,*
 1953
Edition 35; 40
40.3 × 52.3
(15⅞ × 20⅝)
Five colors (yellow, tan, green, brown, black)
BS lower right
Printed by Spruance?
FLP; PMA; NGA; LC

328a, 328b. *Daedalus and Icarus,* 1954
Edition 24; 25; 29
49.7 × 35
(19⅝ × 14)
Seven colors (yellow, red, blue, blue-green,
 light green, brown, black)
Stone unsigned
Printed by Spruance
FLP; PMA

Note: The two illustrations exemplify the range
 of variation in many of Spruance's editions.

Catalogue Raisonné
203

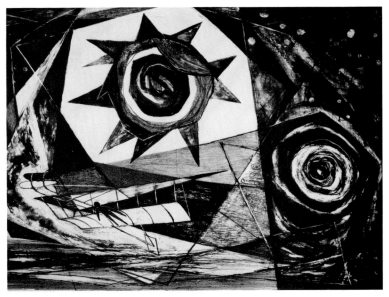

329

330

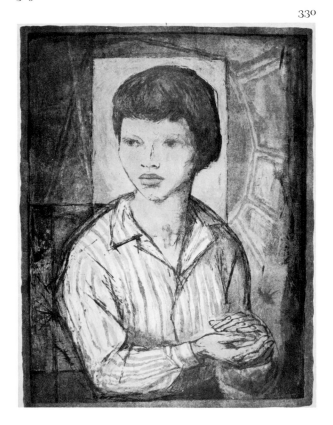

329. *From Kill Devil Hill*, 1954
Edition 30
30.9 × 40.5
(12³⁄₁₆ × 16)
Black ink
BS upper right
Printed by Spruance?
PMA

330. *Portrait of Sandra; Sandra*, 1954
Edition 25
55 × 39.9
(21¾ × 15¾)
Five colors (yellow, light orange, gray, brown,
 red-orange)
Stone unsigned
Printed by Spruance
FLP; PMA

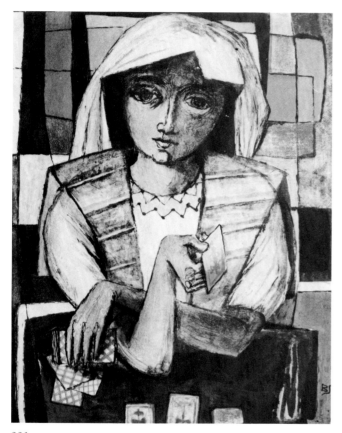

331

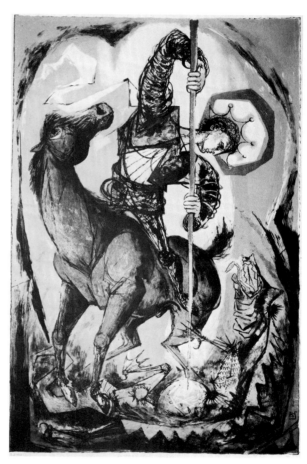

332

331. *Fortune Teller*, 1954
Edition 200 plus 10 artist's proofs
44.3 × 32.5
(17½ × 12⅞)
Four colors (two blues, yellow, black)
BS lower right
Printed by Cuno?
FLP; PMA (with related proof material); NGA
 (with related proof material)
Note: The print was published by the International
 Graphic Arts Society, New York.

The Saints
A series of four lithographs (cat. nos. 332–35)

332. *Saint George*, 1954; 1955
Edition 40; 30; 35
52.3 × 33.2
(20⅝ × 13¹⁄₁₆)
Four colors (gray, yellow, brown, black)
BS lower right
Printed by Spruance?
FLP; PMA

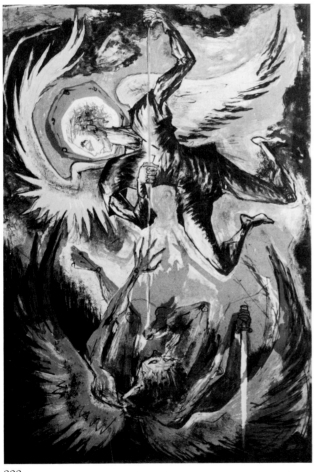

333

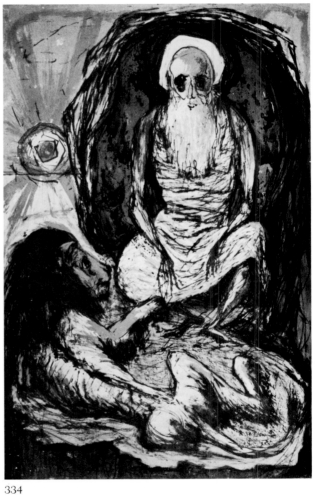

334

333. *Saint Michael*, 1954
Edition 30; 35
51.7 × 33
(20⅜ × 13)
Four colors (gray, yellow, red, black)
Stone unsigned
Printed by Spruance?

FLP; PMA

Note: The print is known in two states; a first state is
known (private collection) in which the background
area, especially between St. Michael and the An-
gel, is less fully filled in.

334. *Saint Jerome*, 1954
Edition 40; 30; 35
51.4 × 32.8
(20¼ × 12¹⁵⁄₁₆)
Four colors (gray, orange, green, black)
Stone unsigned
Printed by Spruance?

FLP; PMA

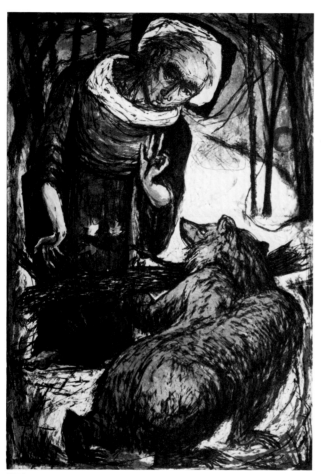

335

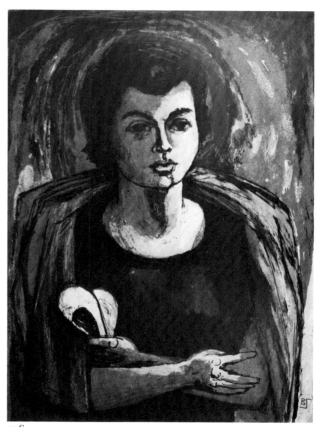

336

335. *Saint Gall*, 1954
Edition 35; 30
50.9 × 32.5
(20 1/16 × 12 3/4)
Four colors (yellow, blue, brown, black)
BS lower right
Printed by Spruance?
FLP; PMA

336. *Dancer; Small Dancer*, 1954
Edition 25
45.1 × 32.7
(18 × 12 7/8)
Seven colors (two blue-greens, rose, tan, violet,
 brown, black)
BS lower right
Printed by Spruance?
FLP; PMA

Catalogue Raisonné
207

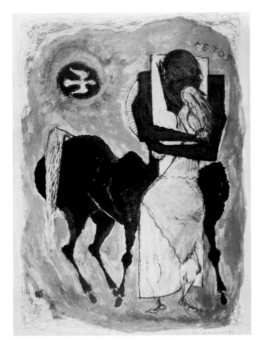

337

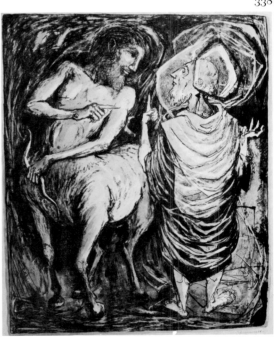

337. *Fragment*, 1954
Edition 30; 20
41.6 × 28.2
(16⅜ × 11⅛)
Five colors (tan, orange-brown, light
 blue-green, yellow, black)
BS lower left
Printed by Spruance
FLP; PMA

The Centaurs
A series of five lithographs (cat. nos. 338–42)

338. *Centaur I—The Saint; The Centaur and
 the Saint*, 1954
Edition 30; 25
52.8 × 40.9
(20¹³⁄₁₆ × 16⅛)
Two colors (light green [or tan] and brown); also
 impressions of brown stone alone
Stone unsigned
Printed by Spruance?
FLP; PMA; LC

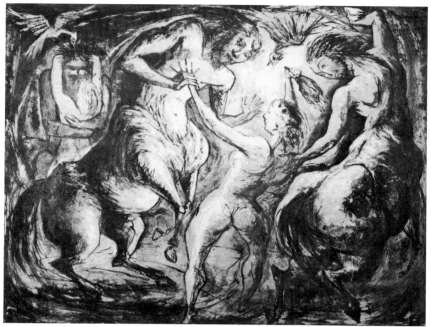

339

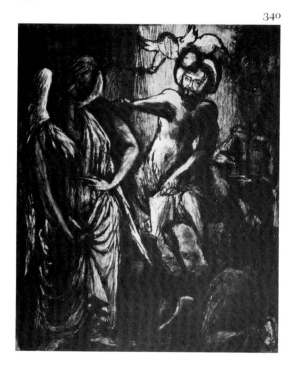

340

339. *Centaur II—The Bride; The Bride*, 1954
Edition 25; 30
40.2 × 51.9
(15¹⁵⁄₁₆ × 20½)
Two colors (pinkish-tan and brown)
Stone unsigned
Printed by Spruance?
FLP; PMA

340. *Centaur III—Apotheosis; Apotheosis,*
 1954
Edition 25; 30
54 × 41.9
(21⁷⁄₁₆ × 16½)
Two colors (tan and black)
BS lower right
Printed by Spruance?
FLP; PMA

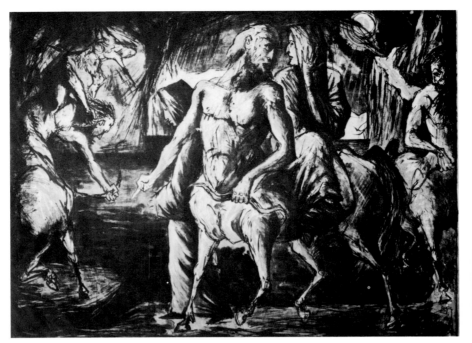

341

342

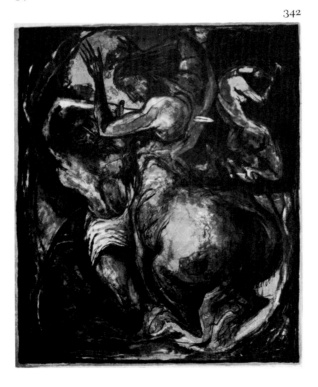

341. *Centaur IV—The Poet*, 1954
Edition 25; 30
40.5 × 52
(16 × 20½)
Two colors (pink [or tan] and gray-green)
BS lower right
Printed by Spruance?
FLP; PMA

342. *Centaur V—The Hero*, 1954
Edition 25; 30
52.8 × 41.7
(20¹³⁄₁₆ × 16⁷⁄₁₆)
Two colors (blue-gray and black)
BS lower right
Printed by Spruance?
FLP; PMA; LC

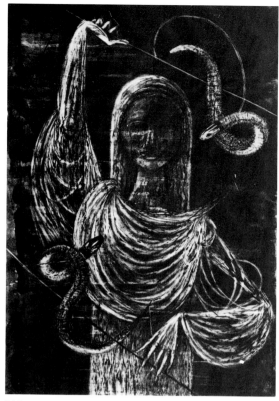

343.

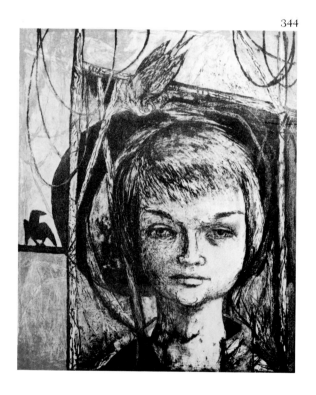

344

343. *Priestess*, 1954
Edition 35; 30
46.2 × 30.2
(18⅛ × 11⅞)
Black ink
BS lower right
Printed by Spruance?
FLP; PMA

344. *Gertrude and the Birds; Gertrude's Birds*,
 1955
Edition 25; 20
44.9 × 33.5
(17¹¹⁄₁₆ × 13¼)
Two colors (red-orange and brown); also
 impressions of image from red-orange stone
 alone, printed in red-orange and printed in
 brown
Stone unsigned
Printed by Spruance
FLP

Catalogue Raisonné
211

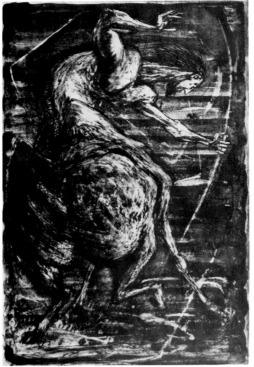

345

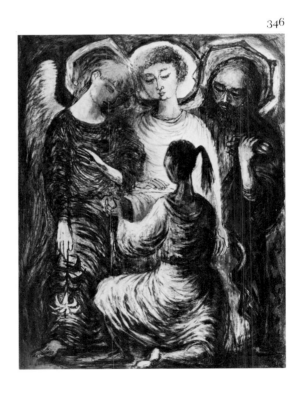

346

345. *Pholus in Hell*, 1955
Edition 35; 30
45.2 × 29.2
(17¹³/₁₆ × 11½)
Black ink
BS lower right
Printed by Spruance?
FLP

346. *Offering*, 1955
Edition 40; 30
51.2 × 38.1
(20³/₁₆ × 15)
Two colors (gold and black); also impressions of
 black stone alone
BS lower right
Printed by Spruance?
FLP; PMA; BPL

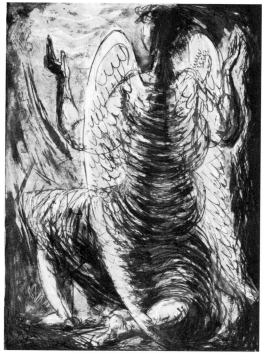

347

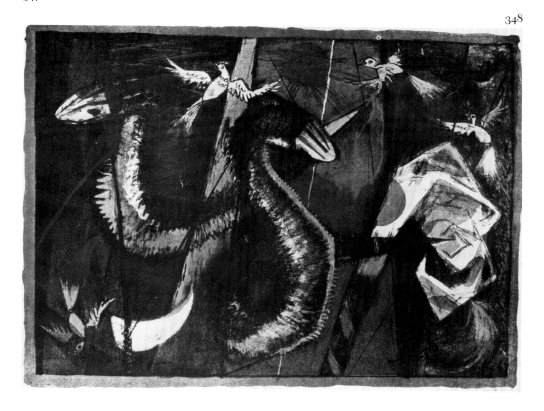

348

347. *Easter Angel,* 1955
Edition 40; 30
40.1 × 28.2
(15¹³⁄₁₆ × 11⅛)
Three colors (yellow, gray-green, red-violet)
BS lower right
Printed by Spruance?
FLP; PMA

348. *Paper Shapes,* 1955
Edition 27; 20; 25; 30
31 × 41.3
(12¼ × 16⁵⁄₁₆)
Seven colors (two greens, yellow, orange, violet,
 tan, blue-black)
BS lower right
Printed by Spruance
FLP; PMA

Catalogue Raisonné
213

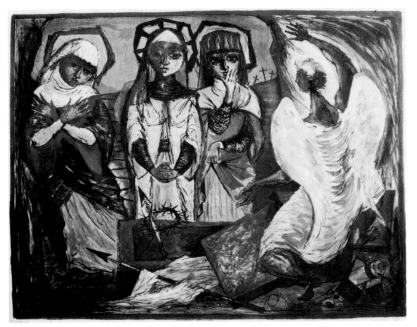

349

350

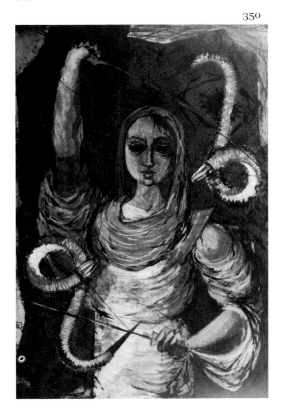

349. *Very Early in the Morning; Early in the
 Morning,* 1955
Edition 40
40.5 × 51.1
(16¹⁄₁₆ × 20⅛)
Five colors (two green-golds, gray-blue, brown,
 black)
Stone unsigned
Printed by Spruance?
FLP; PMA

350. *Priestess,* 1955
Edition 25
50.3 × 33.5
(19⅞ × 13¼)
Seven colors (brown, tan, green, yellow, ochre,
 red, black)
BS (S reversed) lower left
Printed by Spruance
FLP; PMA

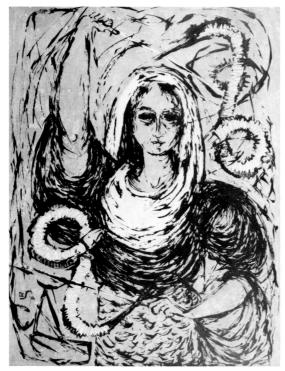

351

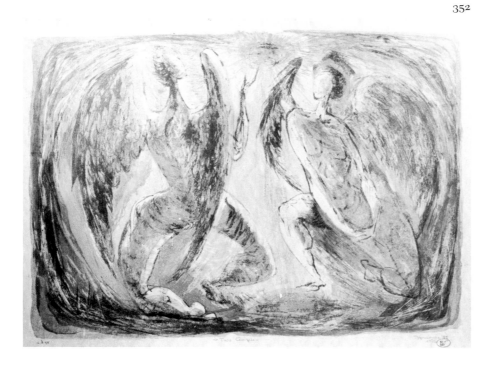

352

351. *Orange Priestess; Priestess*, 1955
Edition 18
49 × 35
(19⅝ × 13⅞)
Two colors (orange and black)
BS lower left
Printed by Spruance
FLP; PMA

352. *Two Angels*, 1955
Edition 40; 20; 25
34.6 × 48
(13⅝ × 18¹⁵⁄₁₆)
Six colors (two yellow-greens, yellow, gray, tan,
 ochre)
Stone unsigned
Printed by Spruance
FLP (with related proof material); PMA

Catalogue Raisonné
215

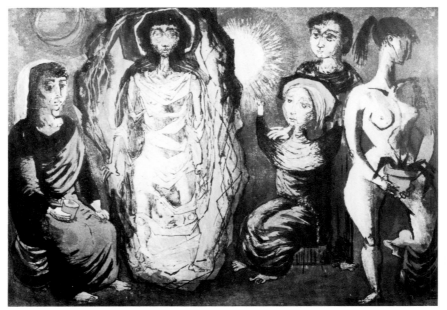

353

354

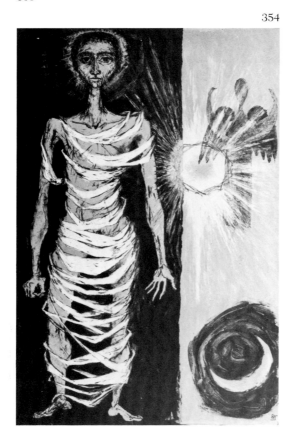

353. *Return of the Hero*, 1955
Edition 30; 35
41.2 × 56.8
(16¼ × 22⅜)
Seven colors (blue-green, green, tan, yellow,
 red, brown, black)
BS lower right
Printed by Spruance
FLP; PMA

354. *Man in Limbo*, 1955
Edition 55; 35
47.9 × 30
(18⅞ × 11¹⁵⁄₁₆)
Two colors (tan and black)
BS lower right
Printed by Spruance?
FLP; PMA

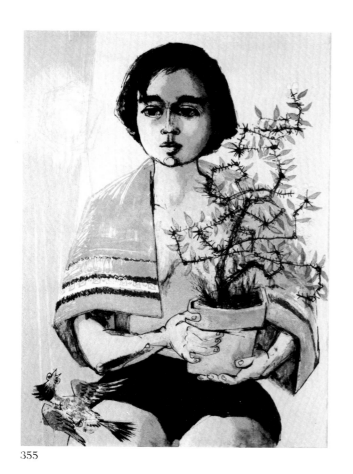

355

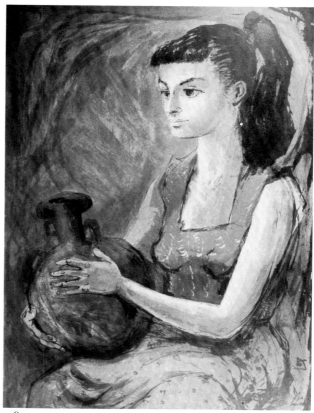

356

355. *Thornbush*, 1955
Edition 25
58.7 × 42
(23⅛ × 16⅝)
Seven colors (two tans, two greens, brown,
 yellow, black)
Stone unsigned
Printed by Spruance
NGA

356. *Water Jar*, 1955
Edition 30; 25
58.6 × 42.5
(23⅛ × 16¾)
Seven colors (two tans, gray-green, blue,
 red-violet, brown, ochre)
BS lower right
Printed by Spruance
FLP; BPL

Catalogue Raisonné
217

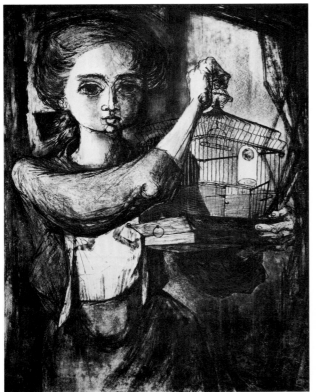

357

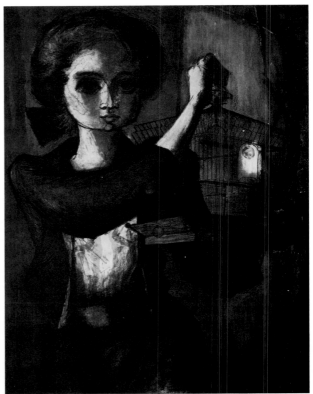

358

357. *Bird Cage*, 1955
Edition 40
55.5 × 40.6
(21¾ × 16)
Black ink
S lower right
Printed by Spruance?
PMA

358. *Bird Cage*, 1956
Edition 35
56 × 41
(22 × 16¼)
Seven colors (two greens, yellow, orange, tan, gray, black)
BS lower right
Printed by Spruance
PMA

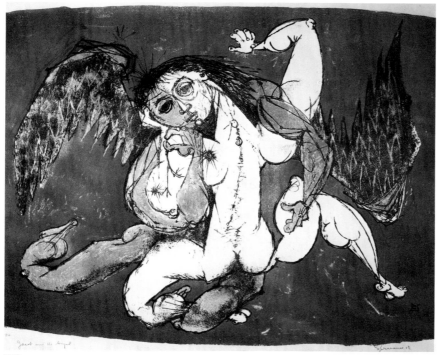

359

360

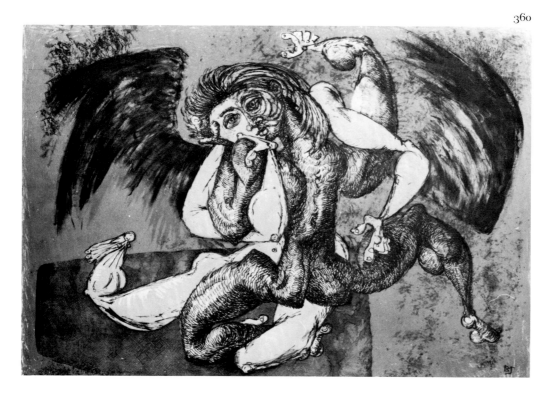

359. *Jacob and the Angel*, 1956
Edition 20; 40
41.2 × 54.3
(16¼ × 21½)
Three colors (brown, tan, dark green)
BS lower right
Printed by Spruance
FLP (with proof material); PMA

360. *Jacob; Jacob and the Angel*, 1956
Edition 40; 30; 35
36.7 × 50.2
(14½ × 19¾)
Three colors (yellow, brown, black)
BS lower right
Printed by Spruance?
FLP

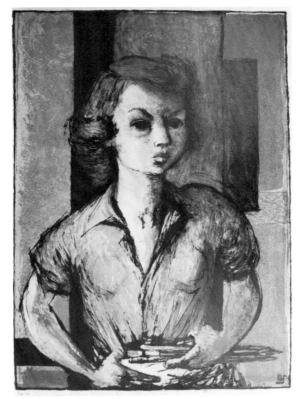

361

362

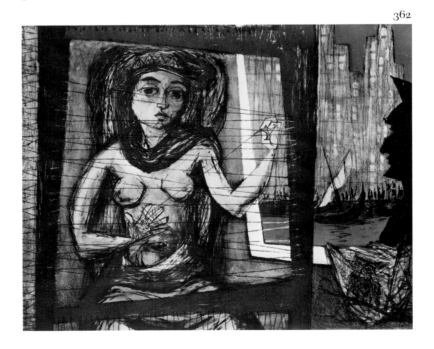

361. *Young Painter*, 1956
Edition 20
57.8 × 39.9
(22¾ × 15¾)
Seven colors (two greens, tan, pink, blue-gray,
 violet, black)
BS lower right
Printed by Spruance
FLP

362. *Penelope*, 1956
Edition 200 plus 10 artist's proofs
38.4 × 48.2
(15⅛ × 19)
Four colors (blue-green, tan, pink, black)
BS lower right
Printed by Cuno
FLP; PMA; NGA
Note: The print was published by the International
Graphic Arts Society, New York.

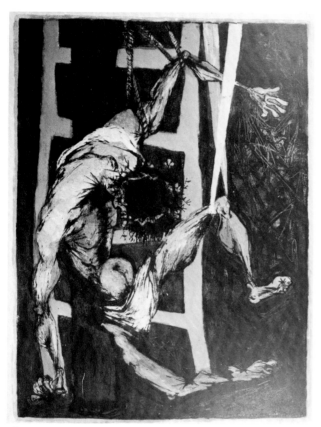

363

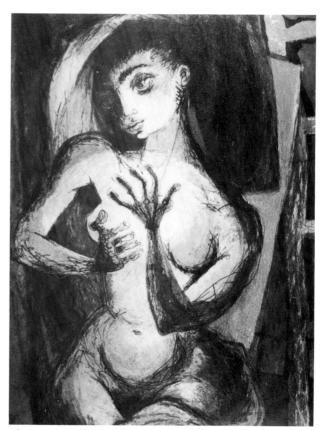

364

363. *Deposition*, 1956
Edition 30
51.3 × 35.8
(20¼ × 14¹⁄₁₆)
Five colors (tan, green, red, brown, black)
Stone unsigned
Printed by Spruance
FLP

364. *Magdalene*, 1956
Edition 30; 35
58.1 × 42.1
(22¹⁵⁄₁₆ × 16⅜)
Seven colors (two tans, blue-green, gray, pink,
 brown, black)
BS lower left
Printed by Spruance
FLP; PMA

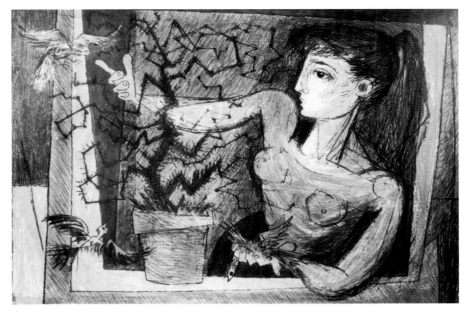

365

366

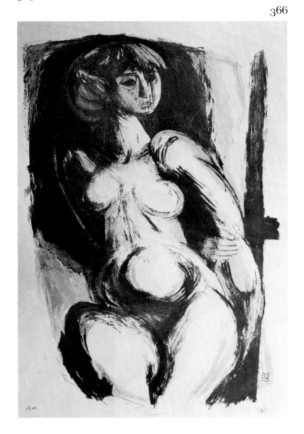

365. *Birds and Thorn Bush; Birds and Thorn Tree*, 1956
Edition 25
36.6 × 51.4
(14⅜ × 20¼)
Six colors (gray, green, blue, pink, red-brown, brown)
BS lower right
Printed by Spruance?
FLP; BPL

366. *Figure*, 1956
Edition 25; 20
57.2 × 36.5
(22½ × 14⅜)
Two colors (tan and brown)
BS lower right
Printed by Spruance?
FLP

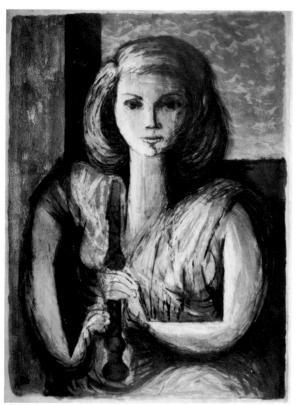

367

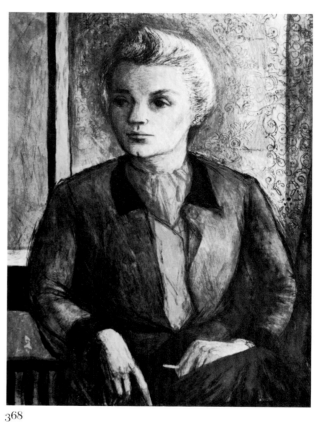

368

367. *Recorder; Red Recorder*, 1956
Edition 22
53.5 × 36.5
(21 × 14⅜)
Seven colors (two browns, light orange, tan,
 gold, red, ochre)
BS lower left
Printed by Spruance
FLP; PMA; BPL

368. *Portrait of Jean Trowbridge; Portrait
 of J.T.*, 1956
Edition 20
51.3 × 37.5
(20³⁄₁₆ × 14¾)
Six colors (two oranges, gold, brown, green,
 black)
Stone unsigned
Printed by Spruance?
FLP

Catalogue Raisonné
223

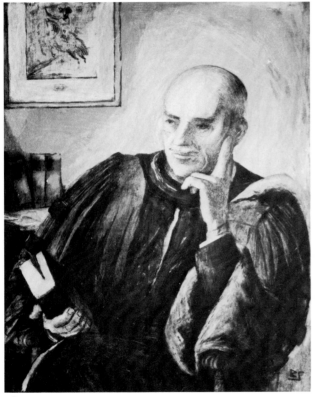

369

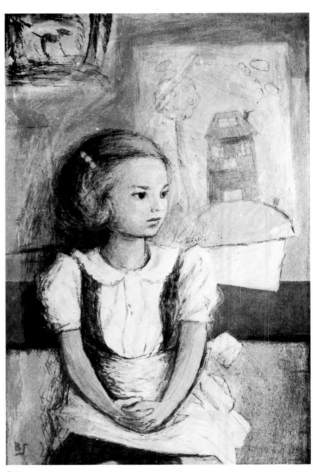

370

369. *Portrait of Dr. Edwin Williams*, 1956
Edition 250
46 × 35
(18⅛ × 13⅞)
Six colors (gray, gold, tan, pink, blue, black)
BS lower right
Printed by Cuno?
FLP; NGA
Note: The print was commissioned to honor Dr.
 Williams on his retirement as provost (1951–56)
 of the University of Pennsylvania.

370. *Miss Ann Schnabel; Ann*, 1957
Edition 25
50.2 × 31.6
(19¾ × 12½)
Seven colors (two tans, two greens, yellow, light
 orange, brown)
BS lower left and lower right
Printed by Spruance
FLP (with related proof material); PMA

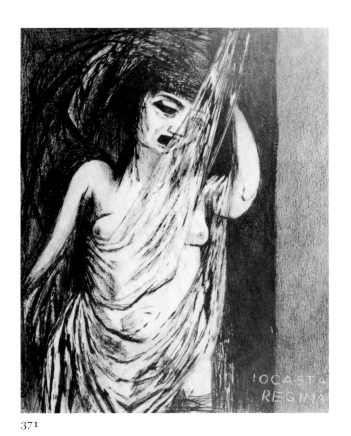

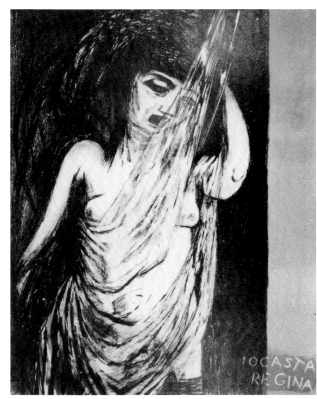

371

372

371. *Jocasta Regina*, 1957
Edition 30
44.7 × 35.2
(17⅝ × 13⅞)
Black ink
BS lower left
Printed by Spruance?
FLP; PMA

372. *Jocasta Regina*, 1957
Edition 40
45.2 × 35.2
(17⅞ × 13⅞)
Three colors (ochre, red, black)
BS lower left
Printed by Spruance?
FLP

Catalogue Raisonné
225

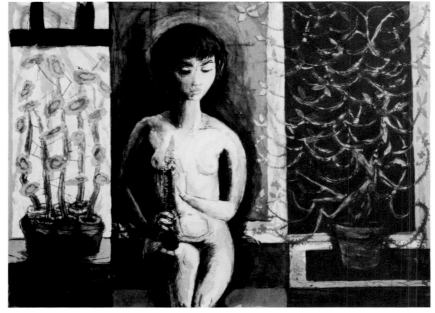

373

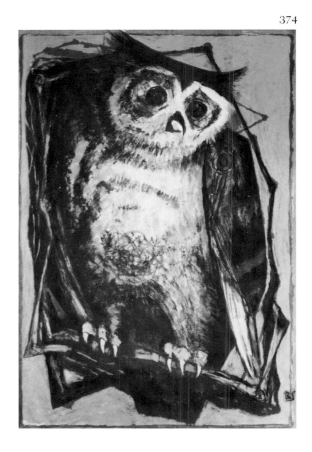

374

373. *Piper*, 1957
Edition 40; 45
41.5 × 54.3
(16⅜ × 21¼)
Six colors (yellow, tan, green, red, orange, black)
BS lower right
Printed by Spruance?
FLP; PMA

374. *Old Owl*, 1957
Edition 40; 30
51.2 × 36.4
(20⅛ × 14¼)
Black ink
BS lower right
Printed by Spruance?
FLP; BPL

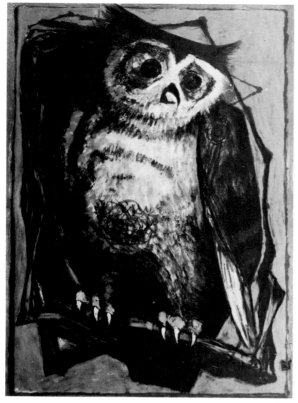

375

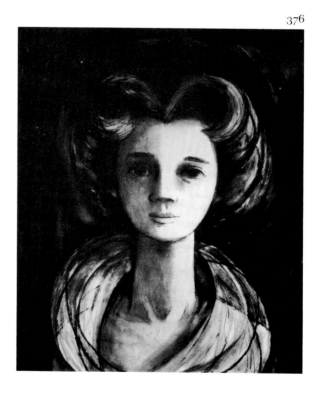

376

375. *Old Owl*, 1957
Edition 40
52.3 × 35.5
(20⅝ × 14)
Three colors (gray-blue, red, black)
BS lower right
Printed by Spruance?
FLP; BPL

376. *Portrait—M.S.; Mary*, 1957
Edition 20; 25
45.2 × 36.5
(17⅞ × 14⅜)
Four colors (gold, green, blue, black); also
 impressions of black stone alone
BS/I lower right
Printed by Spruance?
FLP

Catalogue Raisonné
227

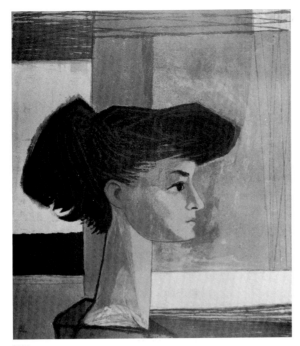

377

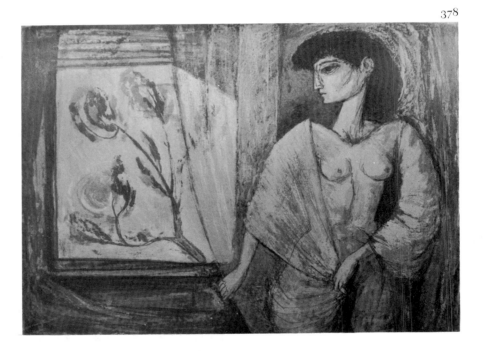

378

377. *Portrait of Judith; Judith—Portrait with
 Ponytail*, 1957
Edition 20
61.4 × 48.3
(24⅛ × 19⅛)
Six colors (two tans, yellow, gray-green, orange,
 black)
BS lower left
Printed by Spruance
FLP

378. *The Window—Day*, 1957
Edition 20; 15
43.5 × 59.1
(17⅛ × 23¼)
Seven colors (two yellows, two greens, tan,
 brown, ochre)
Stone unsigned
Printed by Spruance
FLP; BPL

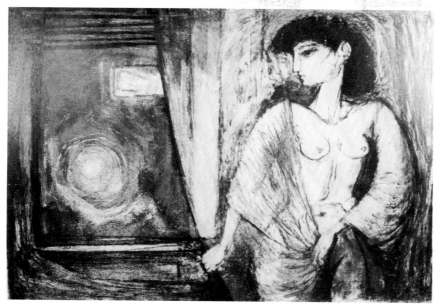

379

379. *The Window—Night*, 1957
Edition 20
43 × 59
(17 × 23¼)
Six colors (gray, green, blue, pink, brown,
	black)
Stone unsigned
Printed by Spruance?
FLP

380. *Remainders*, 1957
Edition 30
61 × 37
(24 × 14⅝)
Seven colors (two greens, yellow, pink, ochre,
	brown, brown-black)
Stone unsigned
Printed by Spruance
FLP; BPL

Catalogue Raisonné
229

381

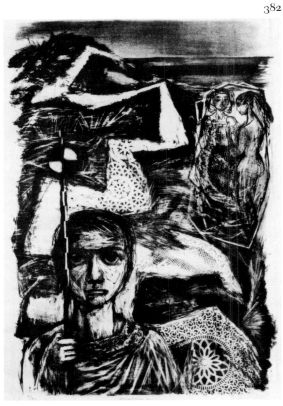

Anabasis
A series of ten lithographs (cat. nos. 381–90;
handwritten title page at BPL)

381. *Anabasis 1: My Glory Is upon the Seas,*
 My Strength is Amongst You, 1957
Edition 40
36.5 × 53
(14⁷⁄₁₆ × 20⁷⁄₈)
Black ink
BS/I lower right
Printed by Spruance?
FLP; PMA; BPL; NGA; LC

382. *Anabasis 2: I Tread, You Tread, In a Land*
 of High Slopes, Clothed in Balm, 1957
Edition 40
52.5 × 34.9
(20¾ × 13¾)
Blue-black ink
BS/II lower right
Printed by Spruance?
FLP; PMA; BPL; NGA; LC

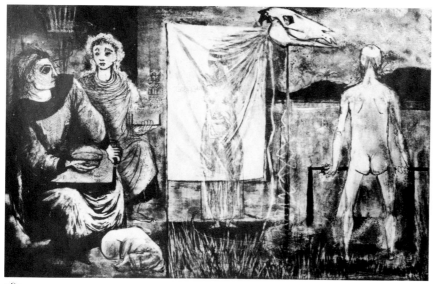

383

384

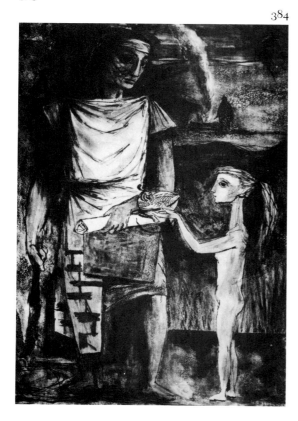

383. *Anabasis 3: On the Point of a Lance,
 Amongst Us, This Horse's Skull!* 1957
Edition 40
36.7 × 52.8
(14¾ × 20¹³⁄₁₆)
Black ink
BS/III lower right
Printed by Spruance?
FLP; PMA; BPL; NGA; LC

384. *Anabasis 4: A Child—Offered Us a Quail
 in a Slipper of Rose Coloured Satin,* 1957;
 1956
Edition 40
52.3 × 35.7
(20⅝ × 14⅛)
Deep violet ink
BS/IV lower right
Printed by Spruance?
FLP; PMA; BPL; NGA; LC

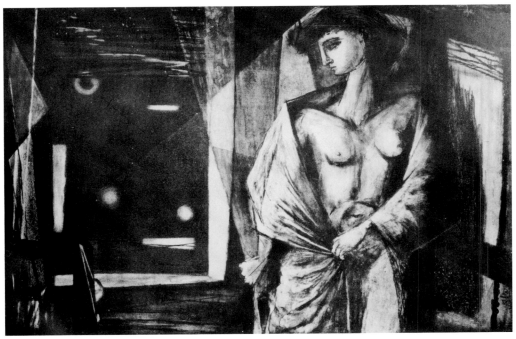

385

386

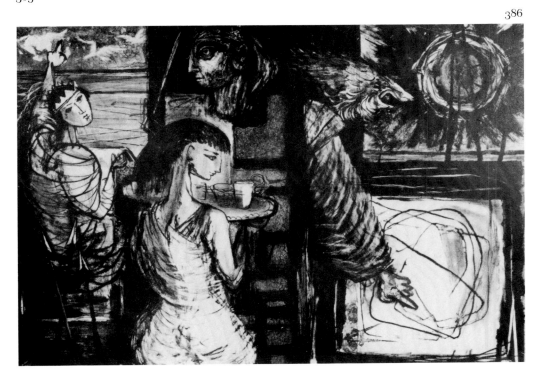

385. *Anabasis 5: And the Stranger Acquires*
 Still More Partisans in the Way of Silence,
 1957
Edition 40
36.8 × 53
(14½ × 20⅞)
Black ink
BS/V lower right
Printed by Spruance?
FLP; PMA; BPL; NGA; LC

386. *Anabasis 6: Great Chargers of Gold Held*
 Up by the Handmaidens Smote the Weariness
 of the Sands, 1957
Edition 40
36 × 51.7
(14¼ × 20⅜)
Black ink
BS/VI lower right
Printed by Spruance?
FLP; PMA; BPL; NGA; LC

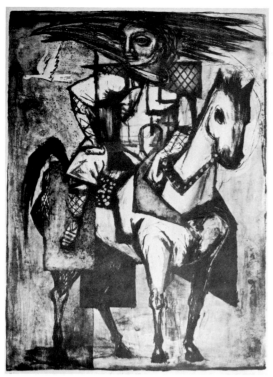

387

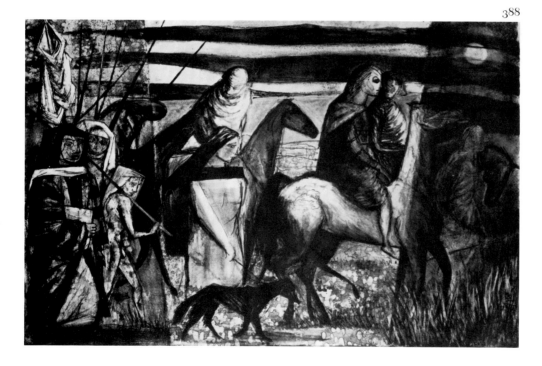

388

387. *Anabasis 7: The Shadow of a Great Bird Falls on My Face*, 1957
Edition 40
52.5 × 35.8
(20⅝ × 14⅛)
Dark green ink
BS/VII lower right
Printed by Spruance?
FLP; PMA; BPL; NGA; LC

388. *Anabasis 8: Roads of the Earth We Follow You. Authority over All the Signs of the Earth*, 1957
Edition 40
36 × 53
(14⅜ × 20⅞)
Black ink
BS/VIII lower right
Printed by Spruance?
FLP; PMA; BPL; NGA; LC

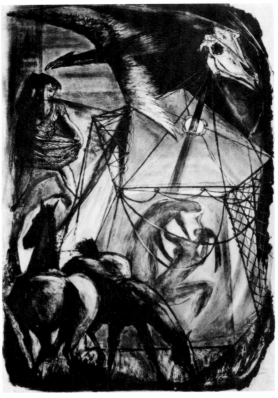

389

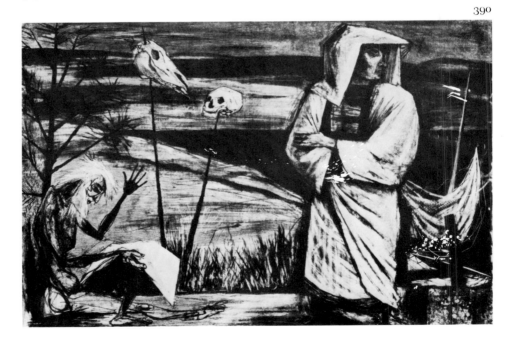

390

389. *Anabasis 9: I Foretell You the Time of Great Blessing and the Bounty of the Evening,* 1957
Edition 40
52.7 × 36
(20¾ × 14¼)
Green-black ink
BS/IX lower right
Printed by Spruance?
FLP; PMA; BPL; NGA; LC

390. *Anabasis 10: Plough-land of Dream! Who Talks of Building?* 1957
Edition 40
36.7 × 51.8
(14½ × 20⅜)
Black ink
BS/X lower right
Printed by Spruance?
FLP; PMA; BPL; NGA; LC

The Prints of Benton
Murdoch Spruance
234

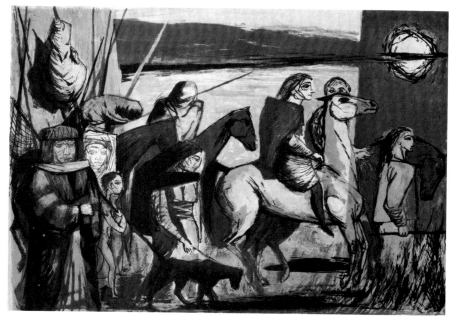

391

392

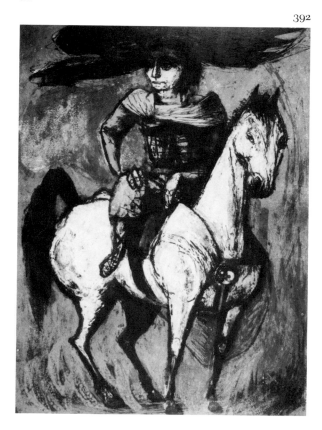

391. *Anabasis—The March*; *Anabasis*, 1957
Edition 30
53 × 60
(17¼ × 23½)
Seven colors (yellow, gold, gray, brown-red,
 tan, brown, black); also impressions of black
 stone alone
Stone unsigned
Printed by Spruance
PMA; BPL; NGA (with related proof material)

392. *Poet on Horseback*, 1958
Edition 20
59 × 42.5
(23⅛ × 16¾)
Seven colors (violet, tan, red-brown, ochre,
 blue-green, brown, black)
BS lower right
Printed by Spruance
FLP

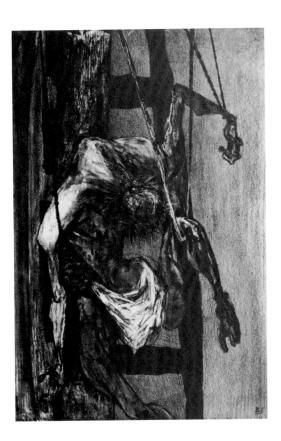

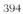

394

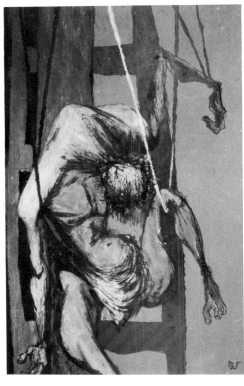

393. *Black Friday*, 1958
Edition 40; 30
51.4 × 32
(20¼ × 12⅝)
Black ink
BS lower right
Printed by Spruance?
FLP

Triptych
A series of three lithographs (cat. nos. 394, 397, 400)

394. Triptych 1: *Black Friday*, 1958
Edition 200 plus 10 artist's proofs
51.6 × 31.8
(20⅜ × 12½)
Four colors (yellow, gray, blue-green, black)
BS lower right
Printed by Cuno?
FLP; PMA; LC
Note: The print was published by the
 International Graphic Arts Society, New York.

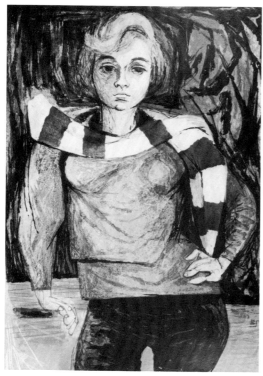

395

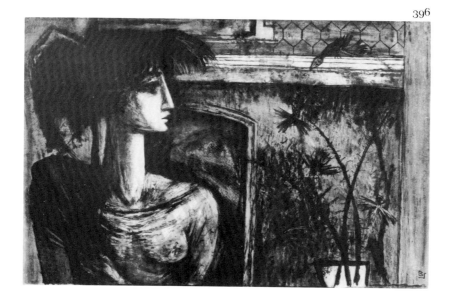

396

395. *Winter Portrait; Winter Portrait—The
 Scarf*, 1958
Edition 25; 30
53 × 34.5
(20⅞ × 13⅝)
Six colors (tan, light orange, yellow, green,
 brown-red, black)
BS lower right
Printed by Spruance
FLP

Note: The print is known in two states; impressions
 exist with a variant black stone in which the
 background area is more fully and evenly
 darkened.

396. *Nests in the Ivy*, 1958
Edition 42; 40
36.2 × 52
(14¼ × 20½)
Two colors (green and black)
BS lower right
Printed by Spruance
FLP; BPL

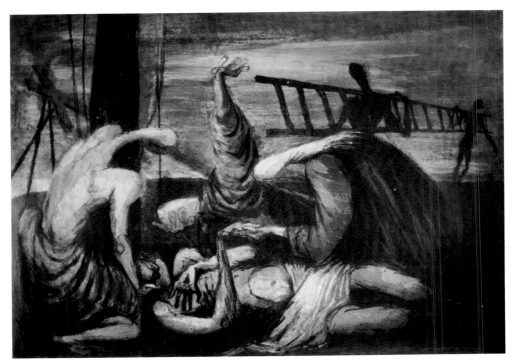

397

398

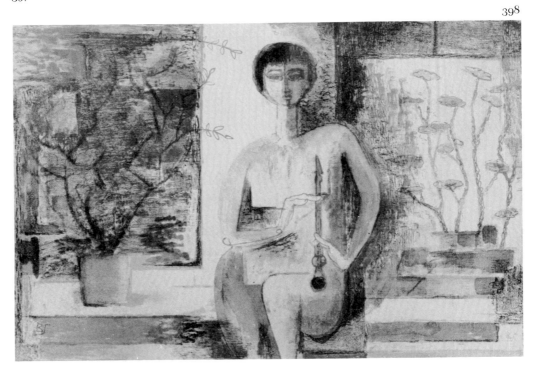

397. Triptych 3: *Pieta—Friday Evening; Friday Evening*, 1958
Edition 30
45.7 × 65.5
(18 × 25¾)
Eight colors (two tans, two greens, violet, blue, red-brown, black)
BS lower right
Printed by Spruance?
FLP; BPL; LC

398. *Figure in a White Studio; White Portrait*, 1958
Edition 20; 40
33.7 × 49.3
(13¼ × 19⅜)
Five colors (two ochres, tan, gray-green, gray-blue)
BS lower right
Printed by Spruance
FLP; PMA

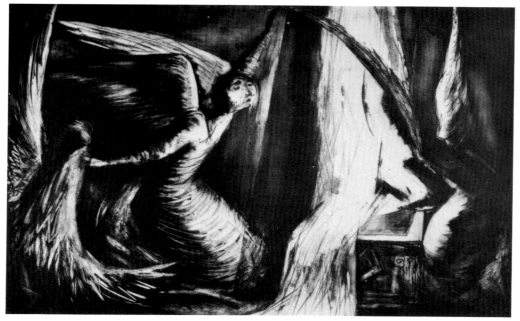

399

400

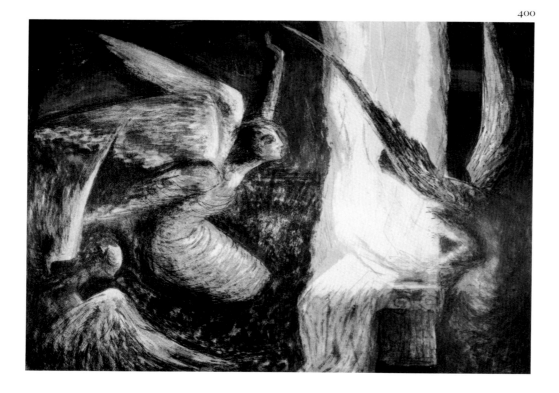

399. *Manifestation with Wings*, 1958
Edition 40
33.7 × 51.2
(13¼ × 20¼)
Black ink
Stone unsigned
Printed by Spruance?
FLP

400. Triptych 2: *Manifestation with Wings*,
 1958
Edition 25; 30
45 × 61
(17¾ × 24)
Ten colors (two grays, two blues, yellow, tan,
 brown, ochre, violet, black)
Stone unsigned
Printed by Spruance?
FLP; BPL; LC

401

402

401. *Boy in Space*, 1958
Edition 20
56.7 × 38.6
(22½ × 15⅜)
Eight colors (two greens, two browns, tan,
 ochre, light orange, black); also impressions
 in black of key line stone alone
BS lower left and lower right
Printed by Spruance?
FLP
Note: The subject is Rudd Canaday, son of art critic
 John Canaday, who was a good friend of the artist.

402. *Summer Sleep*, 1958
Edition 45
39.4 × 57.5
(15½ × 22¾)
Five colors (two blues, tan, ochre, black)
BS lower right
Printed by Spruance?
FLP

403

404

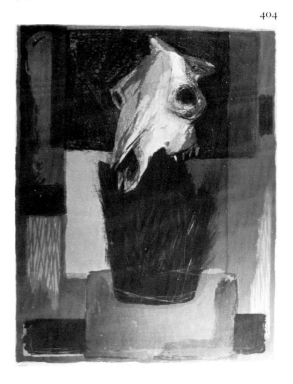

403. *Memory of Germantown*, 1958
Edition 25
42.5 × 55.8
(16¾ × 22)
Seven colors (three greens, gray, pink, tan, brown)
BS lower right
Printed by Spruance?
FLP

404. *Altar*, 1959
Edition 25
61.7 × 44.2
(24¼ × 17⅜)
Eight colors (four greens, pink, violet, brown, black)
Stone unsigned
Printed by Spruance?
FLP

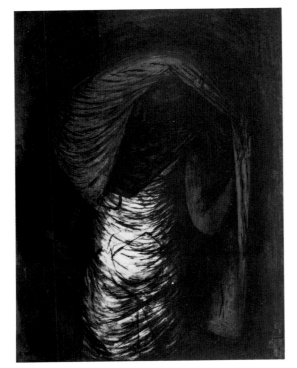

405

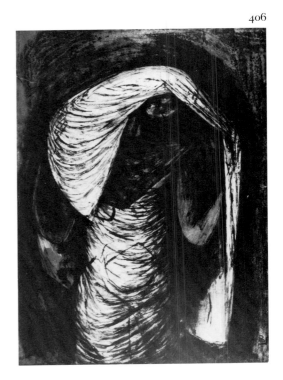

406

405. *Mourning Figure*, 1959
Edition 40; 20
57.4 × 42.5
(22⅝ × 16½)
Three colors (green, brown, black or two greens
 and black); also impressions from black stone
 alone
BS lower right
Printed by Spruance
FLP; LC

406. *White Veil; Mourning Figure*, 1959
Edition 20; 40
57.5 × 42.5
(22⅜ × 16½)
Three colors (gray-green, dark gray, black)
BS lower right
Printed by Spruance
FLP

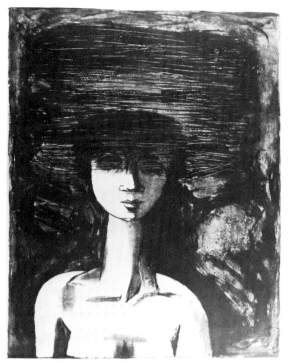

407

408

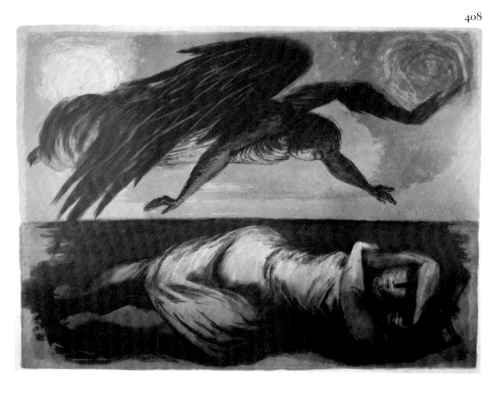

407. *Web of Dream*, 1959
Edition 40
55.5 × 41.3
(21⅞ × 16¼)
Black ink
BS lower right
Printed by Cuno
FLP

408. *Annunciation*, 1959
Edition 35
41 × 52.5
(16⅛ × 20¾)
Eight colors (two greens, blue, black, gray,
 orange, ochre, brown)
BS lower right
Printed by Spruance
FLP

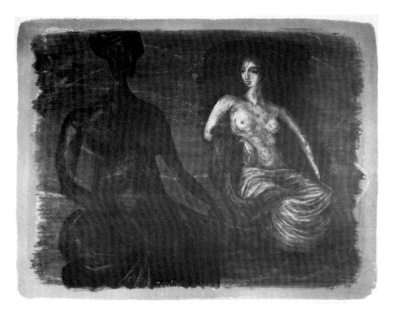

409

410

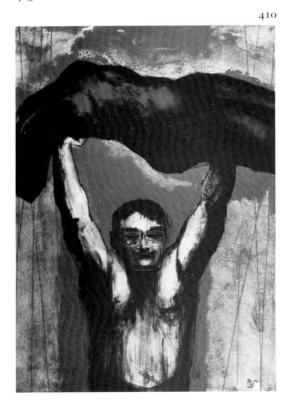

409. *Worship of the Past*, 1959
Edition 30; 40
43 × 53
(17 × 21⅛)
Four colors (tan, gray, brown, black)
BS lower right
Printed by Spruance
FLP
Note: The 1967 Philadelphia College of Art exhibition
 catalogue (see Selected Bibliography) notes impres-
 sions in black alone. It is not clear whether these
 are considered part of the edition. None have been
 seen by present cataloguers.

410. *Pygmalion*, 1959
Edition 40
49.2 × 32.7
(19½ × 12⅞)
Two colors (blue-green and black)
BS lower right
Printed by Spruance?
FLP

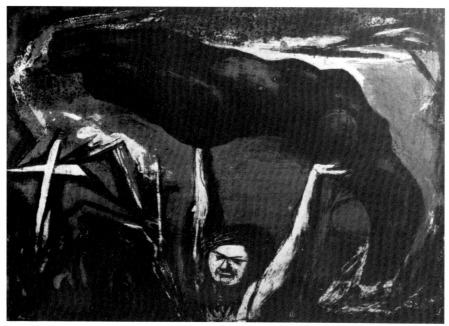

411

412

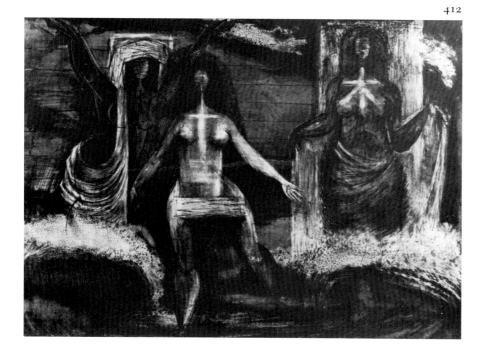

411. *Triumph of Pygmalion*, 1959
Edition 15
44.3 × 59.7
(17¾ × 23½)
Two colors (gray-green and black)
BS lower right
Printed by Spruance?
FLP

412. *Return of the Goddess*, 1959
Edition 25; 30
46.9 × 63.2
(18⁷⁄₁₆ × 24⅞)
Eight colors (two tans, two blue-greens,
 gray-blue, red, ochre, black)
BS lower right
Printed by Spruance
FLP

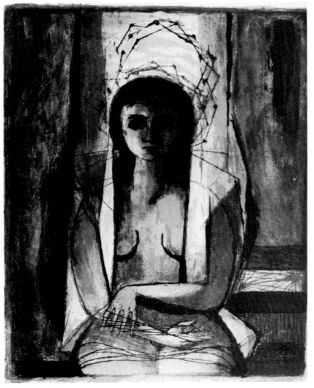

413

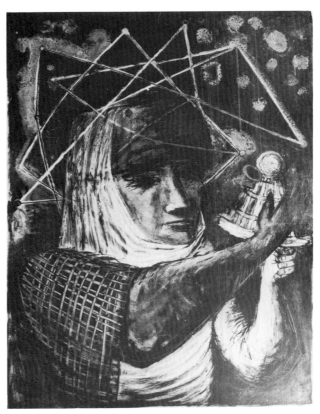

414

413. *Penelope?* 1959?
Edition unknown
61.5 × 48
(24⅛ × 18¾)
Nine colors (two tans, two gray-greens, yellow,
 orange, red, brown, black)
Stone unsigned
Printed by Spruance?
FLP

Seamarks
A series of five lithographs (cat. nos. 414–18)

414. *Seamarks 1: Master of Stars*, 1959
Edition 30
50.7 × 37
(20 × 14½)
Black ink
BS lower right
Printed by Spruance?
FLP; NGA
Note: Fletcher notes a color version; no such
 impression has been located by the present
 cataloguers.

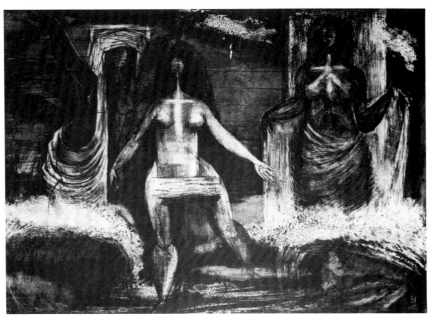

415

416

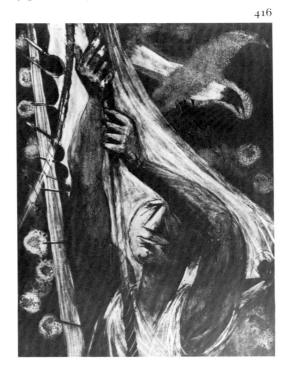

415. *Seamarks 2: The Tragediennes Come to the Ocean; The Tragediennes,* 1959
Edition 30
40 × 52.3
(15¾ × 20⅝)
Black ink
BS lower right
Printed by Spruance?
FLP; NGA

416. *Seamarks 3: Stranger Whose Sail,* 1960;
1959
Edition 30
50.4 × 36.7
(19⅞ × 14½)
Black ink
BS lower right
Printed by Spruance?
FLP; NGA

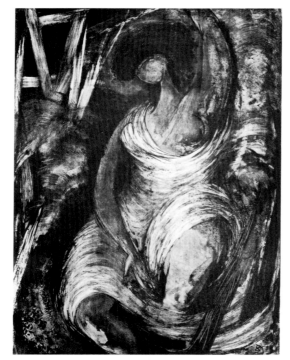

417

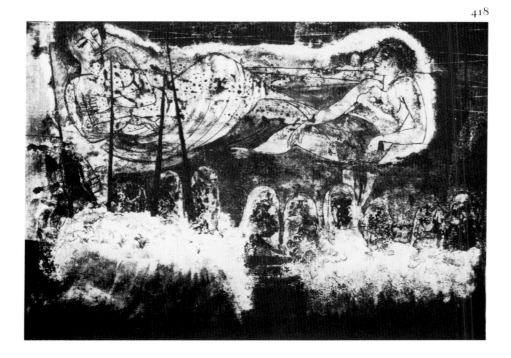

417. *Seamarks 4: O Sea Which Swells in Our Dreams; Poetess of the Sea*, 1960
Edition 30
50.7 × 36.6
(20 × 14⅜)
Black ink
BS lower right
Printed by Spruance?
FLP; NGA
Note: Fletcher notes a color version; no such impression has been located by the present cataloguers.

418. *Seamarks 5: The Patrician Women on Their Terraces*, 1960
Edition 30
39 × 52
(15⅝ × 20⁷⁄₁₆)
Black ink
Stone unsigned
Printed by Spruance?
NGA

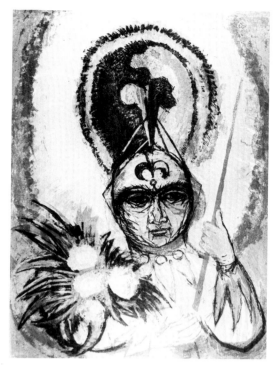

419

420

419. *Mummer*, 1960
Edition 20
60.3 × 44.3
(23¾ × 17½)
Six colors (tan, yellow, orange, green, brown,
 black)
BS lower right
Printed by Spruance
FLP

420. *Mummer's Day*, 1960
Edition 20
47.5 × 63.3
(18¾ × 24⅞)
Seven colors (two oranges, two greens, pink,
 tan, brown-violet)
BS lower right
Printed by Spruance
FLP

421

422

421. *Artemis*, 1960
Edition 26
63.9 × 49
(25⅛ × 19⁵⁄₁₆)
Five colors (four greens and black)
BS lower right
Printed by Spruance
FLP; LC

422. *Odysseus*, 1960
Edition 25
67.2 × 42.9
(26½ × 16⅞)
Seven colors (two greens, light gray, tan, blue,
 brown, black)
BS lower right
Printed by Spruance
FLP; LC

423

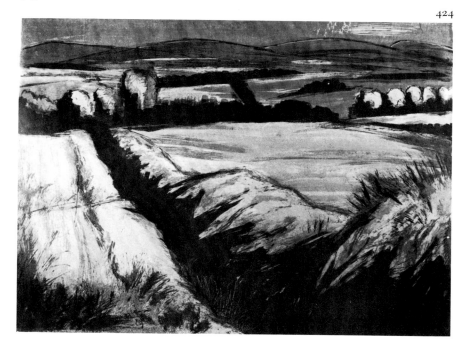

424

423. *Angel with the Trumpet; Revelation—*
Angel, 1960
Edition 40
42.3 × 57.4
(10¹¹⁄₁₆ × 22⅝)
Seven colors (two greens, two blue-greens, tan,
yellow, black)
BS lower center
Printed by Spruance
FLP (with related proof material); PMA

Gettysburg
A series of three lithographs (cat. nos. 424–26)

424. *Gettysburg—July 1—The Cut*, 1960
Edition 25
49.2 × 66.5
(19⅜ × 26¼)
Five colors (four greens and black)
BS lower left
Printed by Spruance
FLP

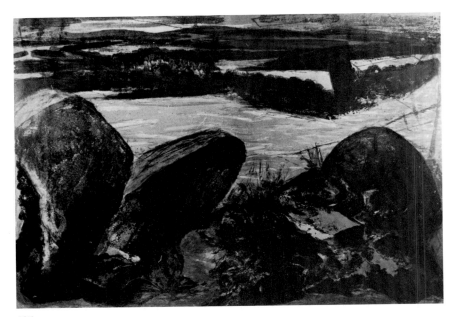

425

426

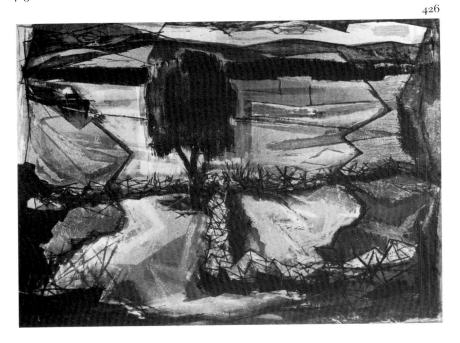

425. *Gettysburg—July 2—Little Round Top,*
 1960
Edition 25
49.5 × 70.2
(19½ × 27⅝)
Six colors (three greens, ochre, light blue-gray,
 black)
BS lower right
Printed by Spruance
FLP

426. *Gettysburg—July 3—The Angle,* 1960
Edition 25
65.3 × 49
(25⅝ × 19⅜)
Ten colors (five greens, two golds, gray-blue,
 orange, black)
Stone unsigned
Printed by Spruance
FLP

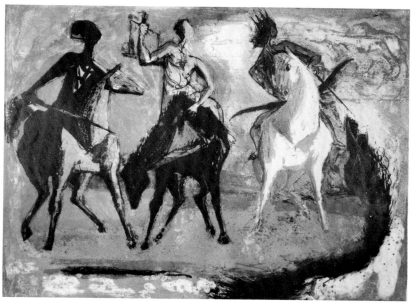

427

428

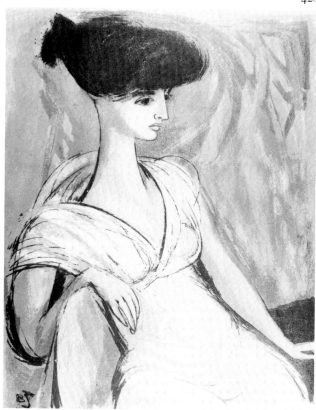

427. *The Fourth Seal*, 1960
Edition 25
47 × 61.5
(18⅝ × 24¼)
Four colors (two gray-greens, brown, black)
Stone unsigned
Printed by Spruance
FLP

428. *White Portrait; White Figure*, 1960; 1959
Edition 20
57.3 × 43
(22⅝ × 17)
Seven colors (two browns, tan, yellow, ochre,
 light blue-green, green)
BS lower left
Printed by Spruance
FLP; LC

Catalogue Raisonné
253

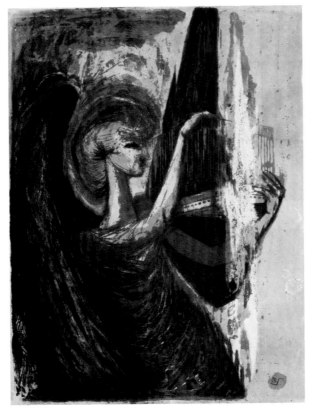

429

430

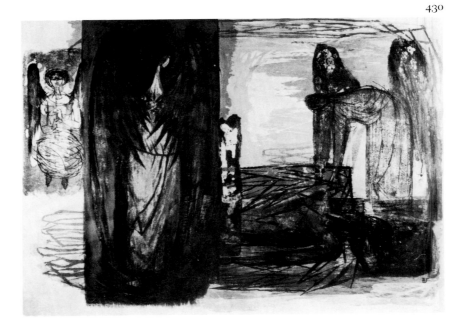

429. *Angel with Freed Bird*, 1961
Edition 25
70 × 50.8
(27⅝ × 20)
Six colors (three greens, two browns, ochre)
BS lower right
Printed by Spruance
FLP; NGA

430. *Icarus with Angels; Icarus Mourned*,
 1961, 1963
Edition 27; 30
52.5 × 73.2
(20¾ × 28⅞)
Ten colors (four greens, yellow, yellow-orange,
 red, red-violet, brown, black)
BS lower right
Printed by Spruance
FLP

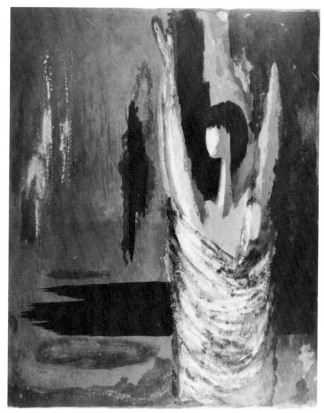

431

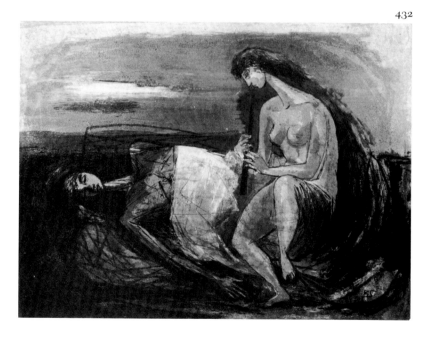

432

431. *I—Lazarus*, 1961
Edition 26; 25
61 × 45.2
(24 × 17⅞)
Six colors (two browns, gray, blue, green, black)
Stone unsigned
Printed by Spruance
PMA; LC

432. *The Sea—Icarus*, 1961
Edition 25
47 × 60.6
(18½ × 23⅞)
Nine colors (four greens, two tans, gray,
 green-blue, black)
BS lower right
Printed by Spruance
FLP; LC

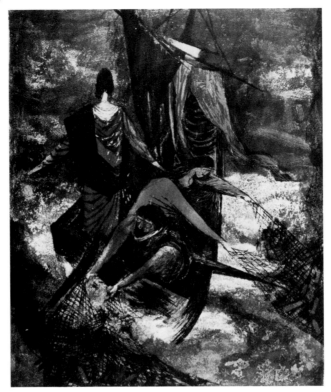

433

434

433. *The Sea—Galilee*, 1961
Edition 25
58 × 45.5
(22⅞ × 18)
Nine colors (three greens, tan, gray, light blue,
 red, brown, black)
Stone unsigned
Printed by Spruance
FLP

434. *Bird Shapes*, 1961
Edition 25
38 × 66.5
(15 × 26⅛)
Six colors (two tans, ochre, gray-blue, brown,
 black)
BS lower right
Printed by Spruance
FLP

435

436

435. *Galilee; The Sea—Galilee*, 1961
Edition 29; 31
62.7 × 46.5
(24¾ × 18¼)
Black ink
Stone unsigned
Printed by Bohuslav Horak at Tamarind
 Lithography Workshop, Inc., with
 blindstamps of printer and workshop
FLP; NGA
Note: Tamarind records show a bon à tirer, three trial
 proofs, nine Tamarind impressions, and twenty-two
 numbered impressions.

436. *Dark Bed*, 1961
Edition 28; 29
47 × 72.5
(18½ × 28¾)
Four colors (tan, blue-green, brown, black)
Stone unsigned
Printed by Spruance
FLP; LC

437

438

437. *Two Figures*, 1961
Edition 25
51.2 × 73
(20⅛ × 28¾)
Ten colors (three greens, two browns, two tans,
 yellow, orange, black)
BS lower right
Printed by Spruance
FLP; NGA

438. *Damascus Road*, 1961
Edition unknown
72.5 × 50
(19¾ × 28½)
Nine colors (four greens, two browns, tan,
 orange, gray-blue)
BS lower right
Printed by Spruance
FLP

439

440

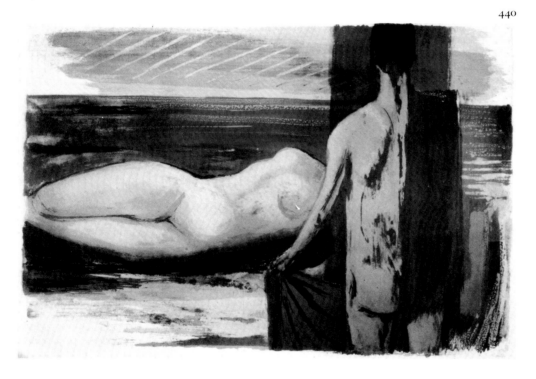

439. (Two angels), 1961?
Edition unknown
41.5 × 58
(16½ × 23)
Six colors (two greens, two violets, tan, ochre)
BS (twice) lower right
Printed by Spruance
FLP

440. (Standing draped man and lying female
 torso), 1961?
Edition unknown
48 × 69.5
(19 × 27½)
Nine colors (four greens, three browns, tan,
 black)
Stone unsigned
Printed by Spruance
FLP

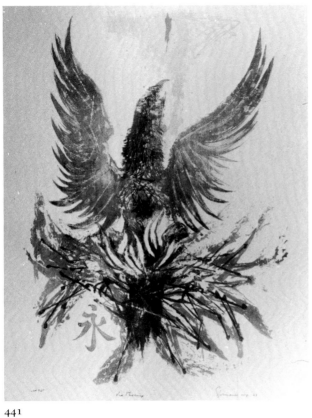

441

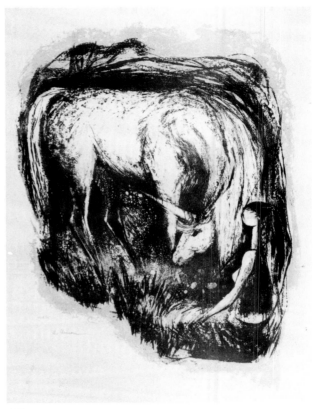

442

Fabulous Beastiary
A series of four lithographs (cat. nos. 441–44)
from a proposed group of six: *The Minotaur* and
The Mermaid were included as drawings in the
Associated American Artists exhibition in 1962
(see Selected Bibliography); we have seen no
evidence that the lithographs were produced.

441. Fabulous Beastiary: *The Phoenix*, 1961;
 1962
Edition 35
56.6 × 38.3
(22¼ × 15⅛)
Three colors (tan, red, yellow)
BS lower right
Printed by Spruance
FLP

442. Fabulous Beastiary: *The Unicorn*, 1962
Edition 35
55 × 41.2
(21½ × 16⅛)
Two colors (pink and brown)
Stone unsigned
Printed by Spruance
FLP
Note: Fletcher notes an edition in black ink; no such
 impressions have been located by the present
 cataloguers.

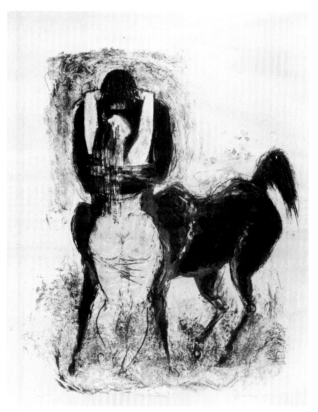

443

444

443. Fabulous Beastiary: *The Centaur*, 1962
Edition 35
53.4 × 41
(21¼ × 16)
Four colors (three greens and yellow)
BS lower right
Printed by Spruance
FLP
Note: The print is known in two states; impressions exist (private collection) prior to addition of green grasses at bottom and right edge of image; also, Fletcher notes an edition in black ink; no such impressions have been located by the present cataloguers.

444. Fabulous Beastiary: *The Sphinx*, 1962
Edition 35
58.4 × 40
(22¾ × 16)
Four colors (two greens, tan, black)
BS center right
Printed by Spruance
FLP
Note: Fletcher notes an edition in black ink; no such impressions have been located by the present cataloguers.

445

446

445. *Orpheus in Hell*, 1962
Edition 25
72 × 51
(28¾ × 20⅛)
Four colors (gray-green, blue, gray, black); also
 impressions in two greens only
BS lower right
Printed by Spruance
FLP

446. *Eagle in the Sky*, 1962
Edition 30
47.7 × 62.3
(18¾ × 24½)
Six colors (two greens, two browns, blue, black)
Stone unsigned
Printed by Spruance
FLP

447

448

447. *Eagle in the Sun*, 1962
Edition 8
47.7 × 61.9
(18⅞ × 24⁵⁄₁₆)
Four colors (tan, gray, blue, ochre)
BS lower right
Printed by Spruance
FLP

448. *Persons Reaching*, 1962
Edition 30
46.4 × 62
(18⅛ × 24⅜)
Four colors (tan, yellow, green, red-brown)
Stone unsigned
Printed by Spruance
FLP

449

450

449. *The Ladder*, 1962
Edition 30
72.3 × 49
(28⅜ × 19¼)
Eight colors (four greens, tan, violet, blue,
 black)
BS lower left
Printed by Spruance
FLP

450. *Trumpeter*, 1962
Edition 25
68 × 45.7
(26¾ × 18)
Three colors (light gray-green, red, black)
Stone unsigned
Printed by Spruance
FLP

451

452

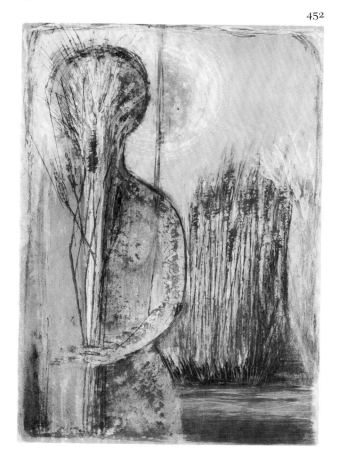

451. *Elements*, 1962; 1963
Edition 25; 20
46 × 24
(18⅛ × 23⅞)
Five colors (tan, gray-blue, green, brown,
 black)
Stone unsigned
Printed by Spruance
FLP

452. *Woman Offering Life*, 1963
Edition 20
62.7 × 43.2
(24⅝ × 17)
Six colors (two gray-greens, yellow, gold, tan,
 brown)
Stone unsigned
Printed by Spruance
Beaver College (Eunice Leopold Collection)

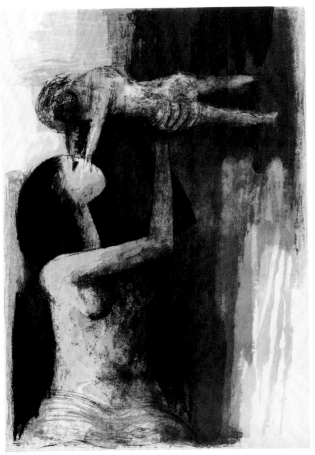

453

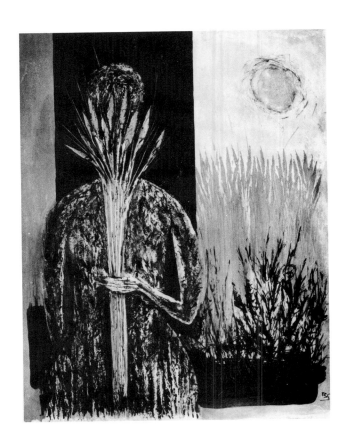

454

453. *Mother and Child,* 1963
Edition 30; 25
69 × 46
(27¼ × 18)
Six colors (two tans, blue [or gray], light green,
 brown, black)
Stone unsigned
Printed by Spruance
Beaver College (Eunice Leopold Collection)

454. *Woman Offering Life No. 2,* 1963
Edition 30
65 × 49.3
(25¾ × 19⅜)
Four colors (yellow, ochre, light orange, gray)
BS lower right
Printed by Desjobert
FLP

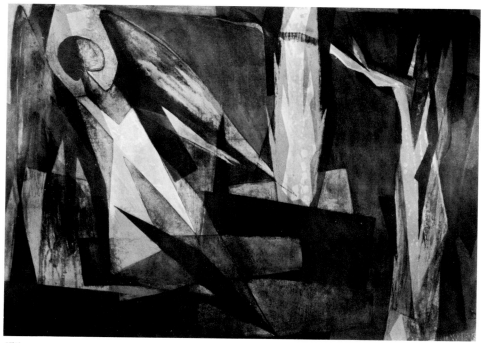

455

456

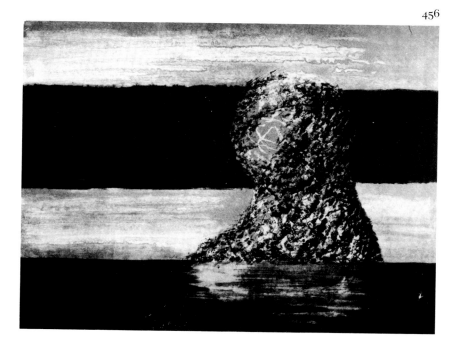

455. *In Homage to a Barn; Homage to a Barn;*
 Resurrection—The Flame, 1963
Edition 25; 30
53.7 × 72.9
(21³⁄₁₆ × 28⅝)
Six colors (two greens, tan, yellow, blue, black)
BS lower right
Printed by Desjobert
FLP

456. *Colossus,* 1963
Edition 30
46.1 × 60
(18⅛ × 23⅝)
Two colors (gray-green and black)
Stone unsigned
Printed by Desjobert
FLP

457

458

457. *Living Rocks*, 1963
Edition 30
46.4 × 63.8
(18¼ × 25⅛)
Five colors (two greens, blue, tan, black)
Stone unsigned
Printed at UM Grafik
FLP; NGA

458. *Northern Minotaur*, 1963
Edition 30
57.5 × 35.5
(22¾ × 14)
Two colors (brown and black)
Stone unsigned
Printed at UM Grafik
FLP; NGA

459

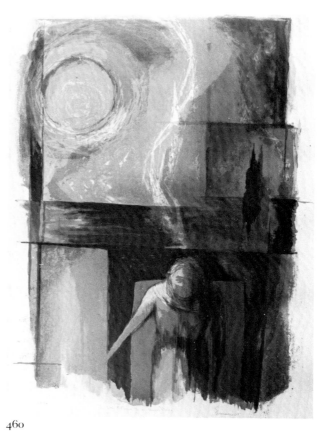

460

459. *Minotaur with Bronze Horns; Northern
 Minotaur with Copper Horns*, 1963
Edition 30
58 × 37
(23¾ × 14⅛)
Five colors (gray, tan, brown, blue, green)
Stone unsigned
Printed at UM Grafik
FLP; NGA

460. *Low Entrance to a High Place*, 1963
Edition 30
63 × 45.5
(24⅞ × 18)
Six colors (two browns, gray, yellow, tan, blue)
Stone unsigned
Printed at UM Grafik
FLP; NGA

Catalogue Raisonné
269

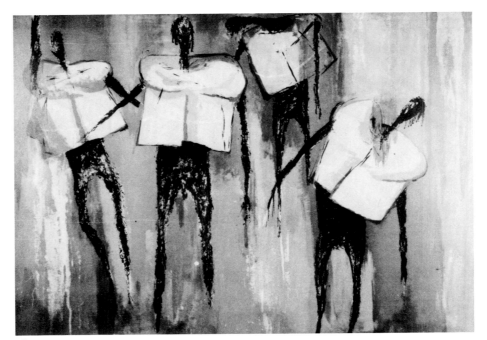

461

462

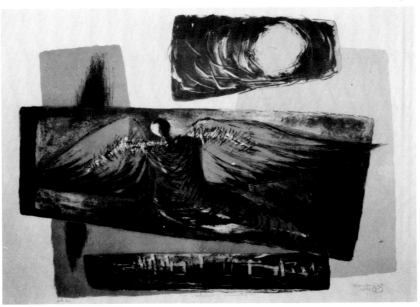

461. *The Survivors,* 1963
Edition 30
48.9 × 65.7
(19⅜ × 25⅞)
Seven colors (three greens, tan, orange, blue,
 gray)
Stone unsigned
Printed by at UM Grafik
FLP

462. *Daedalus Celebrated; In Praise of
 Daedalus,* 1963
Edition 30
41.9 × 54.5
(16½ × 21½)
Four colors (tan, gray-green, brown, orange)
Stone unsigned
Printed at Curwen Press, Ltd.?
FLP

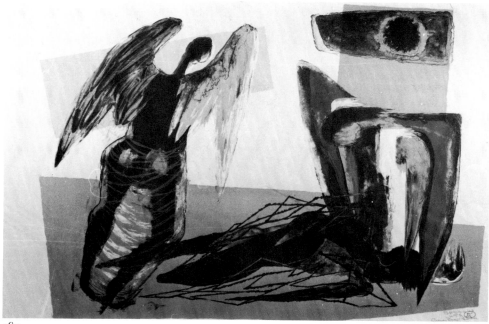

463

464

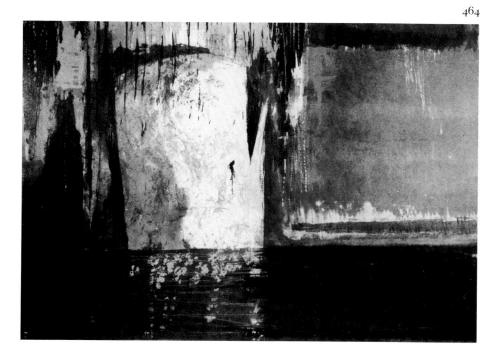

463. *Icarus Mourned; Icarus with Burnt
 Wings*, 1963
Edition 30
45.5 × 62
(17¾ × 24³⁄₁₆)
Four colors (yellow, tan, brown, green)
Stone unsigned
Printed at Curwen Press, Ltd.?
FLP

464. *Spectre of Moby Dick*, 1963
Edition 25; 20
47.4 × 66.5
(18¾ × 26⅛)
Seven colors (five greens, tan, brown)
Stone unsigned
Printed by Spruance
FLP; NGA

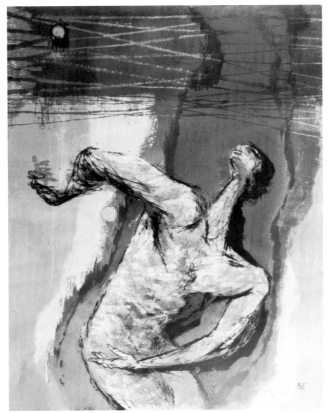

465

466

465. *Juggler*, 1963; 1962; 1965
Edition 25
68.3 × 50
(27 × 19¾)
Six colors (two tans, two blues, gray-green,
 black)
BS lower right
Printed by Spruance
FLP

466. *Islands*, 1963; 1962
Edition 15
39.5 × 56.4
(15½ × 22³⁄₁₆)
Four colors (two greens, ochre, blue)
Stone unsigned
Printed by Spruance
FLP

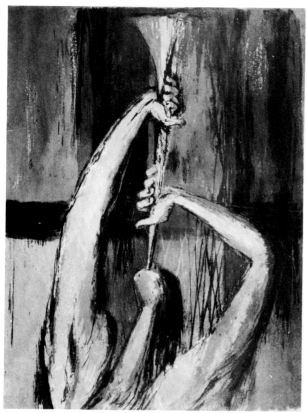

467

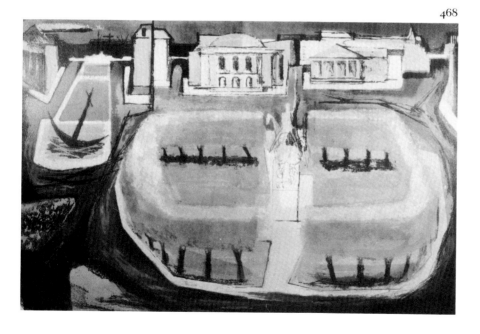

468

467. *Joshua*, 1963; 1962
Edition 25
62 × 44.4
(24⅜ × 17⅜)
Seven colors (three greens, two oranges, two
 browns)
BS lower right
Printed by Spruance
FLP

468. *Monuments—Copenhagen*, 1964
Edition 20; 30
48.2 × 69.6
(19 × 27⅜)
Seven colors (four greens, tan, orange, brown)
Stone unsigned
Printed by Spruance
FLP

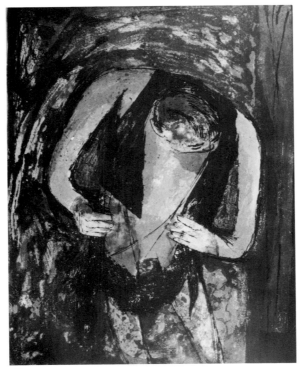

469

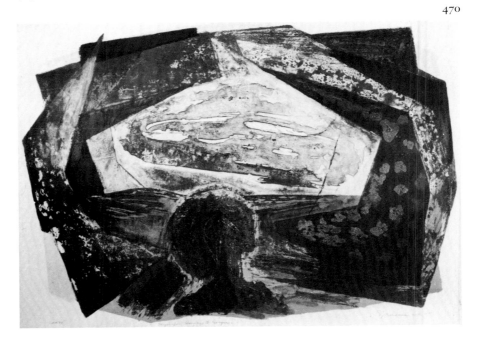

469. *Man Carrying His Dog Home; Man Carrying His Dog*, 1964
Edition 25
59.2 × 45
(23⅜ × 17⅝)
Five colors (two greens [or pink and green], ochre, brown, black)
Stone unsigned
Printed by Spruance
FLP

470. *Skyscape—Homage to Hodgson; Skyscape—to Ralph Hodgson; Homage to Ralph Hodgson*, 1964
Edition 25; 30
52 × 74
(20½ × 29)
Six colors (two greens, two browns, yellow, orange)
Stone unsigned
Printed by Spruance
FLP

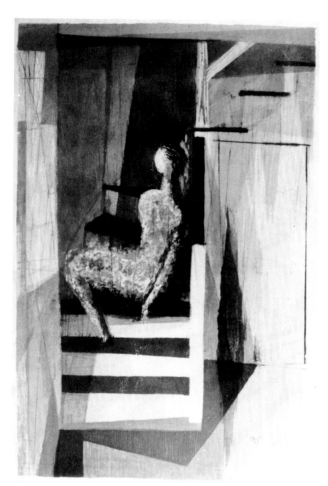

471

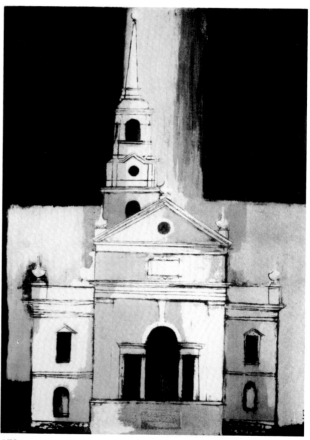

472

471. *Studio Stairs*, 1964
Edition 30; 25
62 × 37.5
(24½ × 14⅞)
Five colors (two tans, yellow, green, brown)
BS lower right
Printed by Spruance
FLP

472. *City Church*, 1964
Edition 45
60.8 × 43
(24 × 16¹⁵⁄₁₆)
Four colors (three greens and brown)
Stone unsigned
Printed by Spruance
FLP; NGA
Note: The building is Christ Church, Philadelphia;
the print was published by the Philadelphia Print
Club for the benefit of its Prints in Progress
program.

Catalogue Raisonné

473

474

473. *Dogs and Broken Gallows*, 1964
Edition 20
47.4 × 65.3
(18⅝ × 25¾)
Five colors (two grays, two greens, brown)
BS lower right
Printed by Spruance
FLP

474. *Priapus*, 1964
Edition 25
44.7 × 59.2
(17⅝ × 23⅜)
Six colors (two greens, two browns, blue, yellow)
Stone unsigned
Printed by Spruance
FLP

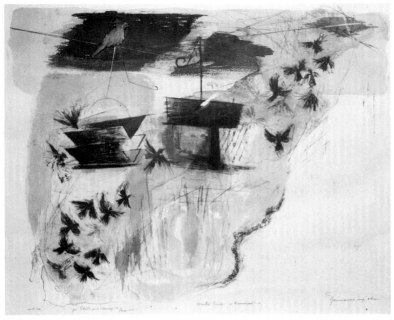

475

476

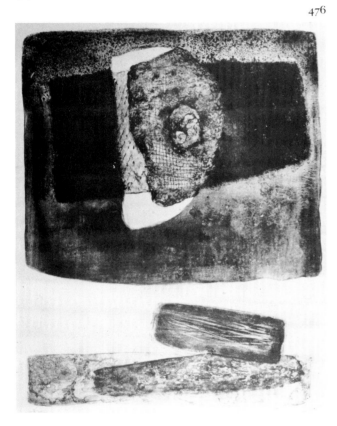

475. *Winter Birds—In Memoriam*, 1964
Edition 20
47·5 × 59·4
(18¾ × 23¼)
Six colors (three greens, yellow, orange, gray)
BS lower right
Printed by Spruance
FLP; NGA
Note: The print was in commemoration of the deaths
by drowning of two grandchildren.

476. *Eclipse*, 1964
Edition 20; 10
57·5 × 43
(22⅝ × 16⅞)
Black ink
Stone unsigned
Printed by Spruance
FLP

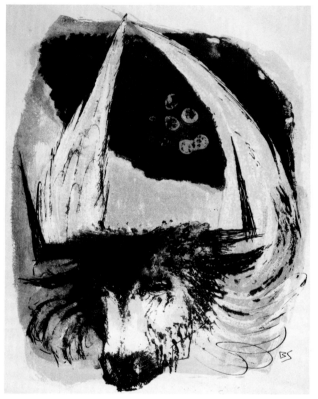

477

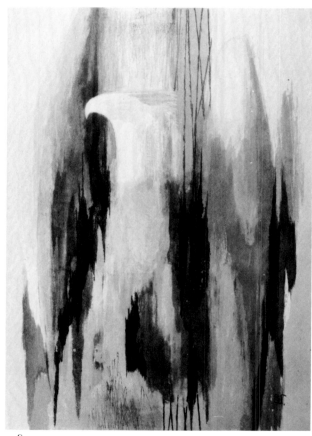

478

477. *Patron Saint*, 1964
Edition 17; 18
38 × 27.3
(15 × 10¾)
Three colors (tan, gray-green, brown)
BS lower right
Printed by Spruance
FLP (with related proof material); PMA; NGA
Note: This is one of eleven prints by eleven artists
presented in a portfolio entitled *For Carl Zigrosser*
produced at the time of Zigrosser's retirement as
Curator of Prints at the Philadelphia Museum
of Art.

The Saints
A series of four lithographs (cat. nos. 478–81)

478. *Saint John, Eagle*, 1964
Edition 25
68 × 46.4
(26¾ × 18³⁄₁₆)
Six colors (two greens, tan, yellow, brown,
gray-blue)
BS lower right
Printed by Spruance
FLP

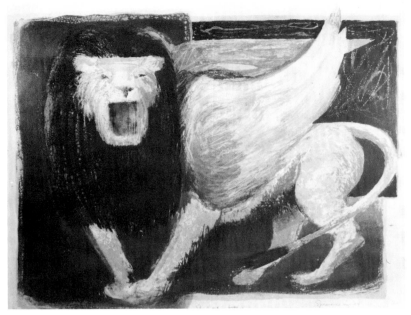

479

480

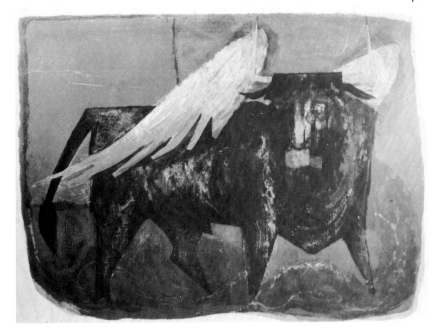

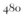

479. *Saint Mark, Lion,* 1964
Edition 25
47.6 × 59
(18¾ × 23⅛)
Six colors (two tans, two greens, orange,
 brown-black)
Stone unsigned
Printed by Spruance
FLP

480. *Saint Luke—Bull,* 1965
Edition 25
48.5 × 61.5
(19 × 24)
Six colors (two blues, two greens, light
 red-violet, brown)
Stone unsigned
Printed by Spruance
FLP

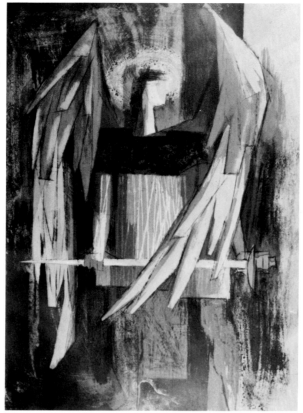

481

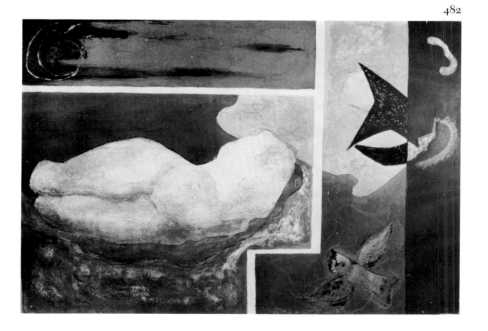

482

481. *Saint Matthew—Angel*, 1965
Edition 25
67.6 × 46.9
(26⅝ × 18½)
Seven colors (three greens, two browns, tan,
 yellow)
BS lower right
Printed by Spruance
FLP

482. *Ariadne and Theseus*, 1965
Edition 25; 22
49 × 69.5
(19⅜ × 27¼)
Eight colors (three blues, two browns, tan,
 orange, gray)
Stone unsigned
Printed by Spruance
FLP

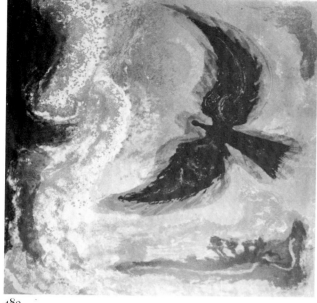

483

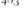

484

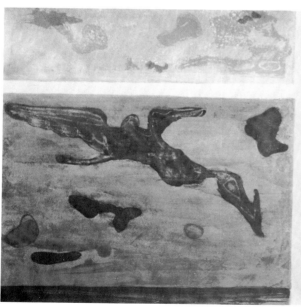

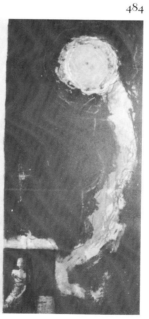

483. *Ariadne and Dionysius*, 1965
Edition 25
68.5 × 48
(27 × 19)
Eight colors (two blues, two greens, tan, pink,
 ochre, brown-black)
Stone unsigned
Printed by Spruance
FLP

484. *Ariadne and Daedalus; Ariadne—The
 Artist*, 1965; 1964; 1963
Edition 25; 30
49.3 × 69.6
(19⅜ × 27½)
Five colors (two greens, blue, red-orange, gray)
Stone unsigned
Printed by Spruance
FLP

Catalogue Raisonné
281

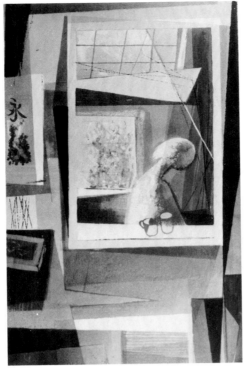

485

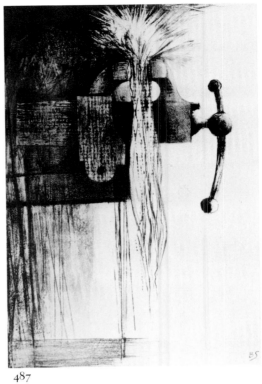

487

486

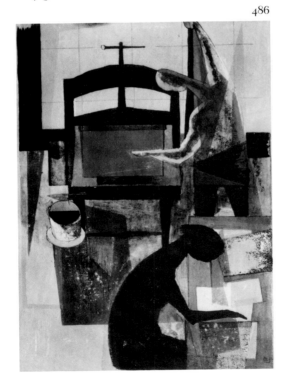

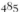

486. *Studio Press*, 1965
Edition 25
61.7 × 43.4
(24⅜ × 17)
Five colors (yellow, tan, blue, brown, black)
BS lower right
Printed by Spruance
FLP

485. *Studio Window*, 1965
Edition 25
62.2 × 38.2
(24½ × 15)
Six colors (three browns, yellow, tan, green)
Stone unsigned
Printed by Spruance
FLP

487. *The Vise*, 1965; 1966
Edition 25; 10
67.5 × 44.3
(29⁹⁄₁₆ × 17⅜)
Black ink
BS lower right
Printed by Spruance
FLP

488

489

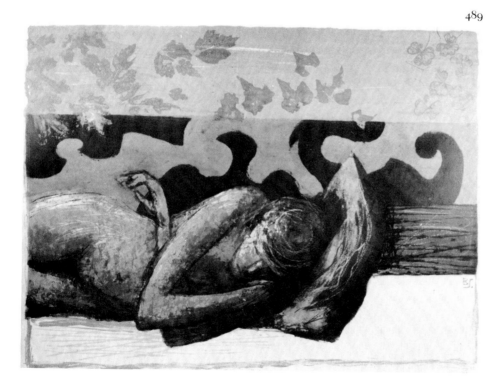

488. *Descent with Fire*, 1965
Edition 25
51.5 × 63.5
(20⅜ × 25)
Five colors (two greens, gray, ochre, black)
BS lower right
Printed by Spruance
FLP

489. *Figure Sleeping; Sleeping Figure*, 1965
Edition 30
51.5 × 66.5
(20⅜ × 26⅛)
Seven colors (three greens, two browns, gray, yellow)
BS right center
Printed by Spruance
FLP

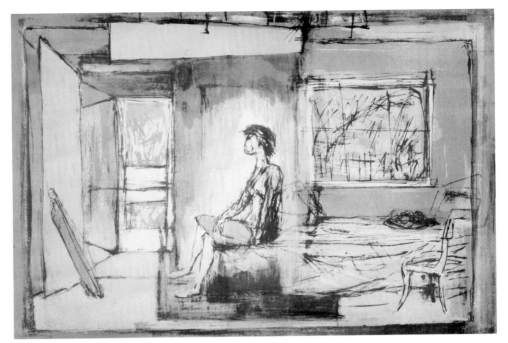

490

491

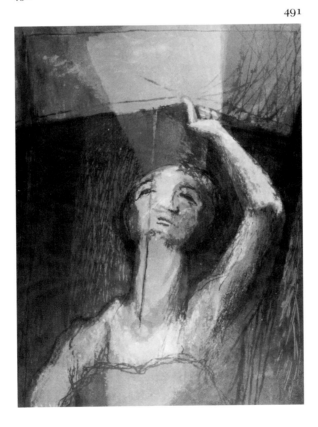

490. *Garden Door*, 1965
Edition 25
51.2 × 72.2
(20⅛ × 28⅜)
Four colors (blue, yellow-green, light brown,
 black)
Stone unsigned
Printed by Spruance
FLP

491. *Shaft of Light*, 1965
Edition 25
65.9 × 47.4
(26 × 18⅝)
Eight colors (three browns, two greens, two
 oranges, ochre)
Stone unsigned
Printed by Spruance
FLP

492

493

Moby Dick: The Passion of Ahab
A series of twenty-six lithographs plus title
page produced from 1965 to 1967 preliminary
to their publication by Barre Publishers in
an offset edition with a text by Lawrance
Thompson. The sheet size of this offset edition
is 40.7 × 55.8 (16 × 22). The edition comprised
450 copies plus 50 deluxe copies with one
original lithograph (cat. no. 527). Several
of the subjects were produced in more than
one version before the published image was
selected. Within each version of each image—
published and others—great variation exists
and many of the proofs are unique; an example
of the range is shown in the two illustrations for
cat. no. 526. Several of the images in the offset
edition were issued in grays rather than colors
because Spruance died before he could complete
the supervision of the project. Published images
are cat. nos. 494–96, 497 (offset edition in
grays), 504–508, 510 (in grays), 511, 512 (in
grays), 513, 514 (in grays), 515–17, 518 (in
grays), 519–20, 522, 523 (in grays), 524–28.

Examples of these offset reproductions have
been mistaken for original lithographs, and
there have been attempts to sell them as such.

492. Moby Dick 1: *First Version of Call Me
Ishmael; Call Me Ishmael,* 1965; 1966
Approximately 10 artist's proofs
69.1 × 36.5
(27⅜ × 14⅜)
Three colors (gray, gray-green, orange)
Stone unsigned
Printed by Spruance
PMA

493. Moby Dick 1: *Call Me Ishmael,* 1965;
1966
Approximately 10 artist's proofs
70 × 39
(27¾ × 15⅜)
Two colors (gray and black)
BS lower right
Printed by Spruance
FLP (AP 2)

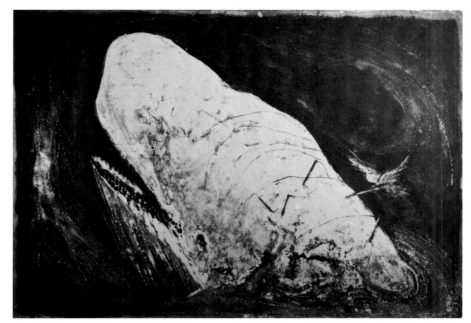

494

495

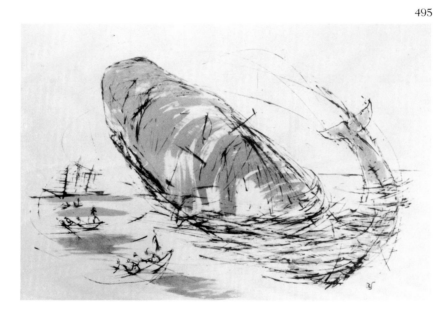

494. Moby Dick 3: *The Whiteness of the
 Whale; The Whale*, 1965; 1966
Approximately 10 artist's proofs
51 × 72
(28½ × 20)
Two colors (gray and blue-green)
BS lower right
Printed by Spruance
FLP (AP 2); PMA (AP 1, related proof material);
 NGA (AP 3, drawings and related proof
 material)

495. Moby Dick 8: *The Jungfrau*, 1965
Approximately 10 artist's proofs
42 × 61
(16½ × 24¼)
Three colors (brown, green, dark gray)
BS lower right
Printed by Spruance
FLP (AP 2); PMA (AP 1); NGA (AP 3, related
 proof material)

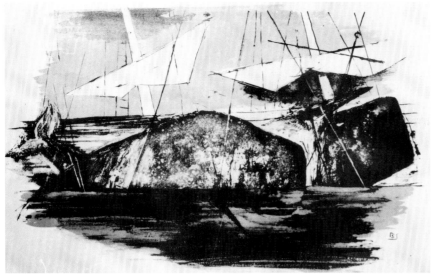

496

497

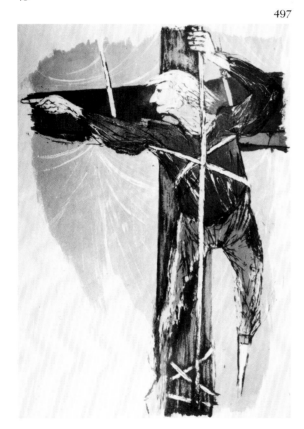

496. Moby Dick 9: *The Rosebud*, 1965; 1966
Approximately 10 artist's proofs
45.5 × 67
(17⅞ × 26½)
Three colors (yellow, green, dark gray)
BS lower right
Printed by Spruance
FLP (AP 2); NGA (AP 3)

497. Moby Dick 18: *Ahab Aloft; Crucifixion of
 Ahab—The Case—1st Day; The Sighting—
 1st Day*, 1965
Approximately 10 artist's proofs
88 × 59
(34⅜ × 23¼)
Five colors (two gray-greens, two gray-blues,
 ochre)
Stone unsigned
Printed by Spruance
FLP (AP 2); PMA (AP 1); NGA (AP 3, drawings
 and related proof material)

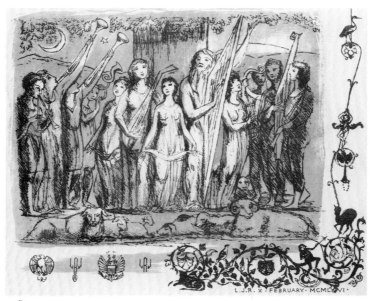

498

499

498. *After Blake's Job* (Lessing J. Rosenwald's birthday print), 1966
Edition 25
41 × 49
(16¼ × 19½)
Two colors (gray and black)
BS lower right
Printed by Spruance
NGA (with related proof material)
Note: The edition was commissioned by Mrs. Rosenwald in honor of her husband's seventy-fifth birthday for distribution to their children and grandchildren.

499. *Angel with Sword,* 1966
Edition 20; 16
42 × 63.5
(16⅝ × 25⅛)
Seven colors (three blues, green, gray, brown, black)
Stone unsigned
Printed by Spruance
FLP

500

501

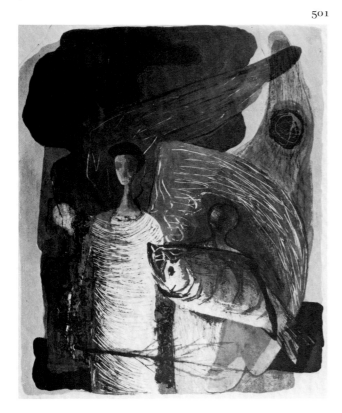

500. *Triumph of the Whale*, 1966
Edition 16
42.6 × 64
(16¾ × 25¼)
Seven colors (two blues, two grays, light brown, tan, black)
Stone unsigned
Printed by Spruance
FLP
Note: Fletcher notes an edition in black ink; no such impressions have been located by the present cataloguers.

501. *Tobias and the Angel*, 1966
Edition 21
67 × 52.3
(26½ × 20½)
Nine colors (four blues, two browns, tan, green, black)
BS lower right
Printed by Spruance
FLP

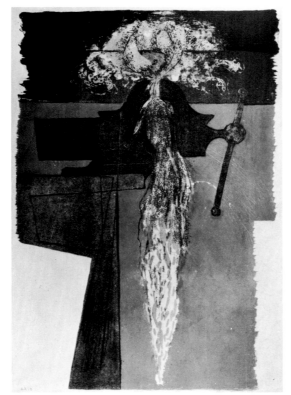

502

503

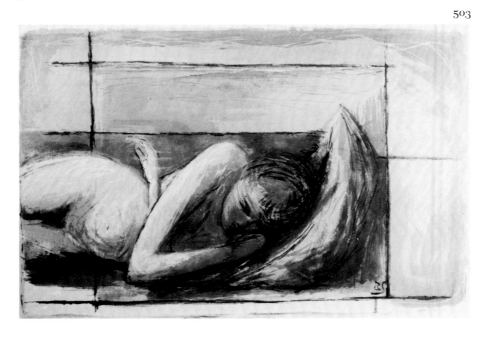

502. *The Vise*, 1966
Edition 15
64.3 × 42.4
(25⅜ × 16½)
Six colors (orange, brown, yellow-green, light
 red, gray, black)
Stone unsigned
Printed by Spruance
FLP

503. *Figure Sleeping; Figure Resting*, 1966
Edition 19; 17
44 × 66.5
(17½ × 26⅛)
Six colors (two blues, gray, yellow, tan, black)
BS lower right
Printed by Spruance
FLP

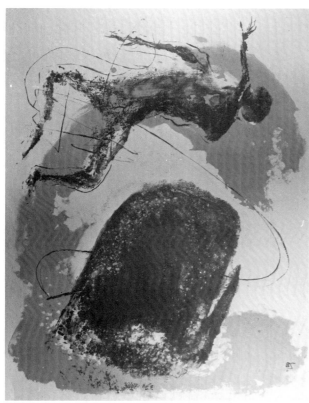

504

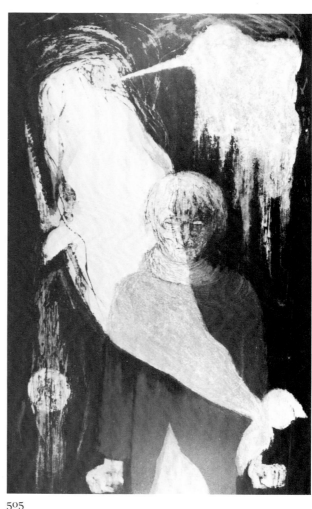

505

504. Moby Dick 2: *Man against Monster;*
Harpooner and Monster; Harpooner against
Monster; The Harpooner, 1966
Approximately 10 artist's proofs
61 × 45.4
(24 × 17⅞)
Three colors (two greens, red)
BS lower right
Printed by Spruance
FLP (AP 2); PMA (AP 1); NGA (AP 3; related
proof material)

505. Moby Dick 4: *Strike through the Mask,*
1966
Approximately 10 artist's proofs
88.5 × 54.3
(34¾ × 21⅜)
Five colors (two greens, blue, gray, black)
Stone unsigned
Printed by Spruance
FLP (AP 2); PMA (AP 1); NGA (AP 3, drawing,
related proof material)

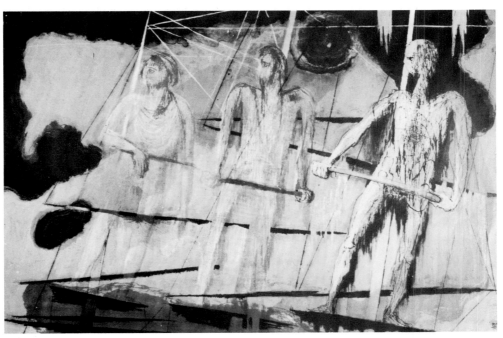

506

507

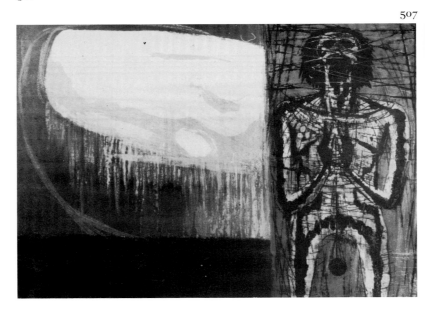

506. Moby Dick 5: *The Albatross; The Ghost
 Ship—Albatross*, 1966
Approximately 10 artist's proofs
60.5 × 87.5
(23¾ × 34½)
Seven colors (four greens, blue, light brown,
 green-black)
BS lower right
Printed by Spruance
FLP (AP 2); PMA (AP 1); NGA (AP 3, related
 proof material)

507. Moby Dick 6: *The Town-Ho*, 1966
Approximately 10 artist's proofs
51.7 × 71
(20⅜ × 27⅞)
Four colors (two greens, brown, green-black)
Stone unsigned
Printed by Spruance
FLP (AP 2); PMA (AP 1); NGA (AP 3, related
 proof material)

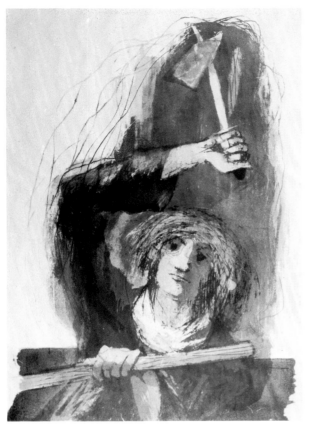

508

509

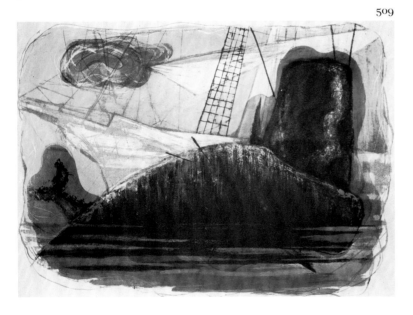

508. Moby Dick 7: *The Jeroboam*, 1966
Approximately 10 artist's proofs
71.5 × 49
(28³/₁₆ × 19⅜)
Nine colors (four greens, two browns, two
 yellows, tan)
Stone unsigned
Printed by Spruance
FLP (AP 2); PMA (AP 1); NGA (AP 3, related
 proof material)

509. Moby Dick 9: *The Rosebud*, 1966, 1967
Approximately 10 artist's proofs
50.5 × 67
(20 × 26)
Five colors (gray, blue, ochre, green,
 blue-black)
Stone unsigned
Printed by Spruance
PMA (AP 1); NGA (AP 3, related proof material)

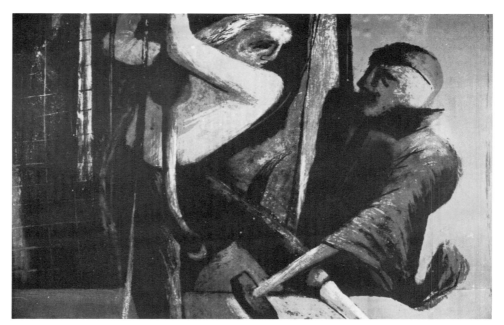

510

511

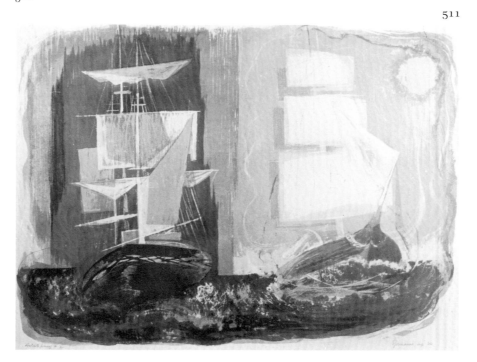

510. Moby Dick 10: *The Samuel Enderby,*
 1966
Approximately 10 artist's proofs
61 × 88.8
(24 × 35)
Four colors (blue, tan, gray, black)
Stone unsigned
Printed by Spruance
FLP (AP 2); PMA (AP 1); NGA (AP 3, related
 proof material)

511. Moby Dick 11: *The Bachelor,* 1966
Approximately 10 artist's proofs
54.8 × 72.4
(21⅜ × 28½)
Six colors (yellow, gold, green, brown, blue,
 black)
Stone unsigned
Printed by Spruance
FLP (AP 2); PMA (AP 1); NGA (AP 3, related
 proof material)

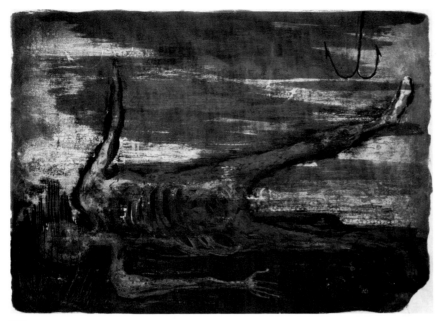

512

513

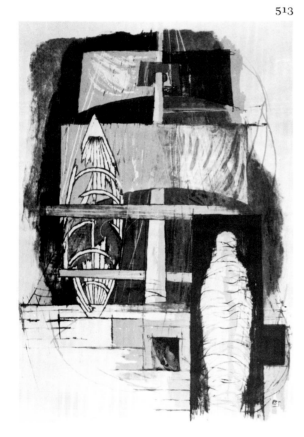

512. Moby Dick 12: *The Rachel*, 1966
Approximately 10 artist's proofs
47 × 62.3
(18½ × 24½)
Five colors (two greens, ochre, tan, black)
Stone unsigned
Printed by Spruance
FLP (AP 2); PMA (AP 1); NGA (AP 3, related
 proof material)

513. Moby Dick 13: *The Delight*, 1966
Approximately 10 artist's proofs
73 × 50.8
(28¾ × 20)
Three colors (light brown, blue-green, black)
BS lower right
Printed by Spruance
FLP (AP 2); PMA (AP 1); NGA (AP 3, related
 proof material)

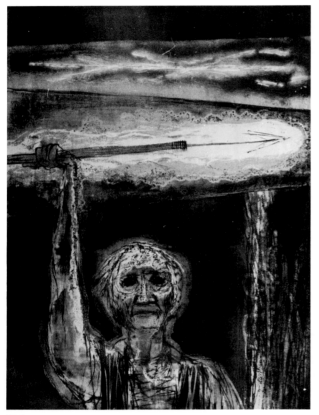

514

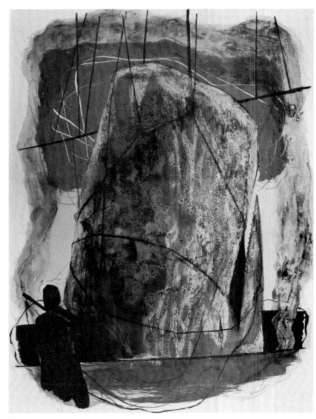

515

514. Moby Dick 14: *The Burning Harpoon;*
 The Candles; Ahab—and the Candles, 1966
Approximately 10 artist's proofs
73 × 52
(28¾ × 20½)
Three colors (light green-blue, gray-green,
 black)
Stone unsigned
Printed by Spruance
FLP (AP 2); PMA (AP 1); NGA (AP 3, related
 proof material)

515. Moby Dick 15: *The Sphinx and Ahab,*
 1966
Approximately 10 artist's proofs
73.5 × 53.2
(29 × 21)
Five colors (two browns, light green, blue,
 black)
BS. lower right
Printed by Spruance
FLP (AP 2); PMA (AP 1); NGA (AP 3, related
 proof material)

516

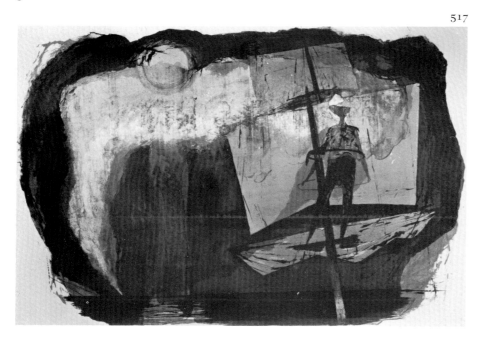

517

516. Moby Dick 16: *The Blue Whale; Book of Job—The Leviathan; Job's Leviathan*, 1966
Approximately 10 artist's proofs
66.7 × 50.2
(26¼ × 19½)
Four colors (brown, blue, green, black)
Stone unsigned
Printed by Spruance
FLP (AP 2); PMA (AP 1); NGA (AP 3)

517. Moby Dick 17: *The Spirit Spout*, 1966
Approximately 10 artist's proofs
61.4 × 89
(24³⁄₁₆ × 35)
Six colors (two gray-blues, two greens, tan, black)
Stone unsigned
Printed by Spruance
FLP (AP 2); PMA (AP 1); NGA (AP 3, related proof material)

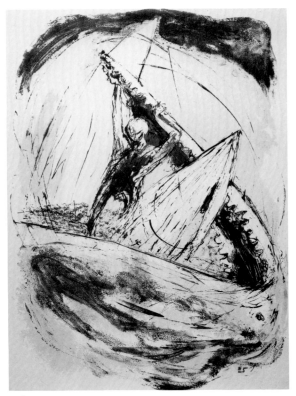

518

519

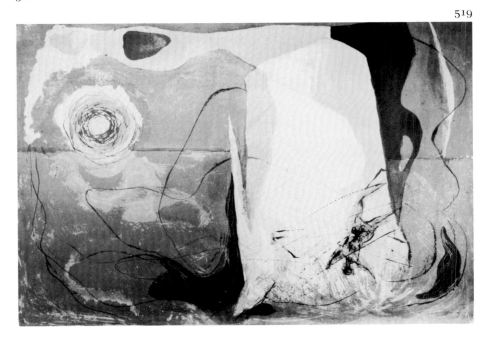

518. Moby Dick 19: *Ahab in the Jaws; The First Encounter*, 1966
Approximately 10 artist's proofs
87 × 59
(34½ × 23)
Four colors (two greens, green-yellow, gray)
BS lower right
Printed by Spruance
FLP (AP 2); PMA (AP 1); NGA (AP 3, related proof material)

519. Moby Dick 20: *The Death of Fedallah; The Prophecy—Fedallah's Death*, 1966, 1965
Approximately 10 artist's proofs
62.8 × 88.3
(24¾ × 34¾)
Seven colors (two ochres, two greens, brown, gray, black)
Stone unsigned
Printed by Spruance
FLP (AP 2); PMA (AP 1); NGA (AP 3, related proof material)

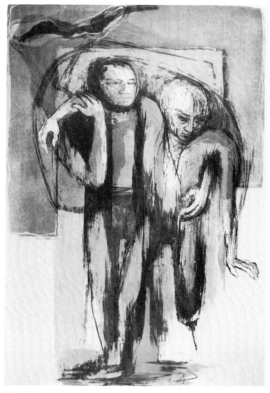

520

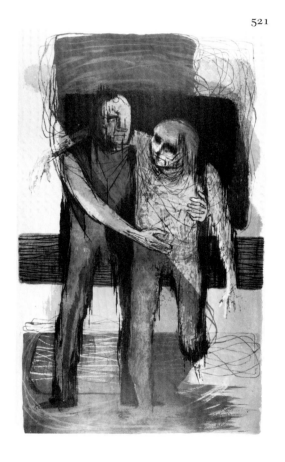

520. Moby Dick 21: *Ahab and Starbuck;*
 Starbuck and Ahab; Ahab with Starbuck,
 1966
Approximately 10 artist's proofs
88.8 × 56.8
(35 × 22⅜)
Four colors (gray, ochre, tan, brown-black)
BS lower right
Printed by Spruance
FLP (AP 2); PMA (AP 1); NGA (AP 3, related
 proof material)

521. Moby Dick 21: *Ahab and Starbuck,* 1966
Approximately 10 artist's proofs
87.4 × 51.7
(34⅜ × 20½)
Eight colors (three greens, two browns, orange,
 green-blue, black)
BS lower right
Printed by Spruance
FLP

Catalogue Raisonné

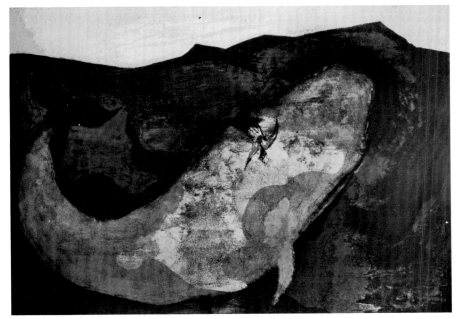

522

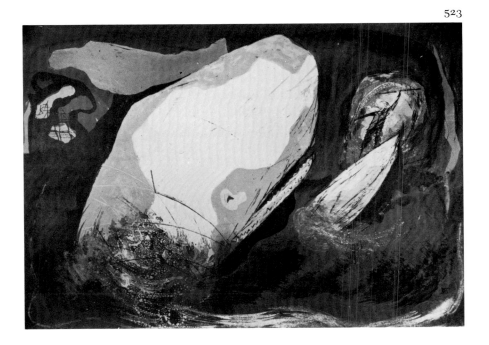

522. Moby Dick 22: *The Death of the Pequod*,
 1966
Approximately 10 artist's proofs
62.2 × 88.2
(24½ × 34¾)
Five colors (tan, green, blue-green, brown,
 black)
Stone unsigned
Printed by Spruance
FLP (AP 2); PMA (AP 1); NGA (AP 3, related
 proof material)

523. Moby Dick 23: *The Last Thrust; The
 Thrust; The Last Thrust—Ahab's Death*,
 1966
Approximately 10 artist's proofs
61 × 87.3
(24 × 34⅜)
Six colors (three greens, tan, brown, black)
BS lower right
Printed by Spruance
FLP (AP 2); PMA (AP 1); NGA (AP 3, related
 proof material)

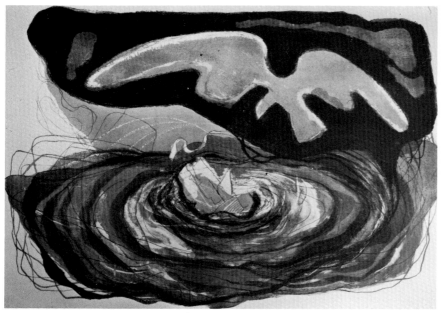

524

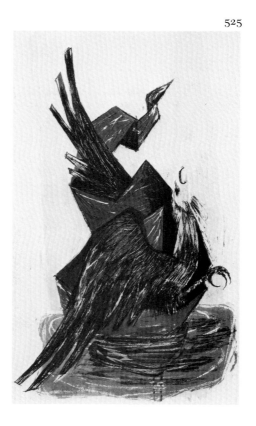

525

524. Moby Dick 24: *The Vortex*, 1966
Approximately 10 artist's proofs
56 × 79
(22 × 31⅛)
Six colors (two greens, yellow, ochre, gray-blue, black)
Stone unsigned
Printed by Spruance
FLP (AP 2); PMA (AP 1); NGA (AP 3, related proof material)

525. Moby Dick 25: *The Skyhawk; The Sea Eagle*, 1966
Approximately 10 artist's proofs
87 × 48
(34¼ × 19¼)
Four colors (ochre, blue-green, gray-brown, black)
Stone unsigned
Printed by Spruance
FLP (AP 2); PMA (AP 1); NGA (AP 3, related proof material)

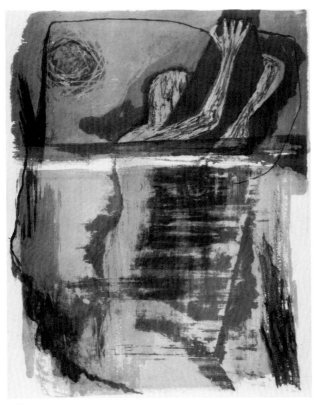

526a

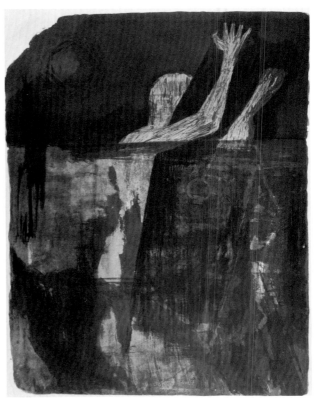

526b

526a, 526b. Moby Dick 26: *Epilogue*; *Ishmael, the Epilogue*, 1966
Approximately 10 artist's proofs
66.5 × 49.5
(26¼ × 19½)
Five colors (three greens, gray-blue, brown-black)
Stone unsigned
Printed by Spruance
FLP (AP 2); PMA (AP 1); NGA (AP 3, related proof material)
Note: The two illustrations give some idea of the range possible with proofs of the same image.

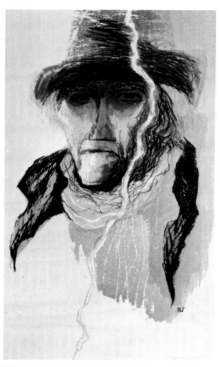

527

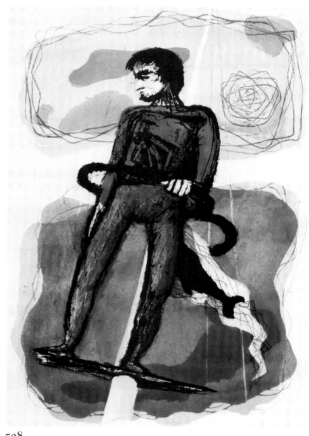

528

527. Moby Dick Title Page: *Master of the
Pequod*, 1967
Edition 50
46 × 25
(18¼ × 10)
Six colors (three greens, tan, light brown,
 yellow-ochre)
BS lower right
Printed by Spruance
FLP (with related proof material and
 preparatory drawing [see fig. 16]); NGA
 (AP 3, related proof material)

528. Moby Dick 1: *Ishmael; Call me Ishmael;
The Whale Watch—Ishmael*, 1967
Approximately 10 artist's proofs
72.5 × 50.5
(28½ × 19¾)
Six colors (two blue-greens, tan, violet, light
 brown, black)
Stone unsigned
Printed by Spruance
FLP (AP 2); NGA (AP 3)

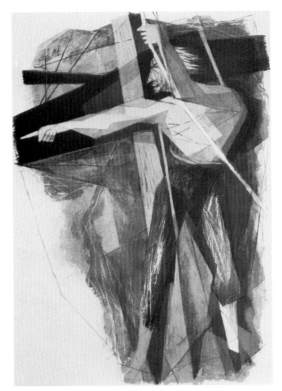

529

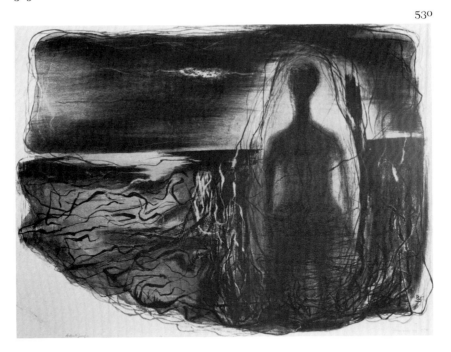

530

529. Moby Dick 18: *Ahab Aloft; The
 Sighting—1st Day; Ahab Aloft—The First
 Day's Chase,* 1967
Approximately 10 artist's proofs
95 × 65
(35¾ × 23¾)
Five colors (yellow, gray, brown, gray-blue,
 green)
BS lower right
Printed by Spruance
PMA (AP 1); NGA (AP 3)

530. *Figure in a Deserted Landscape; Figure
 in a Desert,* 1967
Edition 20
52 × 67.5
(20½ × 26½)
Four colors (light brown, orange, blue-green,
 black)
BS lower right
Printed by Spruance
FLP

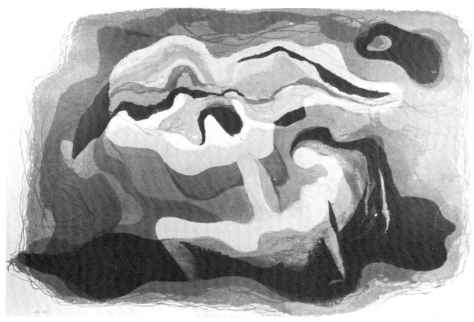

531

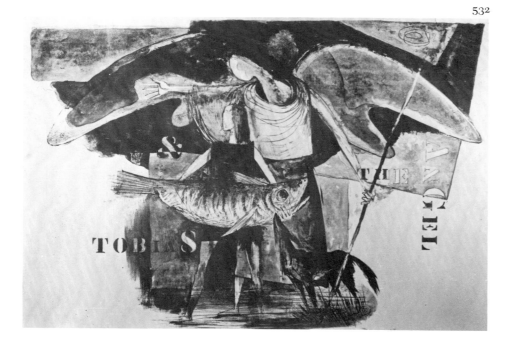

532

531. *Mother of Birds*, 1967
Edition 25
46.3 × 67.5
(18¼ × 26¾)
Seven colors (two grays, two yellow-greens,
 blue, orange, black)
BS lower right
Printed by Spruance
FLP

532. *Tobias and the Angel*, 1967
Edition 40
51.7 × 73.7
(20⅜ × 29)
Gray-green ink
Stone unsigned
Printed by Paul Narkiewicz
FLP; PMA
Note: The print was published by the Philadelphia
 Print Club; their blindstamp appears in lower left.

533

534

533. (The unicorn), 1967
Edition unknown (about 50?)
51.5 × 40
(20¼ × 15⅗)
Gray ink
Stone unsigned
Printed at Curwen Press, Ltd.
FLP
Note: According to annotations by Mrs. Spruance,
 this is an unfinished image for which additional
 colors were planned.

534. (The unicorn), 1967
Edition unknown (about 50?)
59 × 47.5
(23 × 18¼)
Black ink
Stone unsigned
Printed at Curwen Press, Ltd.
FLP
Note: See note to cat. no. 533.

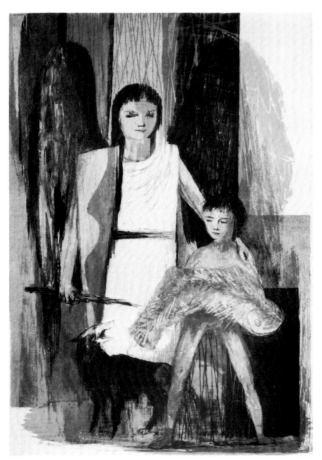

535

536

535. *Tobias and the Angel*, 1967
Edition 20
70 × 46
(27¾ × 18⅛)
Seven colors (three greens, ochre, red-violet,
 red-brown, black)
Stone unsigned
Printed by Spruance
FLP

536. *Night Figure*, 1967
Edition 17
71 × 47.8
(27¾ × 18⅞)
Three colors (blue, dark-gray, black)
Stone unsigned
Printed by Spruance
FLP

537

538

537. (Village church), 1925
Etching
A few proofs
9.7 × 7.3
(3⅞ × 3)
Brown ink
Plate unsigned
Printed by Spruance?
FLP

Note: The print is known in two states, both in FLP:
state 1 with additions drawn in ink and pencil; state
2 with further additions drawn in ink—reworking
shows development of sky in particular, but there is
additional work throughout; state 2 is reproduced.

538. (The woodsmen), 1925
Etching
A few proofs
20 × 15.1
(8 × 6)
Black ink
Plate unsigned
Printed by Spruance?
FLP

539

540

539. (Polo), 1925
Drypoint
A few proofs
10 × 12.5
(4 × 5)
Brown ink
Plate unsigned
Printed by Spruance
FLP

Note: The print is known in two states, both in FLP:
 state 1 has pencil additions throughout; state 2 is
 reproduced.

540. (The ride), 1925
Etching
A few proofs
15 × 20.2
(5⅞ × 8)
Brown ink
Plate unsigned
Printed by Spruance?
FLP

Note: Two proofs in FLP are inscribed "first state"; no
 later states have been located.

Catalogue Raisonné
309

541

542

541. (Go down!), 1925
Etching
A few proofs
9.7 × 12.6
(3⅞ × 5)
Brown ink
Plate unsigned
Printed by Spruance?
FLP

Note: The print is known in three states, all in FLP,
 showing minor changes to the horse at the far right;
 state 3 is reproduced.

542. (The match), 1925
Drypoint
A few proofs
10.1 × 13.9
(4 × 5½)
Brown ink
Plate unsigned
Printed by Spruance?
FLP

543

544

543. (Benjamin Franklin Bridge), 1925
Etching
A few proofs
10 × 7.5
(3 $^{15}/_{16}$ × 2 $^{15}/_{16}$)
Brown ink
Plate unsigned
Printed by Spruance?
FLP

544. (The welders), 1926
Drypoint
A few proofs
20 × 15
(7 $^{7}/_{8}$ × 5 $^{7}/_{8}$)
Impressions in both black and brown ink
Plate unsigned
Printed by Spruance?
FLP

545

546

545. (Philadelphia Museum of Art under
 construction), 1926
Etching
A few proofs
20 × 15
(7⅞ × 5⅞)
Black ink
Plate unsigned
Printed by Spruance?
FLP

546. (Seated nude), c. 1953?
Aquatint
Two posthumous impressions known
30 × 22.6
(11¹³⁄₁₆ × 8⅞)
Black ink
Plate unsigned
Printed in 1982 by Cindi Ettinger
FLP (with copper plate)

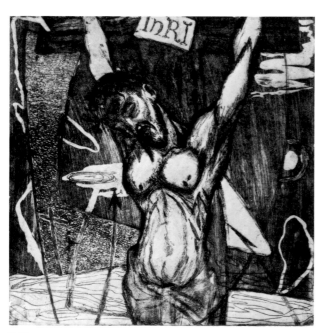

547

548

547. (Christ on the Cross), c. 1953?
Aquatint
Two Posthumous impressions known
24.7 × 23.5
(9¾ × 9¼)
Black ink
Plate unsigned
Printed in 1982 by Cindi Ettinger
FLP (with copper plate)

548. *Minotaur's Death; Minotaur*, 1953
Aquatint
Edition 30
30.3 × 22.7
(11¹⁵⁄₁₆ × 8¹⁵⁄₁₆)
Gray-brown ink
BS lower right
Printer unknown
FLP (copper plate only); PMA

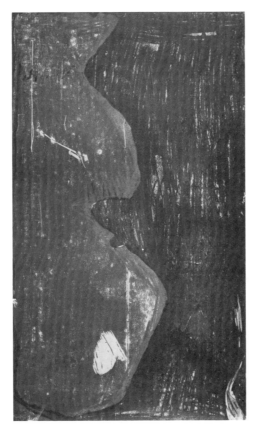

549a

549b

WOODCUTS
(CAT. NOS. 549–552)

549a, 549b. *Book of Job; Jehovah and Satan,*
 1951
Woodcut
Edition 20
45.9 × 25.5
(18 × 10⅛)
Four colors (brown, tan, red-orange, yellow)
Block unsigned
Printed by Spruance?
FLP; PMA
Note: The print is known in two states; both are
 reproduced.

The Prints of Benton
Murdoch Spruance

550

550. *The Word and Job*, 1951
Woodcut
Edition unknown
46 × 29.2
(18¼ × 11⅝)
Black ink
BS lower right
Printed by Spruance?
PMA

551. (Head of a drum majorette), c. 1951?
Woodcut
Edition unknown
35.7 × 29.4
(14⅛ × 11½)
Three colors (tan, red, black)
Block unsigned
Printed by Spruance?
FLP

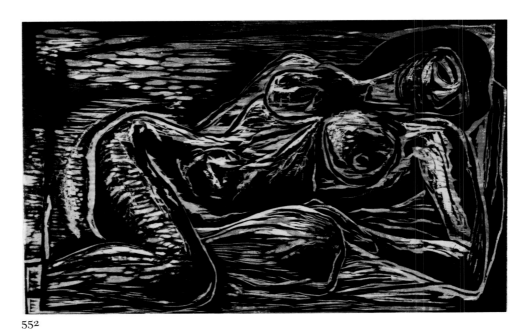

552

553

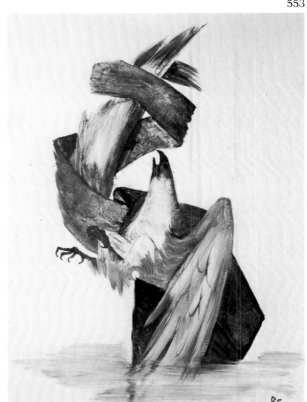

552. *Reclining Nude*, c. 1951?
Woodcut
Edition unknown
29.5 × 46
(11⅝ × 18⅛)
Two colors (green and black); also impressions of
 black block alone
Block unsigned
Printed by Spruance?
FLP

553. *Skyhawk, No. 1*, 1965
Unique impression with a second, lighter
 impression from a second printing without
 reinking
53 × 38.4
(20¾ × 15¼)
Gray ink
BS lower right
Printed by Spruance
NGA (both impressions)

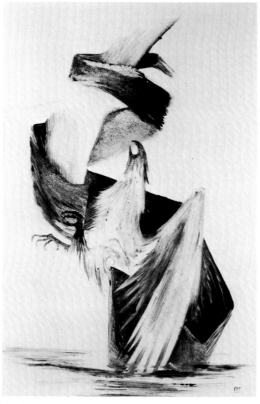

554

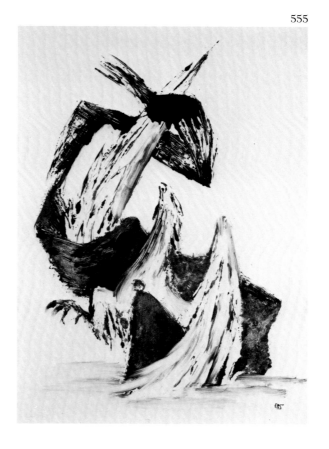

555

554. *Skyhawk, No. 2,* 1965
Unique impression with a second, lighter
 impression from a second printing without
 reinking
52.8 × 33.2
(20¾ × 13⅛)
Two colors (gray and green)
BS lower right
Printed by Spruance
NGA (both impressions)

555. *Skyhawk, No. 3,* 1965
Unique impression with a second, lighter
 impression from a second printing without
 reinking
50 × 34.1
(19½ × 13½)
Gray ink
BS lower right
Printed by Spruance
NGA (both impressions)

MONOTYPES
(Cat. nos. 553–555)

Catalogue Raisonné
317

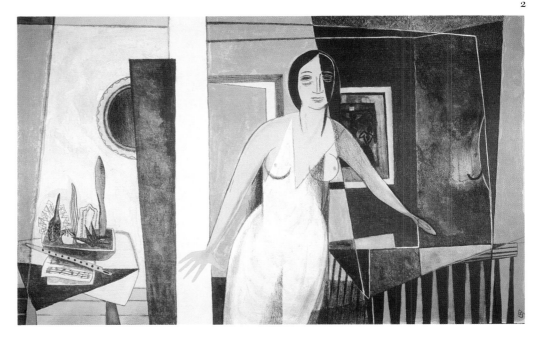

1

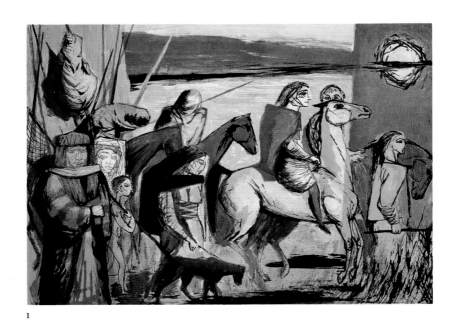

2

Plate 1: *Somnambulist*, 1948, cat. no. 271

Plate 2: *Anabasis—The March*, 1957, cat. no.
391

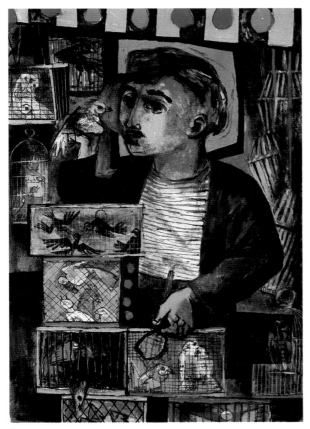

3

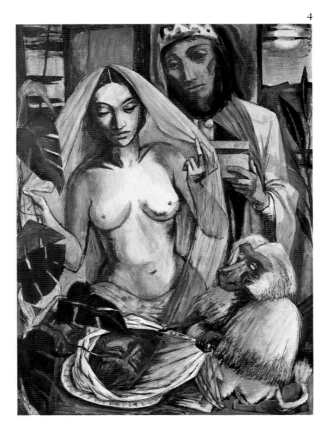

4

Plate 3: *Saint Francis—The Market*, 1953, cat.
no. 326

Plate 4: Vanities II: *Salome—and John*, 1950,
cat. no. 292 (hand-colored black proof)

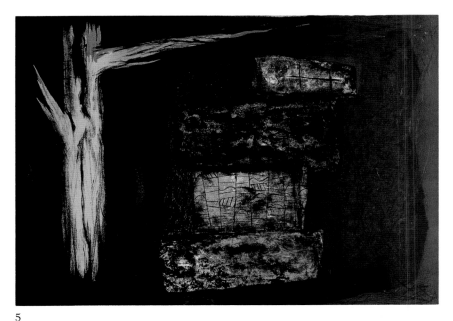

5

6

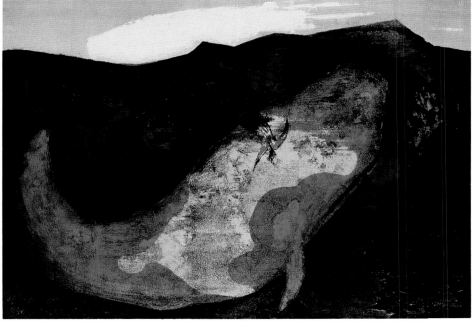

Plate 5: *Living Rocks*, 1963, cat. no. 457

Plate 6: Moby Dick: *The Death of the Pequod*, 1966, cat. no. 522 (Artist's Proof 3)

List of Omissions

The following works, cited in the Fletcher checklist or noted elsewhere, have not been located by the present cataloguers. It is possible, however, that they are represented in the preceding catalogue under variant titles and/or dates.

LITHOGRAPHS
Saints and Angels, 1929
Edward Potter, 1929
Portrait of Manning Lee, 1930
Demolition, 1930
Tina in White (Mrs. Manning Lee), 1931
Reclining Figure (W.G.S.), 1931
Café America, 1933
Arthur Fink, 1933
Poor People, 1933
Collect for Peace, 1933
Backfield Threat, 1937

The Living Among the Dead, 1941
Portrait 1943—The Family, 1943
The Unveiling, 1944
The Initiates, 1951
Studio Chair with Jeb, 1952
Clown, 1952
Prometheus III, 1952
Drachma, 1954
Dark Angel, 1955
Return of Odysseus, 1956
Hieratic Figure, 1958
Resurrection (Angel at the Tomb), 1958
Bird Watchers, 1959
The Argument: Life or Death, 1959
Portrait of Eloise (The Blonde Portrait), 1961
Ariadne and Dionysius, 1963
Finale . . . Victory, 1967

ETCHINGS
The Hunting Call, 1925

Selected Bibliography

Note: With few exceptions, the only checklists given are of Spruance's one-man exhibitions, and the only exhibition reviews and articles are those specifically about Spruance and his work. Also, although the artist's activities are closely chronicled in Beaver College bulletins and news sheets throughout his tenure there—1926–1967—few are included here because important information is documented in more readily available sources. General references are listed alphabetically; catalogues, articles, and reviews are listed chronologically.

GENERAL REFERENCES

American Prints Today/1962, 55, 70. Exh. cat. New York, 1962.

Beall, Karen F. *American Prints in the Library of Congress: A Catalog of the Collection*, 463–64. Baltimore, 1970.

Fine, Ruth E. *Lessing J. Rosenwald: Tribute to a Collector*, 218, 219. Exh. cat. Washington, 1982.

Original Etchings, Lithographs and Woodblocks by American Artists; American Artists Group, Inc., Cat. No. 1, 37. New York, 1936.

Original Etchings, Lithographs and Woodcuts Published by the American Artists Group, Inc., 43, illus. 33. New York, 1937.

Philadelphia: Three Centuries of American Art. 557–59. Exh. cat. Philadelphia, 1976.

Reese, Albert. *American Prize Prints of the Twentieth Century*. New York, 1949.

Thompson, Lawrance. *Moby Dick: The Passion of Ahab*, Barre, Mass., 1968.

Who's Who in American Art. New York, 1933–66.

Zigrosser, Carl. "Benton Spruance." In *The Artist in America*, 82–90. New York, 1942.

———. *The Book of Fine Prints*. Illus. 438, 461. Revised edition. New York, 1956.

BIOGRAPHY

Abernethy, Lloyd M. *Benton Spruance: The Artist and the Man*. The Art Alliance Press, forthcoming 1987.

EXHIBITION CATALOGUES AND CHECKLISTS OF SPRUANCE'S WORK

Lithographs and Drawings by Benton Spruance. Weyhe Gallery. New York, 1933.

Tom Jones: Oils, Watercolors and Sketches; Benton Spruance: Drawings, and Lithographs. Gimbel Galleries, Contemporary Art. Philadelphia, 1935.

Lithographs by Benton Spruance. Introduction by Henri Marceau. Weyhe Gallery. New York, 1940.

BS. 24 Lithographs at the Print Club. Foreword by Carl Zigrosser. Print Club. Philadelphia, 1944.

Exhibition of Lithographs by Benton Spruance. Introduction by J. O. C. Jr. Carnegie Institute Department of Fine Arts. Pittsburgh, 1949; reprinted in *Carnegie Magazine*, 23, no. 6 (June 1949): 24–25.

Benton Spruance: Color Lithographs. Introduction by Elizabeth Mongan. Philadelphia Art Alliance. Philadelphia, 1951.

Lithographs 1928—1954 by Benton Spruance. George Washington University Library. Washington, D.C., 1954.

Lithographs 1928–1953 by Benton Spruance. Woodmere Art Gallery. Philadelphia, 1954.

Spruance. Associated American Artists Galleries. New York, 1962.

Color Lithographs by Benton Spruance. George Washington University Library. Washington, D.C., 1963.

Lithographs: Benton Spruance. Mansfield State College. Mansfield, Pa., 1964.

Benton Spruance. Introduction by Carl Zigrosser. Philadelphia College of Art. Philadelphia, 1967.

Memorial and Retrospective Exhibition: Lithographs, Paintings and Drawings by Benton Spruance, 1904–1967. Foreword by Joseph T. Fraser. Pennsylvania Academy of the Fine Arts. Philadelphia, 1968.

Benton Spruance (1904–1967), A Retrospective: Four Decades of Lithography. June 1. Gallery of Fine Art. Washington, 1972.

Benton Spruance. Preface by John Canaday. Introduction by William D. Fletcher. Sacred Heart University. Bridgeport, Conn., 1973.

Benton Spruance (1904–1967). Introduction by Richard Redd. Lehigh University and circulating. Bethlehem, Pa., 1977.

Benton Spruance (1904–1967). Introduction by Margo Dolan. Associated American Artists. Philadelphia, Pa., 1984. A major retrospective of lithographs from the artist's estate.

ARTICLES AND NOTES BY SPRUANCE

"The Place of the Print-Maker." *Magazine of Art,* 30, no. 10 (October 1937): 614–18.

"The College and the Museum." *Philadelphia Museum Bulletin,* 43, no. 218, part 1 (May 1948): 59.

"About Painting in These Parts." *Carnegie Magazine,* 27, no. 3 (March 1953): 77–80. (About Associated Artists of Pittsburgh exhibition at Carnegie Institute juried by Spruance.)

"Editorial." *AEA Newsletter,* 2, no. 1 (July 1954): 2. (Excerpts from speech given at annual meeting of Philadelphia Chapter, Artists Equity Association at time of Spruance's retirement as president.)

Fortieth Anniversary: The Print Club. Philadelphia, 1954. (One of several brief tributes.)

"The State of Contemporary Art in America." *Germantowne Crier,* 7, no. 2 (May 1955): 7–8. (An opening address delivered at the symposium "The Contemporary Creative Arts in America Today," celebrating the 150th anniversary of the Pennsylvania Academy of the Fine Arts.)

"A Philadelphian Looks at Soviet Art." *Sunday Bulletin,* August 2, 1957, sec. 2, pp. 1–2.

"Eakins Dominates 'Sesqui' Art Show." *Philadelphia Inquirer,* January 1955.

College Artist-Teachers Print Exhibition. Philadelphia Art Alliance, 1959. (Preface to exhibition catalogue.)

"Fine Arts." *Beaver College Herald,* 47, no. 3 (January 1968): 5–7. (Published posthumously.)

EXHIBITION REVIEWS

1929
"Print Club Shows English Etchings." *Evening Bulletin,* October 5, 1929.

1932
"Spruance at Print Club." *Public Ledger.* March 27, 1932.

1933
Elizabeth Luther Cary. "Drawings from Clouet to the Moderns on View." *New York Times,* November 26, 1933.

1935
C. H. Bonte. "Gemberley, Settani and Spruance Exhibits." *Philadelphia Inquirer,* January 6, 1935.

1940
"Spruance Exhibits Taken-from-Life

Lithos." *Art Digest*, 14, no. 10 (February 15, 1940): 25.

J. L. "Spruance's Ordered and Lively Lithographs." *Art News*, 38, no. 20 (February 17, 1940): 19.

1947

Florence S. Berryman. "Art and Artists: Philadelphia Lithographer." *Washington Sunday Star*, May 11, 1947, sec. b8.

1949

Margaret Lowengrund. "A Painter Emerges from a Printmaker." *Art Digest*, 23, no. 7 (January 1, 1949): 17.

Howard Devree. "Diverse Americans." *New York Times*, January 9, 1949.

"In the Art Galleries." *New York Herald Tribune*, January 9, 1949.

"Spruance's One Man Show in New York Receives Good Reviews." *Beaver News*, 15, no. 8 (January 14, 1949): 1.

"Noted Lithographer to Show Prints." *Utica Observer*, January 23, 1949.

Jeanette Jena. "Design for Seeing: Artist's Growth Revealed." *Pittsburgh Post-Gazette*, May 29, 1949.

1951

Walter E. Baum. "Benton Spruance Lithographs in Art Alliance." *Philadelphia Sunday Bulletin*, January 14, 1951.

Gertrude Benson. "Benton Spruance Exhibit Highlight at Art Alliance." *Philadelphia Inquirer*, January 14, 1951.

Walter E. Baum. "Art Exhibit with Voice a New Idea." *Philadelphia Sunday Bulletin*, November 25, 1951.

1954

Gertrude Benson. "Spruance and Hankins in Joint Show at Woodmere." *Philadelphia Inquirer*, March 14, 1954.

Dorothy Grafly. "Woodmere Honors Spruance and Hankins." *Art in Focus*, 5, no. 6 (March 1954): 1, 3.

Florence S. Berryman. "Spruance at GW." *Washington Star*, November 21, 1954.

Leslie Judd Porter. "Art in Washington." *Washington Post and Times Herald*, November 21, 1954.

1955

M.S. "Benton Spruance." *Art Digest*, 29 (March 1 1955): 35.

Howard Devree. "About Art and Artists." *New York Times*, March 3, 1955.

"Spruance Color Prints to Be Shown at HUB." *State College and Bellefonte, Pa., Centre Daily Times*, October 3, 1955.

1956

"Lithograph Exhibit Is Set at LSU." *Baton Rouge State Times*, October 9, 1956.

1960

Dorothy Adlow. "Gallery-Trotting among Boston Exhibitions: Prints by Spruance at the Public Library." *Christian Science Monitor*, April 1, 1960.

Dorothy Grafly. "The Art World: Spruance Solo." *Philadelphia Sunday Bulletin*, May 15, 1960.

1962

Brian O'Doherty, "Lithography by Benton Spruance Is Displayed." *New York Times*, October 20, 1962, sec. C.

"Spruance Show." *Philadelphia Inquirer*, October 21, 1962.

1963

Frank Geitlein. "Art and Artists: GWU." *Washington Sunday Star*, May 12, 1963, sec. B.

1964

Victoria Donohoe. "Art News: Beaver College." *Philadelphia Inquirer*, February 16, 1964.

1966
"Spruance Art Now on Display." *Wisconsin State Journal*, January 29, 1966.

1967
Margaret Halsey. "Benton Spruance's Show Is at Phila. College of Art." *Germantown Courier*, September 20, 1967.
Victoria Donohoe. "Philadelphia College of Art." *Philadelphia Inquirer*, September 24, 1967.
Dorothy Grafly. "Spruance and Meltzer." *Philadelphia Sunday Bulletin*, September 24, 1967.
Dorothy Grafly. "Spruance in Retrospect." *Art in Focus*, 19, no. 1 (October 1967): n.p.

1968
Tom Applequist, "Benton Spruance." *34th Street*, 1, no. 2 (October 25, 1968): 11. (Publication issued by students at the University of Pennsylvania.)
Victoria Donohoe. "Phila. Art Scene: Academy of Fine Arts." *Philadelphia Inquirer*, October 27, 1968.
Jane Holtz Kay. "Spruance: Teacher and Artist." *Christian Science Monitor*, November 20, 1968.

1969
"Benton Spruance Prints on Exhibit this Month." *Philadelphia Art Alliance Bulletin*, 48, no. 2 (November 1969): 6–7.

1970
Jim Kinter. "Community Gallery Showing Prints by Benton Spruance." *Lancaster Daily Intelligencer Journal*, January 8, 1970.

1971
Victoria Donohoe. "Gallery Tour." *Philadelphia Inquirer*, October 22, 1971.

1976
Dorothy Grafly. "A Benton Spruance Re-vival." *Art in Focus*, 27, no. 8 (May 1976): n.p.
Laurie Kotloff. "Gallery Shows Spruance Lithographs." *Germantown Courier*, May 20, 1976.

1981
Harriet K. Goodheart. "A 'Highly Moral' Painter." *Chestnut Hill Local*, November 19, 1981.
Alan Milstein. "Around the Galleries, Spruance: A Humanism All His Own." *Philadelphia Bulletin*, November 29, 1981, sec. H7.

ARTICLES AND NOTES ABOUT SPRUANCE
1928
"Prizes Awarded 24 Young Artists." *Public Ledger—Philadelphia*, May 25, 1928.

1938
"The People Work, Four Lithographs by Benton Spruance." *Scribner's Monthly Magazine*, 108, no. 1 (January 1938): 16–17.
"Medal Won by Spruance." *Philadelphia Inquirer*, December 25, 1938.

1939
"Intimate Glimpses, Lithographs by Benton Spruance." *Coronet*, May 1939, pp. 92–97.

1942
"Spruance Wins Collins Award in Print Club's Lithograph Salon." *Philadelphia Record*, January 11, 1942.

1949
"Institute Brings Art to All." *Utica Observer*, February 3, 1949.

1950
Henry C. Pitz. "Benton Spruance." *American Artist*, 14, no. 9 (November 1950): 33–37, 88.

1953

Mary Jane Affleck. "Famed Artist Backs Lithos as Medium of Democracy." *Germantown Courier*, March 5, 1953.

1958

Joseph C. Sloane. "The Lithographs of Benton Spruance." *College Art Journal*, 17, no. 4 (Summer 1958): 404–15.

1961

"Spruance Art Winner." *Germantown Courier*, May 18, 1961.

1962

"Artist Spruance Gets Grant." *Philadelphia Inquirer*, April 30, 1962.

"Guggenheim Fellow," and editorial tribute, "Benton Spruance Illuminator, Too." *Northeast Breeze*, May 10, 1962.

Drew Deacon. "Prominent Gtn. Artist Gets 2nd Fellowship." *Germantown Courier*, May 10, 1962.

1963

Blanche Day. "'Not Everyone's a Grandma Moses' Artist Warns Amateurs." *Germantown Courier*, March 10, 1955.

Margaret Halsey. "Gtn. Artist Has Captive Audience Enjoying His Latest Mural." *Germantown Courier*, September 19, 1963.

"Artist Says Amateurs Should Think of Hobby as Recreation." *Allentown Evening Chronicle*, March 13, 1963.

Ruth Seltzer. "The Philadelphia Scene." *Philadelphia Evening Bulletin*, August 16, 1963.

1964

Dorothy Grafly. "On a Guggenheim." *Philadelphia Sunday Bulletin*, February 23, 1964.

1965

"Benton Spruance to Receive Sketch Club's First Award." *Philadelphia Evening Bulletin*, February 3, 1965.

"First Award of Sketch Club Given to Benton Spruance." *Germantown Courier*, February 11, 1965.

Margaret Halsey. "Notables of Art World Acclaim Benton Spruance." *Main Line Times*, February 18, 1965, and *Germantown Courier*, February 18, 1965.

"Art Alliance's Top Award Given to Benton Spruance." *Philadelphia Evening Bulletin*, March 19, 1965.

"Benton Spruance Receives Medal from Philadelphia Art Alliance." *Northeast Breeze*, March 25, 1965, sec. B.

Peter Lister. "Philadelphia Printmaker." *Philadelphia Sunday Bulletin Magazine*, April 18, 1965, cover illustration and pp. 14–16.

1967

J. N. T. "Personality . . . (Benton Spruance)." *Glenside News*, January 12, 1967.

Peggy Friedberg. "Dr. Spruance Illustrates 'Moby Dick'; 26 Lithographs to Be Printed in Folio." *Beaver News*, 41, no. 7 (March 8, 1967): 1, 4. (Contains numerous quotes from Spruance.)

"A.I.A. Honor For Spruance." *Germantown Courier*, March 16, 1967.

1968

Trevor Wyatt Moore. "Requiem for Ben." *St. Joseph Magazine*, 69, no. 3 (March 1968): 32–35.

1969

"Beaver Plans Dedication of Spruance Art Center," *Philadelphia Evening Bulletin*, May 1, 1969.

1972

Richard A. Duprey, "Ben Made His Angels Speak," *Sign*, 51, no. 6 (January 1972): 14–16.

1978
"Philadelphia's Benton Spruance." *Destination: Philadelphia*, 7, no. 1 (January/February 1978): 16–17.

OBITUARIES
"Benton M. Spruance, Renowned Lithographer and Painter, Dies Here." *Philadelphia Evening Bulletin*, December 6, 1967.
"Benton Spruance Is Dead at 63, Famed Artist, Lithographer," *Philadelphia Inquirer*, December 7, 1967.
"Benton Spruance Print Maker, 63" *New York Times*, December 7, 1967.
"Obituaries," *Time*, December 15, 1967.
Beaver College Herald, 47, no. 3 (January 1968). (Memorial issue, "The Arts," dedicated to Benton Spruance.)
"Benton Spruance Dies." *Artists Equity Association National Newsletter*, Spring 1968, n.p.

MICROFILMS (FROM ARCHIVES OF AMERICAN ART, SMITHSONIAN INSTITUTION, WASHINGTON, D.C.)
Brooklyn Museum, reel BR24, frames 10–11.
New York Public Library, reel N108, frames 644–71.
Pennsylvania Academy of Fine Arts, reel P79, frames 81–94.
Pennsylvania Academy of Fine Arts, reel P83, frames 308–9.

Acknowledgments

Many people have contributed their expertise and time to this catalogue. The project was initiated several years ago with the assistance of Benton Spruance's widow, Winifred. Mrs. Spruance carefully organized the work remaining in the artist's studio at the time of his death and worked closely with William Dolan Fletcher, who prepared a checklist from which the present catalogue has evolved. More recently, Peter and Stephen Spruance, the artist's sons, and Stephen's wife, Carol, have been extremely generous with their time, providing much helpful information and repeated access to prints in their collections. Jerome Kaplan answered countless questions about Spruance's lithographic techniques and provided details about his professional life. Biographical data were further provided by Lloyd M. Abernethy. The Board of Trustees, and Keith Doms, director, of the Free Library of Philadelphia, gave the project their continuing support, and expedited all related matters whenever possible.

Others who have been helpful in a variety of ways are Clinton Adams, John Axelrod, Karen F. Beall, Madeleine Fidell Beaufort, Dominic A. Carbone, Sylvan Cole, Jr., Jack Davis, Margo Dolan, Maurice Hahn, Roslyn S. Hahn, Jane Haslem, Jane S. Hindley, Sinclair Hitchings, Ellen S. Jacobowitz, Cathy Keen, Mrs. Irving Leopold, Richard G. Lonsdorf, Helen Mangelsdorf, Burr G. Miller, Mary B. Monteith, Berthe von Moschzisker, Peter J. Parker, Ann Percy, Randolph Rosensteel, Thea Rump, Anne Scammon, Karan M. Schwartz, G. Thomas Tanselle, Denise Thomas, Mrs. Stanley L. Thornton, Claire van Vliet, David S. Zeidberg, and the National Gallery of Art Photo Services Department, especially Richard Amt and Ira Bartfield.

For providing information about Spruance holdings in their institutional collections we thank the following: E. Maurice Bloch, Victor Carlson, Verna Curtis, Ellen D'Oench, Ebria Feinblatt, Richard S. Field, Betsy Fryberger, Eleanor Garvey, Elizabeth Harris, Charles Helsell, Sara Hutchinson, Audrey Isselbacher, John W. Ittmann, the late Harold Joachim, Robert F. Johnson, David W. Kiehl, Martin F. Krause, Jr., Robert Rainwater, Louise S. Richards, Brenda Rix, Barbara T. Ross, Dale Roylance, Eleanor Sayre, Richard S. Schneiderman, Michael Shantz, Ellen Sharp, Kristin L. Spangenberg, Roberta Waddell, Judith Weiss, Henri Zerner.

For her editorial skill we thank Joanne Ainsworth of the Guilford Group, and at the University of Pennsylvania we thank the late Maurice English (former director), Thomas Rotell (present director), Jo Mugnolo, and Ingalill H. Hjelm, Managing Editor.

Permission to reproduce photographs for this catalogue raisonné has been granted by the Free Library of Philadelphia except as listed below. We thank the following institutions for their cooperation.

BEAVER COLLEGE, PHILADELPHIA, PA.:
218 *From the Sea*
452 *Woman Offering Life*
453 *Mother and Child*

THE NATIONAL GALLERY OF ART, WASHINGTON, D.C., ROSENWALD COLLECTION
233 *Nero*, B13,755
242 *A Wind Is Rising and the Rivers Flow*, B16,003
269 *Jeanne in a Seminole Blouse*, B19,330
288 *Judith*, B19,338

Marie Carbo, Photographer: cat. no. 218

Joseph Marchetti: cat. nos. 218, 453, 454.

Positive Image: cat. nos. 1–2, 5–14,
 21–22, 30–31, 33–40, 42, 44, 46,
 51–53, 55–56, 58–59, 61–64, 66–91,
 93–96, 98–106, 108–15, 117–18,
 120–26, 130–34, 136–37, 139–49, 151,
 153–54, 158–59, 162–64, 166, 168–69,
 172–84, 186, 189–92, 194, 199, 202,
 204–5, 207, 209, 211–17, 219–32,
 234–41, 243, 245–50, 252–55, 257–61,
 264–68, 270–315, 317–24, 326–28,
 330–36, 338–54, 356, 360, 362, 363–66,
 368–75, 377–79, 381–90, 392–96, 398,
 401, 404, 406–7, 410–26, 428, 430–51,
 454–71, 473–74, 476, 478–85, 487–91,
 494–97, 499–508, 510–11, 513–17,
 519–20, 522–24, 526–27, 530–32, 536.

Arthur Soll, Photographer: cat. nos.
 23–24, 196, 203, 206, 256, 316, 337,
 367, 376, 380, 397, 399–400, 402–3,
 405, 408–9, 427, 486, 493, 521, 526a,
 526b, 533–35, 537–47, 549a, 551–52.

Acknowledgments

Index to Titles